Gesina ter Borch

Illuminating Women Artists: Renaissance and Baroque

Series Editors:
Andrea Pearson, American University, Washington, DC
Marilyn Dunn, Loyola University Chicago

Advisory board:
Sheila Barker, Studio Incamminati School for Contemporary Realist Art
Marietta Cambareri, Museum of Fine Arts, Boston
Stephanie Dickey, Queen's University, Kingston, ON
Dagmar H. Eichberger, Heidelberg University
Vera Fortunati, University of Bologna
Mary D. Garrard, American University, Washington, DC
Helen Hills, University of York
Jesse M. Locker, Portland State University
Claudio Strinati, Art Historian, Rome
Virginia Treanor, The National Museum of Women in the Arts
Katlijne van der Stighelen, KU Leuven
Evelyn Welch, King's College London

Acquisitions editor:
Erika Gaffney

The series *Illuminating Women Artists* launches at a critical moment in contemporary culture. It marks a significant intervention within the broader movement underway among scholars, museums, collectors and the wider world of cultural heritage to make evident and contextualise historically the contributions of women artists. As such, the books, each written by a leading specialist in the field of art history, will appeal to audiences from the academic sphere to the general public. Beautifully illustrated, the volumes collectively offer an unprecedented visual contextualisation of the lives and works of their subjects, to whom in some cases a monograph has yet to be dedicated.

Books in the sub-series *Illuminating Women Artists: Renaissance and Baroque* critically reappraise the lives and works of female artists in Europe from the fifteenth to the early eighteenth centuries. Many of the women represented by the volumes were celebrated professional artists in their own eras, yet their names and works have not been passed down continually in the history of art. As the first series dedicated to correcting this omission, the books interweave established conclusions with new discoveries to reframe how women's artistic production is approached and understood.

Gesina ter Borch

Adam Eaker

Lund Humphries | *Illuminating Women Artists*

For Brandon

Originated by Lund Humphries. First published in 2024 in the United Kingdom by

Lund Humphries
Huckletree Shoreditch
Alphabeta Building
18 Finsbury Square
London EC2A 1AH
UK

www.lundhumphries.com

Published simultaneously in the United States of America by Getty Publications,
1200 Getty Center Drive, Suite 500, Los Angeles, CA 90049-1682, USA

Gesina ter Borch © Adam Eaker, 2024

ISBN: 978-1-84822-520-6

A Cataloguing-in-Publication record for this book is available from the British Library

All rights reserved. No part of this publication may be reproduced, stored in a retrieval system or transmitted in any form or by any means, electrical, mechanical or otherwise, without first seeking the permission of the copyright owners and publishers. Every effort has been made to seek permission to reproduce the images in this book. Any omissions are entirely unintentional, and details should be addressed to the publishers.

Adam Eaker has asserted his right under the Copyright, Designs and Patent Act, 1988, to be identified as the Author of this Work.

Copy edited by Julie Gunz
Project managed and designed by Crow Books
Set in Adobe Caslon Pro
Printed in China

Front cover: Gesina ter Borch, *Self-Portrait*, in *Art Book*, fol.12r, 1661, watercolour, heightened with gold and silver, 24.3 × 36 cm (9 ½ × 14 ⅛ in), Rijksmuseum, Amsterdam
Back cover: Gesina ter Borch, *The Triumph of Painting over Death*, in *Art Book*, fol.2r, watercolour, heightened with gold, 24.3 × 36 cm (9 ½ × 14 ⅛ in), Rijksmuseum, Amsterdam

Contents

Series Foreword 6
Acknowledgements 8
Author's Note 9

 Introduction 11
1 The Family Ter Borch 19
2 Learning to Write 41
3 Modern Pictures 59
4 Art and Love 79
5 The Triumph of Painting 99
6 A Dance with Death 111
 Epilogue 127

Notes 130
Select Bibliography 136
Image Credits 140
Index 141

Series Foreword

The series *Illuminating Women Artists: Renaissance and Baroque* was conceptualised at a pivotal moment in contemporary life, when the call to dismantle structural bias was taking on a new urgency. As social justice movements, such as #MeToo, #BlackLivesMatter, and #TransLivesMatter, exposed assumptions about gender, race, and sexual identity, academic research has been infused with a new energy around these topics. Although approaches to, and even the very applicability of, identity categories as they are defined today vary in regard to the past, early modernity and the contemporary moment share a desire to contend with the power structures that have repressed individuals and groups, albeit in historically distinct ways. Books in *Illuminating Women Artists* advance a specific aspect of this study – the feminist academic enterprise – by making evident various ways that early modern women of the fifteenth through eighteenth centuries negotiated, and sometimes resisted, structural constraints in the sphere of the visual arts.

The series is indebted to feminist art-historical studies produced from the beginning of the 1970s that aimed to disrupt the traditional academic focus on early modern male artists by writing their female counterparts into the discipline of art history. These and other scholarship also began to investigate gender norms in the Renaissance and Baroque, which created different conditions for women and men who sought to practice art as professionals or amateurs. Societal limitations disadvantaged most women (and some men) who aspired to a life in the visual arts. For example, girls were excluded from the formal apprenticeship system through which most male artists were trained, and therefore they sought informal instruction, often from male relatives. Women practitioners who married and became mothers generally experienced a lapse in artistic production while they attended to the responsibilities that came with these roles. On the other hand, fathers sometimes supportively promoted their daughters as artists, which also aggrandised the family and improved its financial standing through patronage and sales.

This series considers early modern women artists within their social, cultural, temporal, and geographic contexts. These female artmakers worked in a period when a literary defence of women's merits began to challenge the patriarchal misogynist ideas that sought to suppress women and their potential. Some women artists may have been aware of this incipient feminism or have visually voiced related issues in their art. But the female artists represented by the series also identified with the social structures of

their place and time. These structures, prominent among them gender and class, contributed to shaping their identities and to forming their conceptions about others. While women challenged normative structures in important ways (some more overtly than others), they also were acculturated into dominant cultural attitudes and thus complicit in supporting social hierarchies of class and race. Renaissance and Baroque women artists themselves derived from a spectrum of social classes – artisan, merchant, professional, or patrician. Membership in these classes made it possible for some women artists to have servants or even to enslave persons who contributed to their households. This practice reduced their own domestic obligations and freed time for artmaking, but in turn contributed to reinforcing existing systems of social stratification regarded as the norm.

Some gendered conditions with which female artists contended did not necessarily impede their success, but, even when women's artistic production was critically acclaimed, it was often evaluated according to gender stereotypes. Yet, certain women independently challenged, and circumvented or broke, restrictive gender protocols to enable prolific art production. In the process, they revised those protocols and influenced the history of art. Some established their own professional studios and trained pupils, both female and male, who in turn established themselves as professionals in workshops of their own. Others produced large bodies of work as amateurs, and some rendered porous the boundaries between these two statuses by bridging them. Still others produced works for members of communities to which they belonged, such as professed nuns in enclosed convents, or for personal reasons, such as to have in their possession a portrait of a family member. Some worked under contract for patrons, producing images for prestigious European courts and churches, where their art came under the eyes of the public. These women in the aggregate produced works that varied widely in subject, including both sacred and secular themes, and in artistic media. Represented in the latter category were the familiar forms of sculpture, painting, and printmaking, and also other ways of artmaking that were valued more highly in the past than they are in the present, including papercutting, embroidery, and weaving.

Five decades of sustained research have transformed our understanding of early modern women artists. *Illuminating Women Artists: Renaissance and Baroque* takes stock of this work through books that offer state-of-the-question analyses of their subjects. These peer-reviewed volumes variously interweave established conclusions with new discoveries investigated through emerging modes of analysis to reframe our understanding of the lives, artistic production, and works of art by European women. Together the books reveal the varied ways in which women of the fifteenth through the seventeenth centuries skilfully and often successfully navigated restricting gender norms to stake out productive lives as artmakers and develop innovative approaches to the works they produced. The volumes offer an unprecedented contextualisation of the lives and works of their subjects, to whom in some cases a monograph has not previously been dedicated.

Marilyn Dunn, Loyola University Chicago
Andrea Pearson, American University, Washington, DC
April 2021

Acknowledgements

Over the many years that I have studied the art of Gesina ter Borch, Alison McNeil Kettering's two volumes cataloguing the Ter Borch studio estate have never left my desk. No serious project on Gesina ter Borch, or any member of the Ter Borch family, would be conceivable without this monumental publication. I therefore wish to thank Alison in these very first lines, not only for her scholarship, but also for her encouragement that I write this book and her great generosity in agreeing to read my work in manuscript. She has been in every respect an exemplary mentor and colleague.

At Alison's suggestion, Andrea Pearson first contacted me to propose a volume on Gesina ter Borch for the *Illuminating Women Artists* series. I am grateful to Andrea, her fellow series editor Marilyn Dunn and acquisitions editor Erika Gaffney for their faith in this book, helpful readings of the text, and patience during its long period of development. At Lund Humphries, Rochelle Roberts and Rebeccah Williams coordinated the editorial process, while an anonymous peer reviewer provided much valuable feedback. As project manager, Lucie Worboys oversaw the book's production and ensured that its elegant design did justice to Gesina's art. Julie Gunz's meticulous copy-editing saved me from many mistakes.

Kristina Moore was an important supporter of this book in an earlier incarnation, and Katherine Stirling generously read a draft of my book proposal. As with all my writing, Allison Stielau provided critical insights at every turn. Invitations to lecture at The Frick Collection and the departments of art history at Johns Hopkins University and Columbia University gave me valuable opportunities to share my research; I also presented on Gesina ter Borch's albums in a panel at the College Art Association annual conference, organized by Carrie Anderson and Marseley Kehoe, and at a conference on early modern women and music at Julliard, convened by Eve Straussman-Pflanzer and Elizabeth Weinfield. My research on Margareta Haverman appeared previously in *The Metropolitan Museum Journal*, in an article co-authored with Gerrit Albertson and Silvia Centeno. An expanded version of my discussion of Gesina ter Borch's portrait of Hillegonda Schellinger is forthcoming in the *Nederlands Kunsthistorisch Jaarboek*.

At the Rijksmuseum, Ilona van Tuinen, who curated a beautiful and insightful display of Gesina ter Borch's work, allowed me the great privilege of handling the Ter Borch albums myself. Laurien van der Werff very generously photographed Anna ter Borch's exercise book for me and shared her thoughts on its function. I am deeply grateful to the Rijksmuseum's forward-thinking leadership and staff for their digitization of Gesina's albums and the open-access policy that has allowed this book to be so richly illustrated. In Zwolle, Saskia Zwiers gave me

a memorable tour of the Vrouwenhuis, while Martin van der Linde discussed with me his research into the Black presence in early modern Overijssel. Eelco Bouwers offered assistance with the archives of the Collectie Overijssel, and Donovan Spaanstra kindly granted permission to illustrate his work. Many years ago, Frans Blom and Wijnie de Groot trained me in early modern Dutch palaeography. Any errors in this text are naturally my own.

I am grateful to my Met colleagues, particularly Maryan Ainsworth, Dorothy Mahon, Nadine Orenstein, Sophie Scully, Joanna Sheers Seidenstein and other members of the working group on early modern Northern European art, for conversations and suggestions as the project evolved. Anna-Claire Stinebring gave the manuscript a sensitive reading, drawing on her deep knowledge of genre painting. Keith Christiansen and Stephan Wolohojian were both supporters of the project, and I am grateful to Andrea Bayer and Max Hollein for giving their blessing. The opportunity to teach a regular seminar at Barnard College on seventeenth-century Dutch art pushed me to refine my thinking about the period; I thank the numerous students who have served as interlocutors for my evolving ideas.

For their scholarship, assistance and insights along the way, I also thank Perry Chapman, Nicole Cook, Wayne Franits, Caitlin Henningsen, Elizabeth Honig, Aaron Hyman, Alexandra Libby, Sarah Mallory, Iris Moon, David Pollack, Joe Scheier-Dolberg, Claudia Swan, Christian Thiemann, Ira Westergård, Betsy Wieseman and Ruth Yeazell.

This book is about a family, and I could never have become a scholar or writer without my own. My mother, Lynn Hamilton, first brought me to the Rijksmuseum and gave me vivid memories of Dutch painting at an impressionable age. My father, Mark Eaker, has been unstinting in his support of my work. This book is dedicated to my husband, Brandon Patrick George. Together, we have built a life filled with music, art and love.

AUTHOR'S NOTE

This book tells the story of both Gesina ter Borch and the larger Ter Borch family, whose artistic legacy she preserved for posterity. For purposes of clarity, I have generally referred to members of this family, including my primary subject, by their first names.

The dates of drawings provided here reflect their original inscriptions, without adjustment to the Gregorian calendar, which was not adopted in the province of Overijssel until 1700.

Unless otherwise noted, all translations from the Dutch are my own.

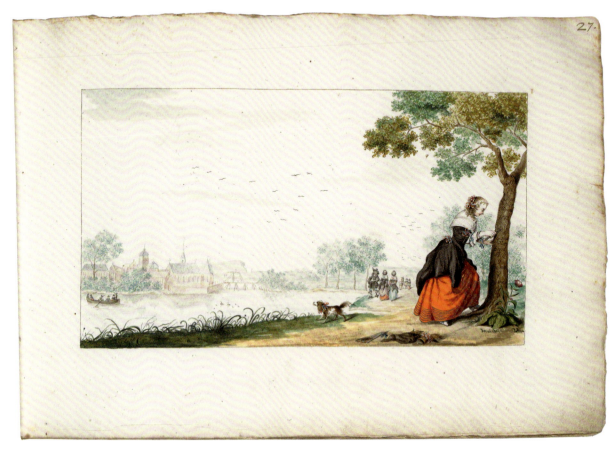

1 Gesina ter Borch, *Self-Portrait Inscribing the Trunk of a Tree*, in *Art Book*, fol.27r, 1661, watercolour, 24.3 × 36 cm (9 ½ × 14 ⅛ in), Rijksmuseum, Amsterdam

Introduction

More than 350 years ago, a Dutch woman commemorated her thirtieth birthday by making a self-portrait (fig.1). The artist appears to have slipped away from a group of day-trippers on the outskirts of a provincial town. She shows herself carving an inscription into the trunk of a tree, one high-heeled shoe braced against its roots. Her fan, gloves and shawl lie discarded on the ground, while her dog, his collar tied with festive ribbons, barks at a boating party on the river. The inscription on the tree gives the date – 15 November 1661 – and a set of initials, as well as the artist's name: Gesina ter Borch. Farther down the trunk she has carved a French phrase: *vive le* ♥ *que mon* ♥ *aime*; 'Long live the heart that my heart loves'.

The birthday portrait appears in one of three albums of drawings and calligraphy that Gesina ter Borch assembled over the course of many years. Housed today at the Rijksmuseum in Amsterdam, these albums represent one of the most remarkable artistic survivals from the seventeenth-century Dutch Republic. For decades, Gesina ter Borch (1631–90) preserved both her own drawings and calligraphy and those of her relatives. She kept her siblings' childhood sketches, annotated by their artist father, as well as those of her own students. She gathered the poems that she and other family members wrote, and the eulogies that admiring contemporaries wrote about them. She was her family's self-appointed historian and archivist. Thanks to this legacy, we can trace not only the growth of the Ter Borchs as artists but also the mundane details of their daily lives. We know the name of Gesina's dog, her favourite poems, and the clothes she wanted her relatives to wear in mourning after her death. We can pore over her self-portraits and read her father's autobiography in verse.

This archive has primarily interested scholars because Gesina's older half-brother Gerard is one of the most celebrated Dutch painters of the seventeenth century. Gerard ter Borch the Younger (1617–81) largely invented the type of picture that scholars now refer to as 'high-life genre painting'. When earlier Northern European painters had depicted everyday scenes, they drew from the so-called low life of taverns and soldiers and peasant merrymaking. Those artists who depicted upper-class revellers located them in fantastic 'gardens of love' or imaginary palaces. Gerard's innovation lay in making art from observations of his own well-to-do family, who sometimes served him as artist's models. Although he also painted scenes of soldiers and sex workers, Gerard's most famous paintings depict patrician women, writing letters or making music in elegant settings. Gerard's subjects are

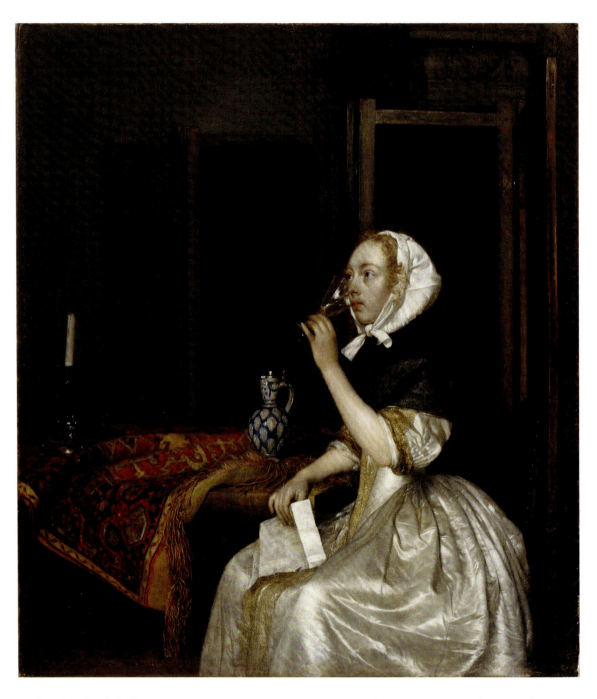

2 Gerard ter Borch the Younger, *Woman Seated Holding a Wine Glass*, c.1665, oil on canvas, 38 × 34 cm (15 × 13 ⅜ in), Sinebrychoff Art Museum, Helsinki

usually beautifully dressed, often in satin – a fabric that perhaps no artist before or since has rendered as skilfully. One of the key innovations of Gerard's paintings was his embrace of narrative ambiguity, allowing room for the beholder's own projections. For this reason, the 'meaning' of his and other contemporaries' depictions of fashionable life has been one of the most contested subjects in the study of Dutch art.

In one such painting, now in Helsinki, Gerard shows a solitary young woman dressed in silver-coloured satin (fig.2). She holds a letter in one hand, while with the other she tips back a glass of wine. These props suggest the vaguest outline of a narrative without a clear moral lesson or conclusion. Who is this woman and what news has she just received? To a traditional iconographer, certain clues might help to tell the picture's story – the rumpled (and very expensive) carpet on the table hints at disorder, while the extinguished candle might signal disappointed hopes. But, like so many of Gerard's other images of women, this painting seems to raise more questions than it answers.

Another way we might begin to interpret Gerard's painting is to tell the story of its model, the artist's half-sister Gesina. Thanks to the self-portraits that Gesina included in her albums (fig.3), we can recognize her throughout Gerard's paintings in the women who write letters, drink wine or entertain suitors in elegant interiors. Because Gesina also regularly portrayed other members of the Ter Borch family, we can trace their own appearances as models within Gerard's paintings. These are not literal portraits, but instead show the Ter Borch family playing parts in theatrical tableaux, including some that contemporaries would have considered morally dubious. Most seventeenth-century painters of figurative subjects used models, who might range from members of their own families to the most vulnerable people in society, such as sex workers, beggars or the enslaved. However, it is extremely rare that we are able to attach names to a seventeenth-century artist's models in the way we frequently can for the genre scenes of Gerard ter Borch. Applying Gesina's albums as an interpretive key to Gerard's paintings gives an unusual insight into the relationship between artist and model as a foundational practice of early modern painting.

Gesina ter Borch's contribution to art history, however, goes far beyond working as an artist's model or a family archivist. Her drawings are a rare and precious legacy: a woman's own images of life in the seventeenth century. Her successful effort to preserve her own artistic production means that her body of work presents almost none of the problems of attribution and dating that complicate the study of other early modern artists, both male and female. Moreover, in their provocative depictions of domestic bliss and misery, Gesina's drawings offer a corrective of sorts to the endlessly alluring fictions of tranquillity painted by her brother and other male artists – depictions that appear to have had little to do with the experiences of actual women. Johannes Vermeer (1632–75), for example, who knew Gerard and drew inspiration from his paintings, almost never painted children, despite having 11 of them himself. But Gesina frequently drew children at play or in the care of women. And she also preserved her father's drawing of her sister Catharina, who died at just ten weeks old, tucked into a coffin with a sprig of rosemary between her small hands (fig.4).

Gesina ter Borch's drawings, ranging from self-portraits to elaborate allegories, offer a counterpoint to Gerard's images of her. Many of them illustrate love poems transcribed in her elegant calligraphy, as well as verse penned by the young men of her town, praising both her beauty and her artistic gifts. Other drawings expand on her albums' themes of courtship and romance, showing young lovers who kiss or carouse or wander the countryside. But there is also a dark side to Gesina's depiction of love. Her albums contain graphic scenes of domestic violence

and even suicide, echoing the recriminations in some of the poems she collected. Gesina's own love affair, commemorated in her birthday drawing, ended in a mysterious estrangement. She chronicled passion as an experience that was at best bittersweet. Read through the lens of this history, Gerard's images of his sister drinking wine or writing letters suddenly appear less enigmatic, more accessible to us all these centuries later. This is not to say that these works should be read in terms of Gesina's biography, but rather that in both her own drawings and in her brother's paintings, Gesina enacted a cultural archetype of the lovelorn woman that contemporary poets and painters were in the process of codifying. Indeed, play with various personae – whether a young marriageable beauty, an Arcadian shepherdess or an erudite painter exclusively devoted to her craft – represents one of the key features of Gesina's art.

In his paintings of Gesina and other women, Gerard crafted introspective, static images of domestic life. His subjects study themselves in mirrors, write letters or play instruments within the respectable confines of the home. By contrast, Gesina's birthday self-portrait is far less demure. She depicted herself out of doors, something Gerard never did. Carving her inscription into a tree, she appears as a writer and image-maker. And whereas Gerard's paintings were meant to be generic images of domestic life, their models anonymous to those outside the family circle, Gesina proudly juxtaposed her own likeness with her name, echoing her albums' larger project of preserving her identity and that of the Ter Borch family.

The distinct nature of Gesina's art reveals the limited opportunities available to female artists during her lifetime. There were professional women artists in the Dutch Republic, but they generally came from a lower social class than Gesina and many gave up their careers upon marriage, or saw their work marketed under their husbands' names. Unlike Gerard, Gesina had no formal training in drawing. Her father did not have her follow the curriculum, based on the study of prints and plaster casts, that he developed for his sons. She almost certainly never travelled outside the Netherlands. Whereas Gerard's paintings circulated on an international art market through the mediation of professional dealers, Gesina's albums stayed at home with their maker. This is not to say that she had no audience – the words of praise incorporated into her albums are ample evidence that she did – but it was an audience of intimates, carefully controlled by the artist herself. And that limited audience, as well as the medium in which she worked, has relegated Gesina to the marginal category of the 'amateur', a status almost as problematically feminized as that of the 'muse'.

While her horizons might initially appear more limited than her brother's, Gesina's story is not simply one of domestic life in the provinces. As her albums demonstrate in abundance, the tumultuous era in which she lived inflected her biography and her art. Canonized as a 'Golden Age', the Dutch seventeenth century was also a period of near-constant warfare. One of Gesina's brothers died at war, while another witnessed the most important peace negotiations of the century. As a middle-aged woman, Gesina endured the occupation of her hometown by enemy forces. Her sister emigrated, leaving Amsterdam for the Dutch colony of Curaçao in the Caribbean, a distant place Gesina attempted to envision in a drawing. Gesina lived in a new nation that actively pursued overseas conquest and took a leading role in the international slave trade. Like other artists of the time, Gesina benefitted from an ever more globalized circulation of images and artefacts. Gesina's albums contain both a Persian miniature and the portraits of two young Black men, 'drawn', Gesina noted, 'from life'.

Moving chronologically, this book surveys Gesina's three major albums and situates them within the broader history of both the Ter Borch family and

3 Gesina ter Borch, *Self-Portrait*, in *Poetry Album*, fol.2r, 1659, watercolour, heightened with gold, 31.3 × 20.4 cm (12 ⅜ × 8 in), Rijksmuseum, Amsterdam

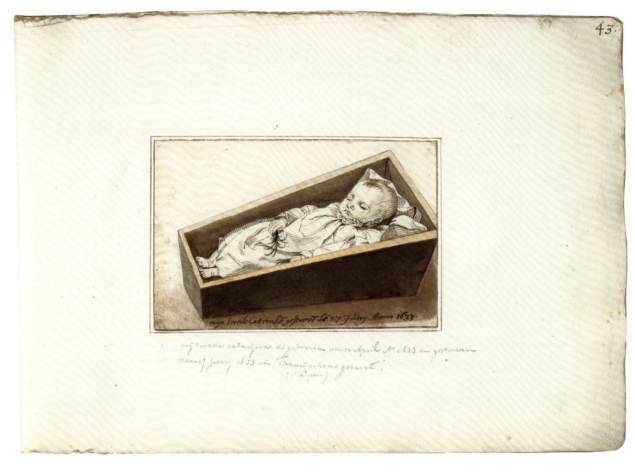

4 Gerard ter Borch the Elder, *Catharina ter Borch in Her Coffin*, in *Art Book*, fol.43r, 1633, pen, ink and wash, 10.5 × 16.2 cm (4 ⅛ × 6 ⅜ in), Rijksmuseum, Amsterdam

women's artistic practices in the Dutch Republic. In their juxtaposition of texts and images, Gesina's albums responded to a number of prior formats and genres, such as the commonplace book, the song book, the friendship album and the book of emblems. Gesina's first album, begun when she was a teenager, is a collection of literary extracts and devotional texts through which she first developed her skills as a calligrapher, documented her wide-ranging reading and took initial steps towards illustrating poetic texts with her own watercolours. This practice blossomed in her second album, a collection of poems and songs in various voices, male and female, that Gesina embellished with her increasingly adept drawings. The third album is both the most ambitious and most eclectic, ranging from elaborate allegories and family portraits to drawings and documents produced by other family members, gathered in the manner of a scrapbook. Alongside extended accounts of Gesina's albums, this book also explores other facets of her world and artistic achievement, including the key contribution she made as a model and collaborator in the development of her brother's famous genre paintings.

 The story of Gesina ter Borch and her family allows for a new perspective on the Dutch seventeenth century and its art. Many modern viewers cherish that art for the unmediated glimpse it seems to offer of everyday life in an era that is both long past and startlingly familiar. Gesina ter Borch's albums complicate that narrative while also going some way towards satisfying the craving expressed by recent novels and films that imagine the women who inspired Vermeer's paintings. Vermeer's models are so historically elusive that a desire to know their stories can only be satisfied with fiction. But Gesina ter Borch, perhaps the most amply documented artist's model of the seventeenth century, is another case entirely. The story that follows attests, after almost four centuries, to her achievement as her own historian.

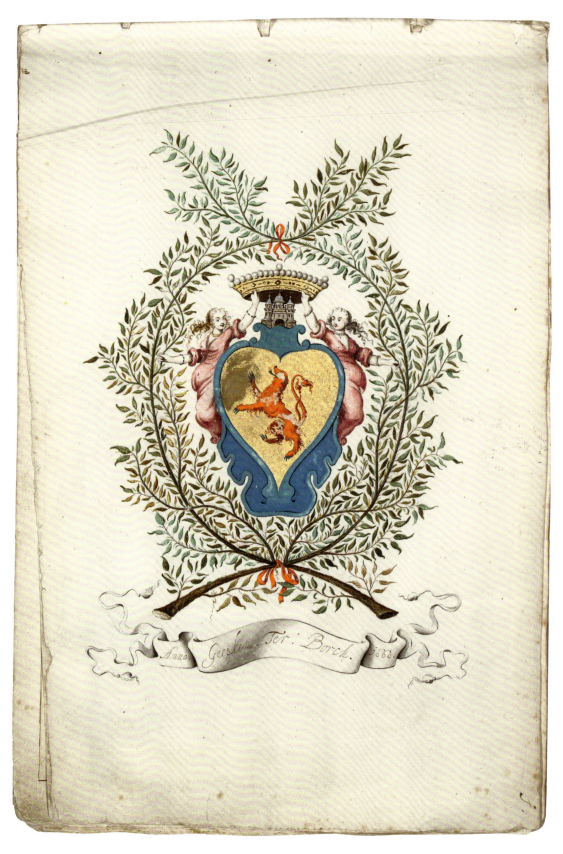

5 Gesina ter Borch, *The Ter Borch Arms*, in *Art Book*, fol.1r, 1660, watercolour and gold leaf, 24.3 × 36 cm (9 ½ × 14 ⅛ in), Rijksmuseum, Amsterdam

I

The Family Ter Borch

Opening the pages of Gesina ter Borch's most ambitious album, what her friend Hendrik Jordis called her *Konstboek* or *Art Book*, we find the artist's depiction of the Ter Borch coat of arms (fig.5). Working with watercolour, egg wash and gold leaf, Gesina carefully crafted an image of status and lineage that announced her album as the work of both an artist and a family. The Ter Borch arms show a lion rampant, on a heart-shaped field topped by a fortress (or *borch* in old Dutch). Gesina embellished this traditional device with two female figures holding aloft a crown. These are framed in turn by bent branches of laurel, tied with red ribbon bows. The artist further emphasized that this was no ordinary coat of arms by including her signature on a fluttering banner below. Using the diminutive form of her name, Geesken, she signed and dated the work 1660, the same year that she slipped a nearly identical coat of arms into her earlier album of illustrated poems and songs.

As a means of representing individual identity, heraldry predominated over painted portraiture for much of European history. Instead of focusing on the chance accidents of physical appearance, coats of arms tell a visual story about descent and continuity. Within the mobile and destabilized society of the seventeenth-century Dutch Republic, families often went to great lengths to establish their pedigrees. Prompted by the rediscovery of Gesina's albums in the late nineteenth century, genealogists traced the Ter Borch family back to the fifteenth century, showing that by the time of Gesina's birth they had long been leading citizens in the town of Zwolle, in the eastern Dutch province of Overijssel.[1] Gesina's grandfather, father and brother Harmen (1638–before 1677) all held the lucrative office of licence master in Zwolle, collecting customs duties on commercial goods passing between the Dutch Republic and the Holy Roman Empire. Some of Gesina's earliest drawings are on the backs of bills of lading that list the stores of indigo, tobacco, sugar and brandy that her father inspected as they made their way down the town's waterways.[2]

The preservation of family portraits and documents represented a cultural imperative in a society preoccupied with genealogy. In her will, Gesina stipulated that the portraits she owned of her grandparents, her parents and her brother Moses (1645–67) should not be sold off but 'kept for the children' of her sister.[3] This was the same wish she expressed for her own albums, clearly seeing them, like the portraits, as inalienable Ter Borch family property. Gesina's will was the concluding act in her lifelong project of safekeeping family memory

through artworks, documents and the portraits she painted of her relatives. The recurrence of the Ter Borch coat of arms throughout her albums is an alternate form of self-portraiture that subordinates the artist to her lineage.

Although she had deep roots in Zwolle on her father's side, other family members connected Gesina to the turbulence and dislocation that defined Dutch society for much of the sixteenth and seventeenth centuries. Gerard ter Borch the Elder's (*c*.1583–1662) first wife, Anna Bufkens (1587–*c*.1621; mother of Gesina's half-brother Gerard the Younger), was born in the Flemish city of Antwerp, making her one of many immigrants who came to the northern Dutch provinces from the Southern Netherlands during the decades-long Dutch Revolt (*c*.1566-1648). At the start of the sixteenth century, the corner of north-western Europe now comprised of the modern countries of the Netherlands, Belgium and Luxembourg formed a fairly cohesive cultural and political region under the rule of the Habsburg dynasty, whose empire in this period also included Spain and its recently colonized territories in the Americas. With artistic and economic capital concentrated in wealthy southern cities like Bruges, Brussels and, above all, Antwerp, the region was defined by the political autonomy of the towns, all densely interconnected with each other and the rest of Europe by extensive trade routes. But in the middle of the sixteenth century, as more inhabitants of the region embraced the Protestant Reformation at the same time as the Habsburgs sought to impose increasingly centralized and draconian rule, this world split apart.

The Dutch Revolt, whose outbreak most historians associate with a spate of iconoclastic violence in 1566, would not reach an official end until 1648, when Gesina was 17 years old. The embattled nature of the young Dutch Republic defined much of her life in the town of Zwolle. The brutal repression of the revolt by the Spanish, particularly as inflicted on the city of Antwerp, drove many refugees into the northern provinces, including Overijssel, home of the Ter Borch family. Among the refugees were merchants, artisans and artists whose skills and experience would soon contribute to the cultural flowering of the northern Dutch cities, most of which were spared the brunt of the Spanish invasion. The hostility of many Protestants towards devotional images, meanwhile, forced artists to develop new specializations in secular imagery, such as landscape and scenes from everyday life.

The Dutch Revolt divided the Netherlands into two distinct cultural spheres – a politically independent and officially Protestant north, and a south under Habsburg rule, where Catholicism was mandated. Nonetheless, ties of family, language and culture kept the border between the two regions relatively porous. Historians estimate that some 40 per cent of the population of the Dutch Republic remained Catholic, and this included many prominent citizens and artists such as Johannes Vermeer, who converted to Catholicism at the time of his marriage. The example of the Ter Borchs shows that even a Protestant family in the Dutch Republic could maintain many contacts with Catholic Europe.

In a series of drawings made between 1657 and 1659, Gesina recorded her own interest in Catholicism. One of these, signed and dated 1658, shows the interior of a Catholic church, with a confessional in the foreground and kneeling congregants attending mass in the background (fig.6). The friar taking confession from the kneeling cavalier wears the habit of the Order of the Holy Cross; it is possible that Gesina visited the order's monastery in the Westphalian town of Emmerich.[4] Her drawing deftly collapses multiple features of Catholicism that would have been exotic to her as a Protestant: confession, the display of the Eucharist in a monstrance by a tonsured priest, and the profusion of religious images, including two crucifixes and a painting of the Virgin and Child. While some of the details are inaccurate (the monstrance should be covered), Gesina's drawing lacks the elements of

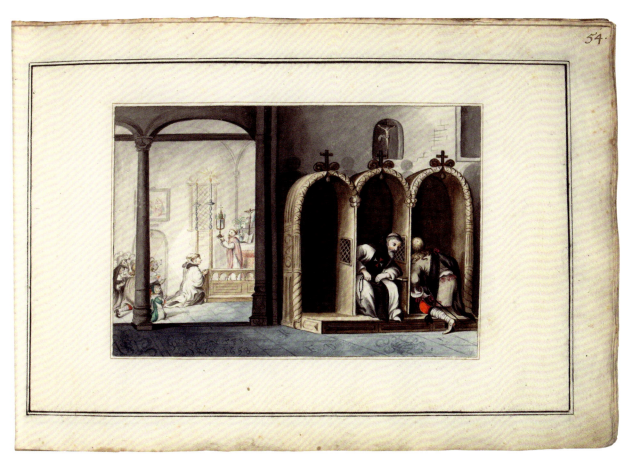

6 Gesina ter Borch, *Church Interior with Confessional*, in *Art Book*, fol.54r, 1658, watercolour, 24.3 × 36 cm (9 ½ × 14 ⅛ in), Rijksmuseum, Amsterdam

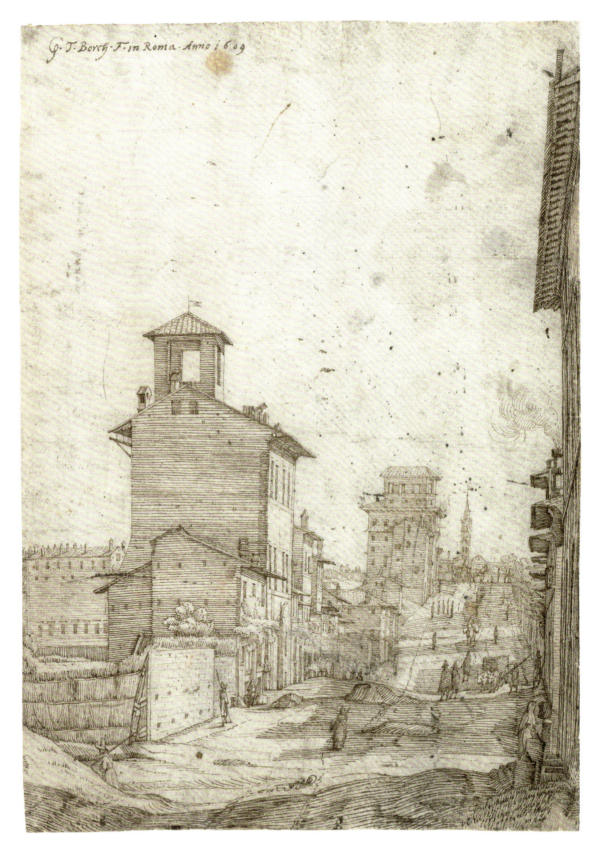

7 Gerard ter Borch the Elder, *View along the Via Panisperna towards S. Maria Maggiore, Rome*, 1609, pen and ink, 27.4 × 19.7 cm (10 ¾ × 7 ¾ in), Rijksmuseum, Amsterdam

censure or parody we might expect from a Dutch Protestant representation of Catholicism. Instead, she took the striking, even macabre, step of placing her signature on a flagstone, as though marking her own burial site next to a loose rendering of the Ter Borch family arms.

Whether or not Gesina ever visited a Catholic church herself, she would have been amply informed about Catholic practices thanks to the travels of both her father and her half-brother Gerard. Born in 1582 or 1583, Gerard the Elder set off for Italy in his late teens, like many other young Northern European men of the period with artistic ambitions. According to a police record from 1608, Gerard the Elder lived in Rome at the palace of Cardinal Colonna, a learned prelate who served as Cardinal-Protector of Flanders.[5] Growing up, Gesina would have seen the detailed drawings of Rome and other Italian locales that her father made on his travels (fig.7). Building on traditions of topographic drawing among Netherlandish artists in Italy, Gerard the Elder captured not only the ruins of classical architecture, but also the modern city of Rome and the daily lives of its inhabitants.

Beyond the drawings preserved by Gesina, very little of Gerard the Elder's work survives today. In one painting, he depicted the Biblical story of Abraham and Isaac, in which an angel intervenes to prevent Abraham from sacrificing his son, as commanded by God (fig.8). The small heads and elongated limbs reveal Gerard's indebtedness to an earlier, highly stylized form of painting that art historians refer to as Mannerism. But the vivid distress on the young Isaac's face as he holds out his bound wrists in a pleading gesture also indicates Gerard's familiarity with cutting-edge developments in Roman painting, particularly the art of Caravaggio (1571–1610). The elongated limbs seen in the painting recur in Gerard the Elder's drawing of the Virgin and Child with St Anne from 1616, which Gesina later copied, adding coloured washes (fig.9).

Returning to Zwolle by 1612, Gerard the Elder soon married the Flemish émigrée Anna Bufkens, who gave

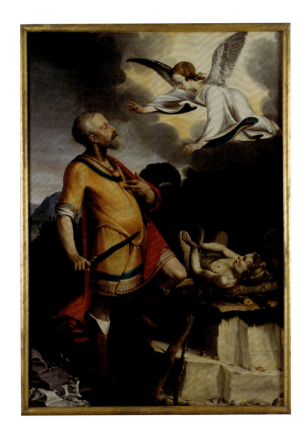

8 Gerard ter Borch Elder, *The Sacrifice of Isaac*, c.1619, oil on canvas, 168 × 118 cm (66 ⅛ × 46 ½ in), Collectie Overijssel, Zwolle

birth to their son, Gerard the Younger, in December of 1617. Following Anna's death sometime before 1621, Gerard the Elder married twice more, both times to women from the nearby city of Deventer. His third wife, Wiesken Matthijs (1607–83), was the mother of nine of his children, including Gesina, who was born in Deventer on 15 November 1631 (fig.10). With many young children to support, Gerard the Elder soon gave up his aspirations to be a professional artist, instead following in his father's footsteps to become Zwolle's licence master. But the artistic achievements

THE FAMILY TER BORCH 23

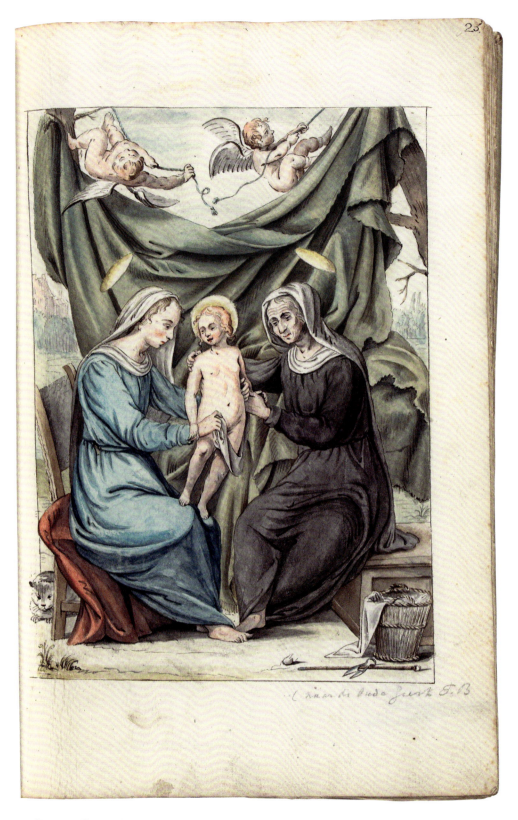

9 Gesina ter Borch, after Gerard ter Borch the Elder, *Madonna and Child with Saint Anne*, in *Poetry Album*, fol.25r, *c.*1653, watercolour, 31.3 × 20.4 cm (12 ⅜ × 8 in), Rijksmuseum, Amsterdam

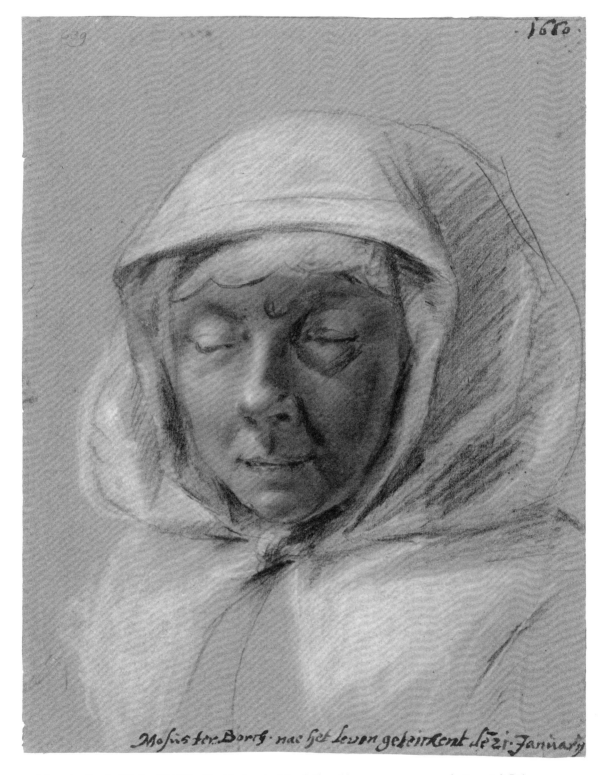

10 Moses ter Borch, *Wiesken Matthijs*, 1660, black and white chalk on blue paper, 29.3 × 23 cm (11 ½ × 9 in), Rijksmuseum, Amsterdam

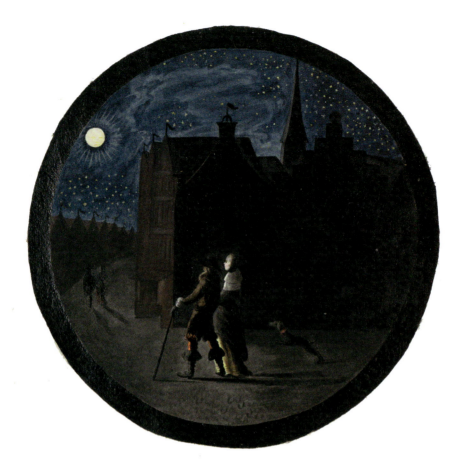

11 Gesina ter Borch, *Couple Strolling by Moonlight*, in *Art Book*, fol.52r, c.1654, watercolour, 12.5 cm (5 in) diameter, Rijksmuseum, Amsterdam

of a number of his children, grounded in instruction from their father, indicate that the visual arts remained central to his life and his identity.

As well as being a draughtsman and painter, Gerard the Elder was a poet, and Gesina preserved his verse in her albums. These texts express the Calvinist values that remained intact despite Gerard's long residence in Rome and that formed another crucial ingredient in Gesina's cultural and spiritual identity. For example, a poem that Gerard the Elder wrote to Gesina's mother Wiesken on the occasion of their marriage combined a statement of faith with praise of his new wife as a 'noble flower born of a good house'.[6] The Calvinist cultural ideal of the wife and mother who paired virtue with physical beauty and good breeding provided an archetype that both Gerard the Younger and Gesina would explore – and to a certain extent, subvert – in their paintings.

The imagery in Gesina's albums reflects a central contradiction within early modern Dutch culture when it came to the status of women. On the one hand, foreign travellers were repeatedly shocked by

the assertiveness of Dutch women and the freedoms they enjoyed, particularly when it came to courtship. For example, Fynes Moryson, a late sixteenth-century visitor from England, noted that: 'mothers of good fame [reputation] permit their daughters at home after they themselves go to bed, to sit up with young men all or most part of the night, banqueting and talking, yea with leave and without leave to walk abroad with young men in the streets by night'.[7] Both Gerard and Gesina ter Borch depicted many scenes of young lovers enjoying the unsupervised liberty that foreign observers like Moryson decried. Indeed, Gesina seems to have had a particular interest in scenes of nocturnal courtship and flirtation (fig.11).[8]

But such freedom was not symptomatic of a culture of libertinism; rather, it was an ostentatious show of the trust the Dutch placed in their daughters. Once married, virtuous women were expected to remain largely at home, maintaining a scrupulously ordered and scrubbed domestic establishment. Dutch genre painters celebrated homemakers as embodiments of national virtue, at the same time as they ridiculed slovenly or inattentive housewives.[9] Given the elimination of female monasticism under the Reformation, there was little provision for unmarried women in Dutch society. Sex workers (whose occupation was criminalized) and other women who fell foul of society's moral strictures might face public shaming or detention in so-called *spinhuizen*, houses of correction where inmates were sentenced to hard labour. In one notorious example, Hendrickje Stoffels (1626–63), the common-law wife and frequent model of Rembrandt van Rijn (1606–69), was forced to appear before the church council of Amsterdam to confess to having 'committed the acts of a whore with Rembrandt the painter'.[10]

Within the home, women performed essential tasks of cooking, cleaning, child-rearing and making or maintaining the textiles that represented a significant portion of most families' wealth. Before her early death, the Amsterdam printmaker Geertruydt Roghman (1625–51/7) provided a unique record of female domestic labour, as viewed by a woman artist, in a series of five engravings from the late 1640s or early 1650s.[11] Unlike many genre paintings that transform women's household tasks into allegories of virtue or vice, most of Roghman's engravings are disarmingly straightforward. The depiction of a woman scouring metalware evokes the muscle required for her task and the ache of a back bent over dirty dishes (fig.12). Because she is viewed from behind, the protagonist of the engraving becomes a kind of Everywoman, standing in for the unceasing labour that kept Dutch households so famously neat.

Dutch women had higher rates of literacy than their contemporaries in other European countries, and they appear as writers and readers in genre paintings with striking frequency. In one celebrated example, Gerard the Younger depicted a woman modelled on Gesina, writing with a quill pen poised above a sheet of paper, having pushed aside an expensive table carpet to create a writing surface (fig.13). Making use of their literacy and wealth, women participated in the art market not only as artists and models, but also as patrons, collectors and dealers. Particularly in widowhood, women might have considerable control over their own property and finances. But the example of Gesina ter Borch shows that some unmarried women also enjoyed financial independence, acquired property and disposed of their assets as they saw fit. Indeed, it is impossible to overstate the degree to which Gesina's ability to devote herself to art as an unmarried woman depended on her position of social and financial privilege.

The city of Zwolle, to which Gerard the Elder returned after his journeyman years, and where his daughter Gesina spent almost all of her life, occupied a cultural borderland between the Holy Roman Empire and the rich cities of the province of Holland, such as Haarlem, Delft, Amsterdam and Leiden, that have dominated most accounts of seventeenth-century Dutch art.[12] Four rivers – the IJssel, the Vecht, the Aa and the Zwarte Water – make Zwolle a waystation

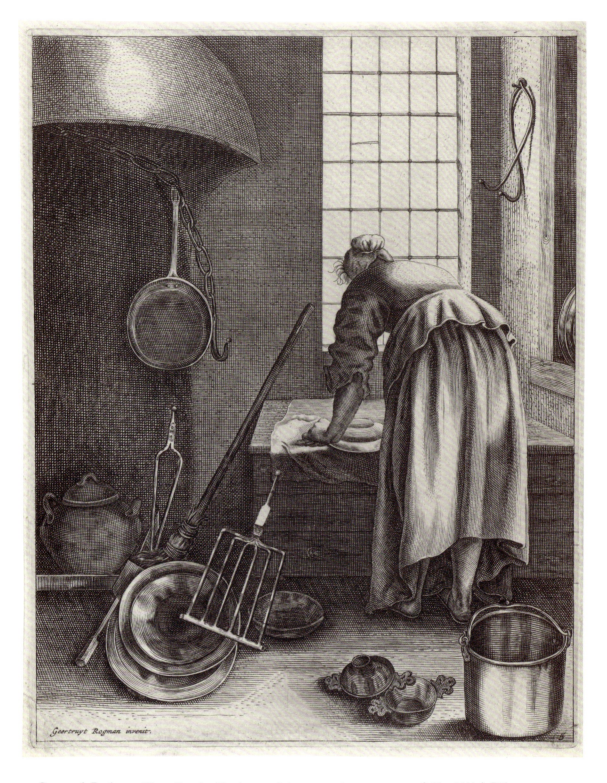

12 Geertruydt Roghman, *Woman Scouring Metalware*, c.1648–52, engraving, 21.3 × 17.1 cm (8 ⅜ × 6 ¾ in), Rijksmuseum, Amsterdam

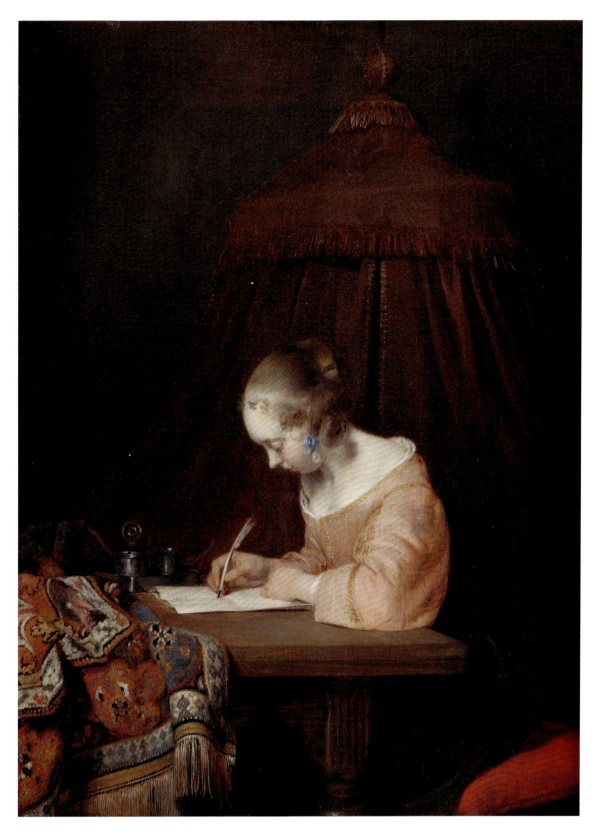

13 Gerard ter Borch the Younger, *Woman Writing a Letter*, 1655, oil on panel, 38.3 × 27.9 cm (15 ⅛ × 11 in), Mauritshuis, The Hague

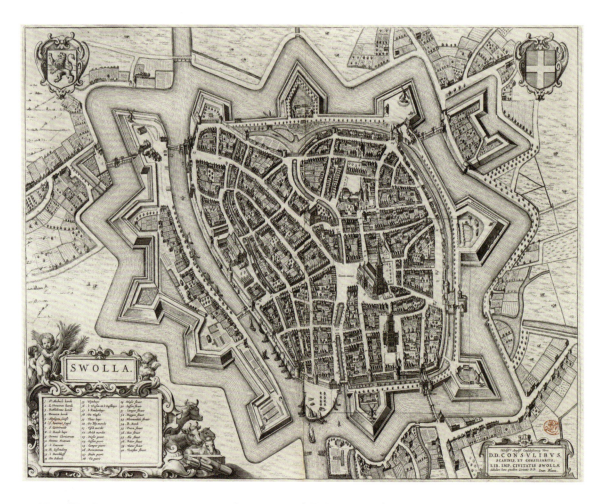

14 *Map of Zwolle*, 1652, engraving, 42.2 × 53 cm (16 5/8 × 20 7/8 in), Rijksmuseum, Amsterdam

between the Atlantic ports and the cities of the Rhineland; its geographic position resulted in both prosperity and recurrent danger from foreign invasions. Spared extensive destruction during the wars of the twentieth century, much of the urban landscape that the Ter Borchs knew can still be visited today.

A map of Zwolle, published when Gesina ter Borch was a young adult, presents her hometown as a carefully fortified island (fig.14). In the seventeenth century, however, residents of Zwolle increasingly pushed past the city walls, building country homes and taking pastoral excursions like the outing recorded in Gesina's birthday self-portrait. As a young man, Gerard the Younger slipped a small sketchbook into his pocket to go drawing in the area where town gave way to countryside, applying the lessons of his father's Roman topographical views to the fortifications, farmhouses and church towers at the edge of the city (fig.15).

In 1655, Gesina drew her own view of the Sassenstraat, the street where the Ter Borch family lived (fig.16). Here, the wobbly recession of the gabled facades provides the backdrop to a scene of everyday

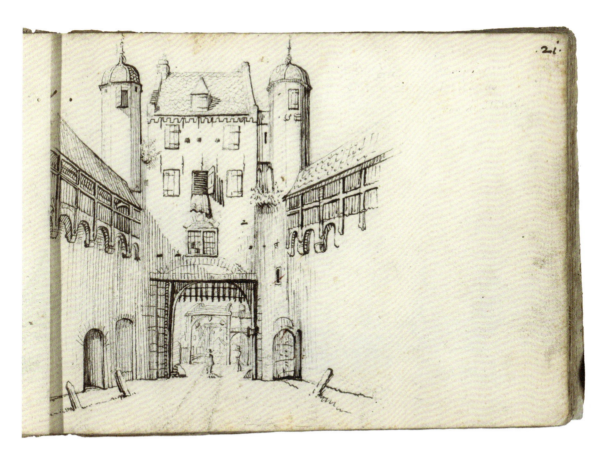

15 Gerard ter Borch the Younger, *The Kamperpoort, Zwolle*, in *Landscape Sketchbook*, fol.21r, *c.*1631–3, pen and ink, 15 × 21.2 cm (5 ⅞ × 8 ⅜ in), Rijksmuseum, Amsterdam

amusements. A pair of young women, some children and a man have all gathered to watch a cockfight on the cobbled street. Another man seems oblivious to their activity, craning his neck up at the buildings while his dog paws at his thighs for attention.

The comparison between Gesina's view of the Sassenstraat and Gerard's own Zwolle street scene is instructive about differences between the artistic practices of these two half-siblings. The focus of Gerard's pen and ink sketch is the Kamperpoort, a fifteenth-century gate at one entrance to the fortified city. The two figures standing beneath the portcullis are drawn with a minimum of detail and appear largely for purposes of scale. Occupying roughly half of a page in a small sketchbook, the drawing gives the impression of a quick notation by an assured and well-schooled draughtsman. By contrast, Gesina's drawing of the Sassenstraat reveals both her artistic strengths and the limitations of her training. Her scene is lively and colourful, with close observation of body language and anecdotal detail. At the same time, her rendering of the architecture and the distorted scale of the figures indicate that she did not benefit from the same training in topographical drawing that Gerard the Elder gave to Gerard the Younger. Gerard the Elder clearly took pride in his son's development

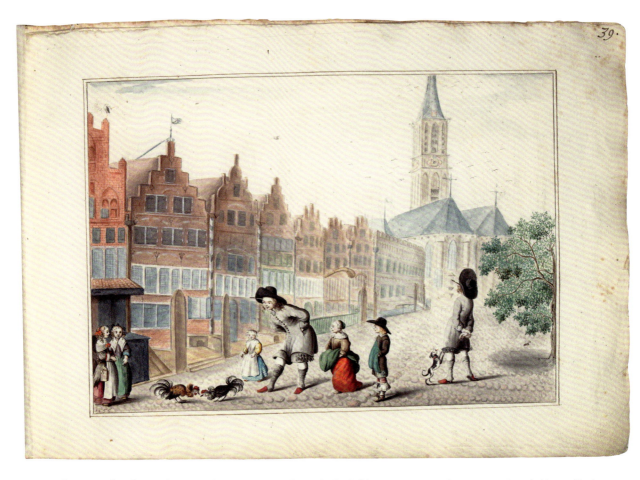

16 Gesina ter Borch, *Cockfight in the Sassenstraat, Zwolle*, in *Art Book*, fol.39r, 1655, watercolour, 24.3 × 36 cm (9 ½ × 14 ⅛ in), Rijksmuseum, Amsterdam

as a draughtsman, annotating drawings he made beginning at the age of eight or nine. These drawings indicate a traditional artistic curriculum combining sketches from life with careful copies after prints and plaster casts that helped Gerard master techniques for rendering spatial recession and the human figure. The surviving drawings of Gesina's younger brothers Harmen and Moses document a similar curriculum. There is no indication, however, that Gerard the Elder gave such instruction to Gesina (or any of his other daughters). Her formal artistic education, as will be seen, was confined to the art of calligraphy.

Because she lacked the formal training of her brothers, and because she did not sell her work, some scholars have described Gesina as an amateur. But the pejorative implications of the term 'amateur' in our own day would not have made sense to Dutch people in the seventeenth century. Their closest equivalent term was *liefhebber*, which, like the word amateur itself, literally means 'lover'. The *liefhebber* was a figure of some prestige in the seventeenth-century art world, a person with a serious knowledge of art who nonetheless had the social standing and economic resources not to depend on making art to survive. Although seventeenth-century Dutch (male) artists made significant strides towards attaining recognition as practitioners of a liberal art, with a few even writing intellectual treatises, they still lived in a culture that often deprecated manual labour. Girls in the families of some professional artists received the same training as their brothers so that they could contribute to the household income. But for a well-to-do bureaucrat like Gerard the Elder, it would have been a point of pride that his daughters required no professional training.

At the same time, aristocrats and even royalty in the seventeenth-century Netherlands took an increasing interest in art-making and manual dexterity as personal accomplishments. The King and Queen of Bohemia, living in exile at The Hague, had the court portraitist Gerard van Honthorst train their daughters in drawing and painting. In a poem written about one of these daughters, Princess Louise Hollandine (1622–1709), the English writer Richard Lovelace (1617–57) compared her to Minerva, the Roman goddess of wisdom (fig.17).[13]

The poems that filled Gesina's albums, praising her artistic accomplishments, represent a provincial emulation of such courtly tributes. Like Louise Hollandine, Gesina was understood to make art purely for her own pleasure, as an accomplishment insulated from the pressures and exposure of the marketplace. Because the Ter Borchs' class identity was less secure than that of the princesses in The Hague, Gerard the Elder may have felt a greater pressure to define his daughters as elite, and therefore non-working, by denying them the rigorous professional training that he gave his sons.

The reputational perils facing women who did acquire professional training become clear from the example of Margareta Haverman (1693–after 1722), a Dutch still-life painter born at the end of the century (fig.18). The daughter of a schoolmaster who had previously served as secretary to the King of Denmark, Haverman apprenticed as an adolescent with the celebrated flower painter Jan van Huysum (1682–1749). According to Van Huysum's early biographer Johan van Gool, Van Huysum was so secretive that he refused to take on any students until Haverman's father persuaded him to accept her as a 'disciple'. Haverman's 'tireless zeal and diligence' soon led her 'not only to copy [Van Huysum's] paintings but also to paint beautifully from life; even to the amazement of connoisseurs, who came to see her work'. Threatened by his pupil's achievement, Van Huysum is said to have used an unnamed misdeed (*slechte daet*) on Haverman's part as a pretext to terminate her tutelage. Despite her father's pleas to keep silent, Van Huysum 'trumpeted everything' and 'drove [Haverman's] father into the grave, and the whole household into ruin'.[14] Haverman subsequently moved to Paris, where she became one of the first women admitted to the Royal Academy of Painting and Sculpture, but then she disappears from the historical record.[15]

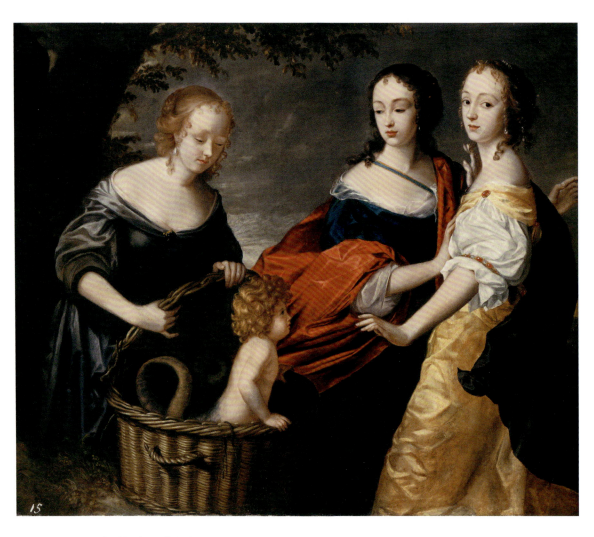

17 Princess Louise Hollandine of the Palatinate, *Allegorical Portrait of Three Ladies and a Child as The Finding of Erichthonius*, n.d., oil on canvas, 132.7 × 157.5 cm (52 ¼ × 62 in), private collection

Modern feminist scholars have done much to recover the achievement of women artists in the seventeenth-century Dutch Republic.[16] The majority of their attention has gone to those women, such as Judith Leyster (1609–60), Maria Sibylla Merian (1647–1717) or Rachel Ruysch (1644–1750), whose training and practice align with twenty-first-century conceptions of the professional artist. Unlike Gesina ter Borch, these artists made a living from their work, which circulated on the open market. Perhaps the most famous seventeenth-century Dutch woman painter, Judith Leyster, was born in Haarlem in 1609, the daughter of a Flemish-born weaver who later purchased a brewery (fig.19).[17] When she was a teenager, her parents experienced bankruptcy and were barred by the church council from receiving communion. Leyster most likely apprenticed with a local painter as an adolescent and was already receiving praise in print by the age of 19. In

18 Margareta Haverman, *A Vase of Flowers*, 1716, oil on panel, 79.4 × 60.3 cm (31 ¼ × 23 ¾ in), The Metropolitan Museum of Art, New York

19 Judith Leyster, *Self-Portrait*, c.1630, oil on canvas, 74.6 × 65.1 cm (29 ⅜ × 25 ⅝ in), National Gallery of Art, Washington, DC

20 Jan Steen, *The Drawing Lesson*, c.1665, oil on panel, 49.2 × 41.2 cm (19 ⅜ × 16 ¼ in), The J. Paul Getty Museum, Los Angeles, CA

1633, she enrolled in Haarlem's Guild of St Luke (the painters' guild), in an important mark of professional recognition. At around this same time, she established her own workshop where she took on several male students. In 1636, Leyster married a fellow painter, Jan Miense Molenaer (c.1610–68), and moved with him to Amsterdam. From this point forward, Leyster's artistic production becomes difficult to track. Like many other women artists, she may have chosen or been compelled to give up her career upon marriage, or she may have been an unacknowledged contributor to paintings marketed under her husband's name. The couple also appear to have been active as art dealers, with Leyster frequently taking the lead in their financial affairs.

Many aspects of Judith Leyster's career, such as her apprenticeship, guild membership and activity on the art market, distinguish her from Gesina ter Borch. While Leyster's career, rather than Gesina's, matches our current model of professionalism, it is important to remember that contemporaries would in no way have viewed Gesina as a lesser figure than a woman, such as Leyster, who sold her work on the open market. Leyster's parents could not provide her with independent means, necessitating a career that reflected her lower social status compared to Gesina. Indeed, Leyster appears to have given up her workshop and most of her artistic production as soon as she was financially able to do so. (Some male artists, like Ferdinand Bol (1616–80), also gave up their artistic careers upon making advantageous marriages.) By contrast, Gesina made art without apparent financial motive and continued to do so throughout her life. Both her own self-presentation in portraits and allegories as well as contemporary commentaries on her art indicate that her artistic ambition was no less than that of women who operated on the art market.

A painting by Gesina's contemporary Jan Steen (1626–79), painted around 1665, gives some insight into how contemporaries perceived the artistic education of well-to-do young women (fig.20). In a studio full of plaster casts, works on paper and other artistic paraphernalia, an elegantly dressed girl sharpens a drawing implement, leaning forward to observe her teacher's work on a sheet of blue paper. He may be demonstrating his technique to her, or perhaps is making an emendation to her own drawing. Another pupil, likely the girl's younger brother, looks on. Rather than being a straightforward scene of artistic instruction, however, Steen's painting, as is typical for his work, bristles with symbolic objects and suggestions of narrative. Most striking is the plaster cast of Cupid that hangs from the ceiling, directly above the teacher and his female student. Cupid's placement draws the viewer's eye to the detail of the teacher's hand resting on the back of his pupil's chair, with the thumb that he has inserted in his palette just about to graze her shoulder. In an expression of ambivalence about women's creativity, Steen shows artistic instruction veering dangerously close to seduction.

We have only scant evidence for Gesina's artistic training compared to that of her brothers, but she does not seem to have received the professional instruction imagined in Steen's painting. Her earliest dated drawing (one of only two that her father annotated) is from 1648, when she was 17, almost a decade older than her brother Gerard was at the start of his artistic education (fig.21). This sheet of figure studies predates Gesina's view of the Sassenstraat by seven years, but shares its droll observation of contemporary fashions and street life. Assembled across three registers, men and women from a variety of social classes preen, pose or go about their business. As she grew more confident as an artist, arranging figures in space and in more complex compositions, Gesina would return to these prototypes, using them to illustrate the contemporary songs and poems that provided so much fodder for her imagination. To understand how Gesina developed her distinctive artistic voice, it is necessary to turn to these texts and to the practices of writing and reading that provided such a crucial element of her education.

21 Gesina ter Borch, *Figure Studies*, in *Materi-boeck*, fol.10r, 1648, watercolour, 15.5 × 21.1 cm (6 × 8 ¼ in), Rijksmuseum, Amsterdam

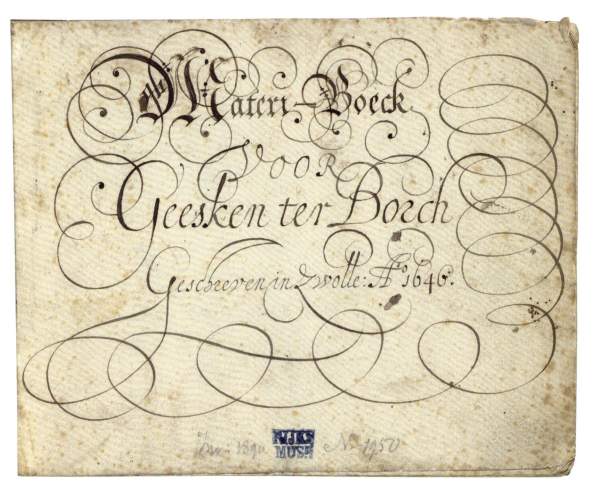

22 Gesina ter Borch, Title Page to *Materi-boeck*, 1646, pen and ink, 15.5 × 21.1 cm (6 × 8 ¼ in), Rijksmuseum, Amsterdam

2

Learning to Write

The earliest of Gesina's albums, begun when she was 15 years old, is the so-called *Materi-boeck*, a homespun booklet of oblong pages folded in half, stitched together, and slipped inside a cover stamped with a simple gridded pattern. The title page, now foxed with mildew, displays the young artist's calligraphic skill and ambition (fig.22).

Adopting the diminutive form of her name by which she was known to family and friends, Gesina wrote out the title, *Materi-boeck for Geesken ter Borch. Written in Zwolle Anno 1646*. She inscribed the first two words in sharp-edged Gothic lettering, the rest in an elegant italic hand. The opening initial M is heavily reinforced and slightly smudged, one of the few signs of inexperience Gesina revealed as she modulated the pressure on her quill pen to thicken or attenuate a line, dissolving letters into curlicues that swoop and pool to fill the margins of the page. Below, a later hand has roughly stamped the seal of the Rijksmuseum in smeared indigo-coloured ink, the mark of Gesina ter Borch's incorporation into the Netherlands' national museum.

The term Gesina used for her first album, a *materi-boeck*, denoted a primer or copy book that imparted both good handwriting and edifying sentiments. The progressive humanist Dirck Volckertszoon Coornhert, who promoted the Dutch vernacular in philosophical and ethical texts, had used the phrase as a subtitle for his 'new ABC book' in 1564.[1] As a teenager, Gesina's older sister Anna (1622–79) practised her penmanship by copying out extracts from Ovid's *Metamorphoses* and a contemporary play (fig.23). Anna ter Borch worked primarily in a workmanlike Gothic script rather than a more up-to-date italic hand. Gesina's *Materi-boeck*, by contrast, reflects her participation in the Dutch Republic's so-called 'Golden Age of Calligraphy', a boom that embraced both male and female, as well as amateur and professional, practitioners.[2]

Linked to the iconophobia of Calvinism, which replaced figurative altarpieces with boards inscribed with scriptural passages, the flourishing of Dutch calligraphy was also an anachronistic gesture that celebrated the handwritten mark in the midst of an ever-expanding print culture. On a more practical level, printed calligraphic manuals catered to an audience of polyglot traders who needed to switch between different 'national' hands to conduct their commercial correspondence in various languages. Gesina's handwritten title page for her first album, like her use of the phrase *materi-boeck*, emulates printed calligraphy books at the same time that it celebrates her name and individual mark.

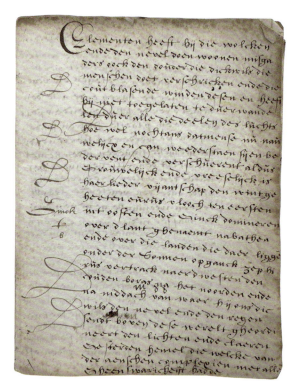

23 Anna ter Borch, *Exercise Book*, fol.1r, c.1638–41, pen and ink, 18 × 22.5 cm (7 ⅛ × 8 ⅞ in), Rijksmuseum, Amsterdam

Before she became a calligrapher, Gesina had to acquire basic literacy, either at a local primary school or through home instruction. Schoolmasters had children first form letters, then words, and finally 'ABC poems' specially devised to promote both penmanship and virtue. To motivate students, teachers would hold contests in which the children copied out set texts, the winner receiving an example of the teacher's own calligraphy on vellum.[3] In addition to her letters, Gesina also had to learn how to trim a quill pen and to make ink. While her later albums are professionally bound, Gesina probably stitched together the *Materi-boeck* herself. Although little evidence for this survives, needlework would almost certainly have formed another important part of her education. Poetry written to her as an adult indicates that she also was trained in music, learning to sing and play the harpsichord.[4]

The Ter Borchs counted the calligrapher Joost Hermans Roldanus (c.1595–1682), a schoolmaster in Zwolle, among their family friends, and he wrote several poems in praise of Gesina's artistic accomplishments as an adult. Gesina likely studied with him as well as from printed manuals by calligraphers such as the schoolmistress Maria Strick (1577–1639). Engravings after Strick's writing display an astonishing variety of calligraphic hands, used to write out extracts in many European languages (fig.24). Whereas painters and engravers might repeat a recognizable signature or trademark, Strick, like other calligraphers, varied her name in each plate, making it further evidence of the copiousness of her invention. One of Strick's manuals, the *Toneel der loflijcke schrijfpen*, or *Theatre of the Praiseworthy Pen*, also includes an acrostic poem on her own name that makes an explicit reference to her 'woman's hand'.[5] Like no other medium, calligraphy allowed for the centring of a woman's name in an assertion of authorship that Gesina ter Borch repeated time and again in her albums.

Calligraphic manuals like Strick's present a complicated interplay between printed and handwritten texts. Meticulously recreating the mark of a specific (female) hand, the manual nonetheless relied on mechanical reproduction to spread the calligrapher's fame. (In the case of Strick's albums, the plates that reproduced her calligraphy were incised by her husband.) One surviving copy of the 1617 edition of Strick's manual, with a provenance going back to the Jesuit House of Profession in 1630s Antwerp, is bound together with both printed and handwritten recipes for ink, as well as blank printed cartouches in which budding calligraphers might practise their own writing.[6]

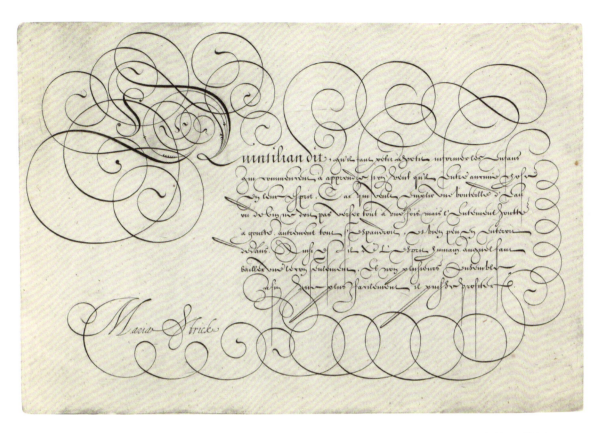

24 Hans Strick, after Maria Strick, *Calligraphy Sample with the Letter Q*, 1618, engraving, 19.8 × 29.5 cm (7 ¾ × 11 ⅝ in), Rijksmuseum, Amsterdam

The few learned women who enjoyed celebrity status in the Dutch Republic were known for their calligraphy. The internationally famous savante Anna Maria van Schurman (1607–78) not only studied Hebrew, Arabic and other Semitic languages, but used them in the calligraphy she inscribed in friends' albums or circulated as gifts (fig.25). (Van Schurman had originally trained her hand by studying one of Strick's model books.[7]) The poet Anna Roemers Visscher (1583–1651), from a well-known literary family in Amsterdam, created a calligraphic manuscript of her poems, and, like other learned women, used a diamond to make an inscription on a drinking glass as a gift for a prominent admirer (fig.26).[8] These women occupied the most socially elevated end of a broad spectrum of women's cultural practices in which elegant writing played a central role. By channelling his daughters' artistic gifts towards calligraphy, as opposed to the life drawing in which he schooled his sons, Gerard ter Borch reflected contemporary gender norms regarding suitable accomplishments for well-born men and women.

Following its title page, Gesina's first album begins, as *materi-boecken* were meant to do, with the letter A, hovering in the upper-left-hand corner within a swirl of lines emerging from the crown of the letter (fig.27). This A also introduces a passage from the Bible,

LEARNING TO WRITE 43

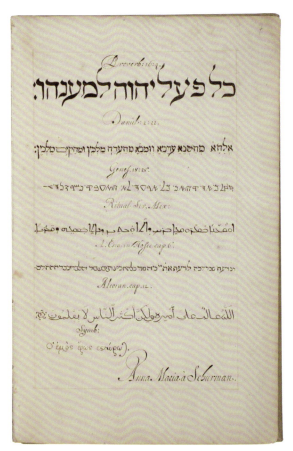 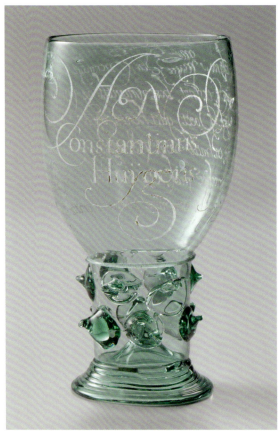

25 Anna Maria van Schurman, *Samples of Hebrew, Greek and Arabic Calligraphy*, n.d., from the *album amicorum* of Nicolas Chevalier, fol.7r, Koninklijke Bibliotheek, The Hague

26 Anna Roemers Visscher, *Glass with a Poem to Constantijn Huygens*, 1619, glass with diamond engraving, 14 cm (5 ½ in) high, Rijksmuseum, Amsterdam

setting the high-minded tone of what will follow: 'As obedient children, not fashioning yourselves according to the former lusts in your ignorance: But as he which hath called you is holy, so be ye holy in all manner of conversation' (Peter 1:14–15). Below this, Gesina copied out the whole of the alphabet in her adept hand, first an upper-case A, and then every letter in miniscule.

Demonstrating her control of the pen, Gesina also displayed her own obedience. Contemporary sources attest that calligraphy functioned both as an art form and as a practice of virtuous self-discipline.[9] In a poem on the art of calligraphy preserved in the Ter Borch family archive, Roldanus proposed an explicit equivalence between calligraphy and painting, declaring that 'the noble art of the pen does as much as a good brush', and recommending that it be learned in 'one's youth, alongside fear of God and virtue'.[10] As the young writers of *materi-boecken* tackled more difficult calligraphic challenges over the course of

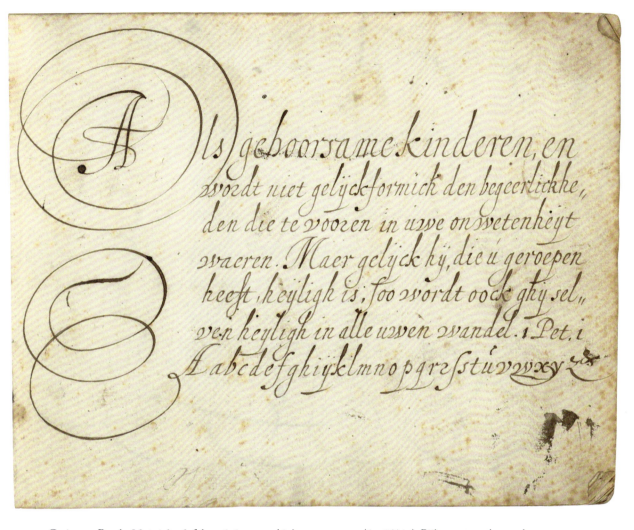

27 Gesina ter Borch, *Materi-boeck*, fol.1r, 1646, pen and ink, 15.5 × 21.1 cm (6 × 8 ¼ in), Rijksmuseum, Amsterdam

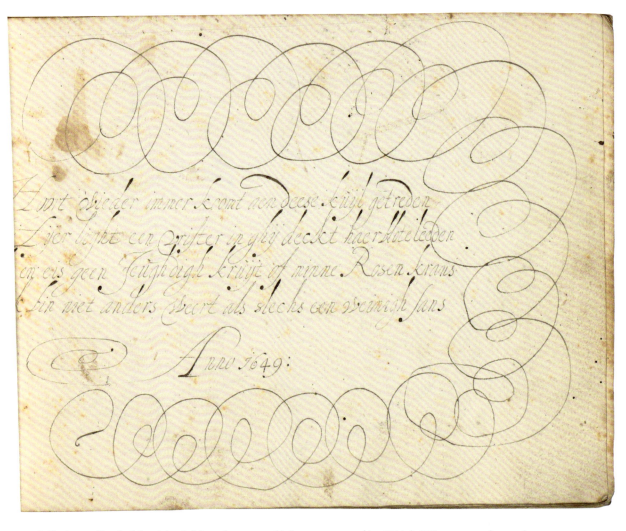

28 Gesina ter Borch, *Materi-boeck*, fol.4r, 1649, pen and ink, 15.5 × 21.1 cm (6 × 8 ¼ in), Rijksmuseum, Amsterdam

their albums, their journey into mastery was meant to model their spiritual growth. The biblical passage Gesina chose to begin her alphabet announced an intention to be holy *in alle uwen wandel*, which in Dutch extends beyond mere conversation to 'all one's conduct'.

The next two pages continue the teenage calligrapher's moralizing progress through the alphabet. B introduces another biblical passage, this time about loyalty to one's neighbours in both woe and wealth. C, meanwhile, departs from biblical texts to provide a justification for the project of the *Materi-boeck* itself, with Gesina writing that: 'Art and learning are more esteemed by thinking people than fleeting possessions and earthly riches. Therefore, all young people ought, in their youth, to be diligent in learning the fine arts and sciences.'[11] Alison McNeil Kettering, who catalogued Gesina's albums, speculated that the text was devised by Gesina's calligraphy teacher, Roldanus, connecting it with the sentiments in his own poetry. But both the awkwardness of the language, in its redundant yoking of 'young people' and 'in their youth', as well as Gesina's placement of her name below the passage suggest that she may herself have devised this justification of her project – one that seems to have quickly bored her, causing her to neglect the album for a full three years.

When Gesina eventually returned to her album, she took it in an entirely new direction. By 1649, the date of the next page of the *Materi-boeck*, Gesina had replaced the Bible quotes and dutiful sentiments of her first pages with source material of a far worldlier nature (fig.28). The *Materi-boeck*'s next page leaves the moralizing alphabet behind, addressing the following words to the reader:

> Hark! you who tread past this hole –
> Here lies a lover [*vrister*], you cover her naked limbs,
> And I demand no youthful herb, or love's rose garland,
> I merit nothing more than a bit of sand.[12]

Returning to her album after a pause of three years, Gesina chose to express herself not through biblical passages but rather in a voice taken from romantic fiction. As befitted her new source material, Gesina's calligraphy changed as well. Her new hand was spidery, faint, but with bold and heavy ascenders. At first glance, this style of writing gives the appearance of an ink-spattered page but in fact requires utmost control, a carefully calibrated modulation between extremes of pressure and delicacy.

On this page, for the first time, Gesina uses a literary extract to speak in an explicitly female voice. The verses identify the speaker as a *vrijster* (in Gesina's spelling, *vrister*), a Dutch word that has no precise English equivalent. Literally, it is the feminine form of *vrijer*, meaning a suitor or lover. In seventeenth-century usage, it specifically denoted a young woman experiencing courtship. The *vrijster*, embodying the liminal status of a woman who had passed out of girlhood but not yet become a wife, was a figure of intense fascination for seventeenth-century Dutch writers and artists.[13] For example, Jacob Cats (1577–1660), by far the most popular Dutch author of the 1600s, wrote a bestseller called *Houwelick*, or *Marriage*, that is divided into chapters that trace the course of a woman's life from girlhood to courtship, marriage, maternity and widowhood.[14] The frontispiece to *Houwelick* by Adriaen van de Venne (1589–1662), seen here in the 1628 edition, maps out these stages moving clockwise, from girlhood at 7 o'clock, to the *vrijster* with her suitor directly above, and on to the widow bent over her sewing on the right (fig.29). The idea expressed here, that clues of costume and pose can identify specific stages of a woman's life, was to preoccupy both Gesina and Gerard ter Borch in their art.

In the chapter of *Houwelick* devoted to the figure of the *vrijster*, Cats imagines a dialogue between a newly married woman named Sibille and her still single friend Rosette. When Sibille criticizes the freedom that parents give to their daughters,

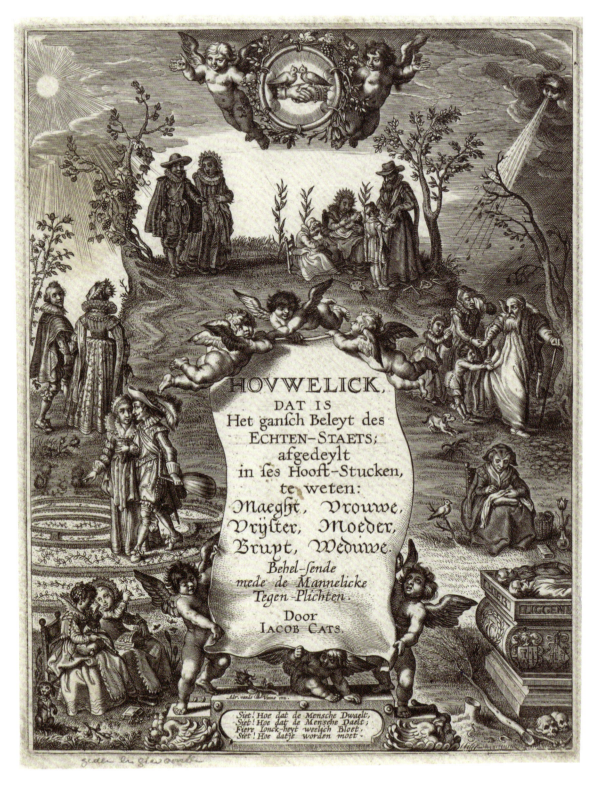

29 Pieter de Jode I, after Adriaen van de Venne, Frontispiece to Jacob Cats, *Houwelick*, 1628, engraving, 19 × 15 cm (7 ½ × 5 ⅞ in), Rijksmuseum, Amsterdam

Rosette puns on the Dutch words for freedom and courtship to make an explicit comparison between the hard-won liberty of the Dutch Republic and the anomalous freedoms enjoyed by young Dutch women, declaring:

> We are a country that has fought itself free [*een vrij-gevochten lant*],
> Why then should there be here a narrow band?
> Why such a hard law
> Imposed on tender maidens?
> In courting [*vrijen*] one should be free [*vrij*] . . .[15]

As noted above, foreign visitors to the Dutch Republic frequently commented on the independence and assertiveness of local women. Passages such as this indicate that, for the Dutch themselves, the figure of the liberated *vrijster* was central to an emerging Dutch national identity grounded in concepts of regulated freedom.

In transcribing a passage into her *Materi-boeck* in which a *vrijster* writes her own epitaph, the 18-year-old Gesina ter Borch announced her arrival at this fraught chapter of life, choosing an especially provocative text to do so. The lines that Gesina inscribed into her album come from another book by Jacob Cats, the *Trou-ringh*, or *Wedding Ring*, first published in 1637.[16] Cats conceived of this voluminous publication as a series of linked tales, in which two men, one old and experienced, the other a young bachelor, tell each other stories about love and marriage on three separate days. These stories present marriage as a 'unifying element in world history', beginning with Adam and Eve, and culminating in Christ's role as heavenly bridegroom wedded to the individual Christian.[17] One of the love stories concerns Emma, daughter of the Emperor Charlemagne, and the scholar Eginart. In his retelling of this medieval legend, Cats endows the art of calligraphy with a distinctly erotic valence, recounting how Eginart seduces the princess, who 'was used to seek her pleasure and her recreation in neatly written books', by introducing her to a 'script that runs more wildly'.[18]

Gesina's *Materi-boeck* quotes from another, more disturbing tale within this collection about the beautiful young daughter of a wealthy merchant. Fittingly named Misandre ('man-hater'), she spurns every suitor and all talk of marriage. Driven to distraction by his desire for her, one suitor, the smooth-talking nobleman Euglottus, endears himself to Abdon, a North African man enslaved by Misandre's father. Abdon boasts that he himself enjoys Misandre's favours every night and offers to have Euglottus take his place in the attic. That night, Misandre sneaks upstairs, and she and Euglottus have sex in the dark. His desire quenched, Euglottus reveals his identity and launches into a vituperative tirade against Misandre. Horrified, she flees into the wilderness. An old hermit helps her to discard her luxurious clothes in exchange for a cloak, a scene whose illustration by Adriaen van de Venne Gesina copied out and preserved in her archive (fig.30). After her meeting with the hermit, Misandre wanders the forest, weeping and beating her breast. Eventually she dies in a grave she has dug for herself beneath a tree inscribed with her own epitaph, the text that Gesina ter Borch copied into her *Materi-boeck*.[19]

In the context of Cats's *Trou-ringh*, the tale of Misandre and Abdon serves to caution parents against leaving their daughters unsupervised. Misandre represents the *vrijster* with too much freedom, whose desire drives her into a fatal affair with an unfree man. The enslaved Abdon represents the *vrijster*'s inverse – a man who has been robbed of the liberty that early modern writers saw as constitutive of manhood. Cats mobilizes Abdon's racial difference and enslavement as a marker of Misandre's degradation. At the same time, the text makes his sexual potency and erotic fascination clear – he is the one man whom the man-hating Misandre cannot resist.

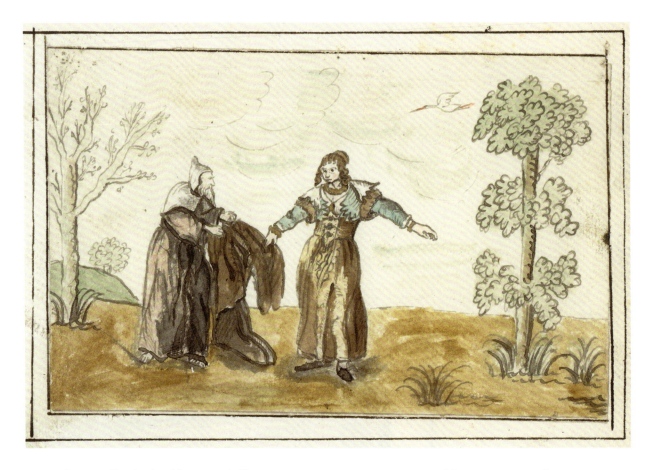

30 Gesina ter Borch, after Adriaen van de Venne, *Misandre and the Hermit*, in *Art Book*, fol.123v, *c.*1649, watercolour, 10 × 16 cm (3 ⅞ × 6 ¼ in), Rijksmuseum, Amsterdam

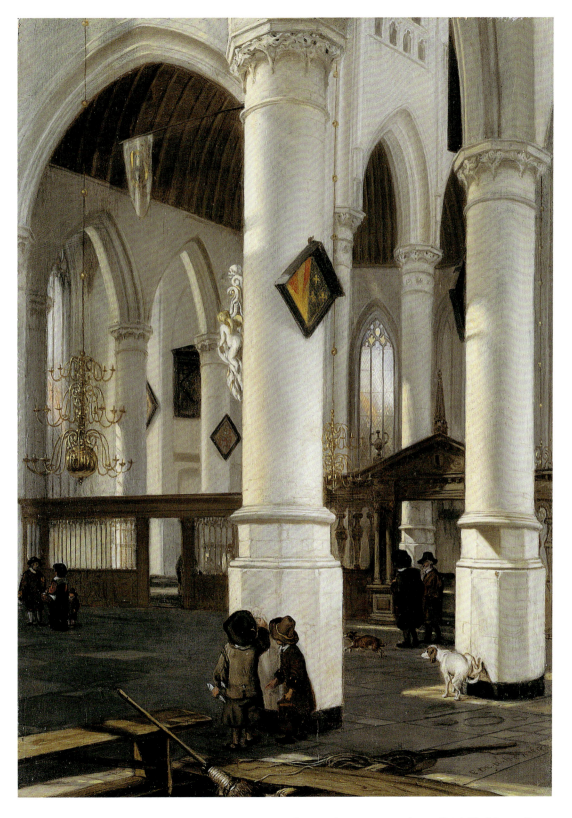

31 Emanuel de Witte, *Interior of the Oude Kerk, Delft*, c.1650, oil on panel, 48.3 × 34.6 cm (19 × 13 ⅝ in), The Metropolitan Museum of Art, New York

Commonplace books like Gesina's album extract texts from their contexts, potentially endowing them with new meaning. They serve as important documents in the history of literary reception by attesting to the passages that caught the eye of individual readers.[20] Gesina's albums, with their abundant literary quotations, demonstrate the breadth of texts available to an affluent and culturally connected female reader in the Dutch Republic. The first pages of the *Materi-boeck* document Gesina's maturation as a consumer of culture in a shift from reading as a disciplinary exercise to an active practice of selection from a wide range of secular and spiritual texts. By isolating Misandre's makeshift epitaph from the rest of her story, Gesina read Cats's tale against the grain and stripped it of its explicit moral. Misandre seems to have fascinated Gesina as a model of what might go wrong as she embarked on a new chapter of life as a *vrijster*. This character allowed Gesina to ventriloquize the voice of a woman destroyed by her own desire, but also a woman who insists on leaving her words for posterity.

Misandre's gesture of carving into the trunk of a tree had another, less mournful afterlife in Gesina's art. More than a decade after she inscribed this passage in her *Materi-boeck*, Gesina commemorated her thirtieth birthday by drawing the self-portrait with which this book opened, where she carves the date, her lover's initials and her own name into a tree (fig.1 above). Gesina's gesture of recording her love in the trunk of a tree had a long literary provenance, extending far past Jacob Cats to the Hellenistic poets and Virgil's eclogues.[21] Amidst a flourishing culture of Dutch pastoral poetry, Gesina ironized and adapted this well-worn device. Inscribing a tree within her self-portrait, she made this act into an allegory for her larger artistic project. Relocated from a timeless pastoral Arcadia to the rural outskirts of Zwolle, the inscription becomes the commemorative mark of a particular woman made at a milestone in her own personal history.

Misandre's fictive epitaph, reworked in Gesina's birthday drawing, itself played with the conventions of real epitaph plaques in Dutch churches, a significant feature of the ecclesiastical interior that straddled the verbal and visual arts. Another manifestation of the widespread practice of calligraphy, incised and sculpted epitaphs were an art form that blossomed in the Calvinist Dutch Republic. In whitewashed church interiors, elaborate calligraphic wall plaques took the place of painted memorial altarpieces.[22] These memorials also caught the eye of contemporary painters. In a view of Delft's Oude Kerk by Emanuel de Witte (c.1616–92), for example, the central pier juxtaposes a painted hatchment, or coat of arms, with the sinuous profile of a more elaborate sculpted memorial (fig.31). Gesina's self-portraits adopt the format of some of these epitaphs, with her likeness enclosed in a fictive auricular frame, crowned with the Ter Borch arms and placed above a poetic inscription in elegant calligraphy (fig.3 above).

Gesina's interest in playing with different voices and amorous themes continues in the rest of the *Materi-boeck*. In her bold new calligraphic hand, she inscribed its pages with a rueful love song, in a man's voice, lamenting that his mistress has left him for another and declaring love 'a strange thing, / full of foolishness'.[23] The *Materi-boeck* attests not only to Gesina's early growth as a calligrapher and a reader, but also as a watercolourist. Two pages after the song on the strangeness of love, we encounter a sheet with studies of two fashionable women in profile (fig.32). Like the figures in her earliest drawing (fig.21 above, which was later bound in with the rest of the *Materi-boeck*), but on a larger scale, these women attest to Gesina's burgeoning interest in costume and body language. Kettering has noted the formal links between Gesina's calligraphy and her early drawings, made 'with the same brown ink [and] the same spidery line'.[24] Watercolour, the medium in which Gesina made the vast majority of her work, had a

32 Gesina ter Borch, *Two Women*, in *Materi-boeck*, fol.9r, watercolour, *c*.1649, heightened with gold, 15.5 × 21.1 cm (6 × 8 ¼ in), Rijksmuseum, Amsterdam

33 Gesina ter Borch, *Boy Playing the Fiddle*, in *Materi-boeck*, fol.17r, 1650, watercolour, 15.5 × 21.1 cm (6 × 8 ¼ in), Rijksmuseum, Amsterdam

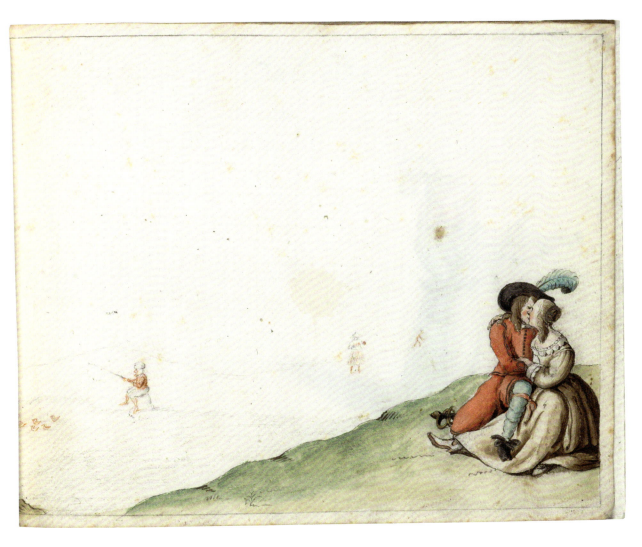

34 Gesina ter Borch, *Two Lovers*, in *Materi-boeck*, fol.16r, 1650, watercolour, 15.5 × 21.1 cm (6 × 8 ¼ in), Rijksmuseum, Amsterdam

distinctly gendered valence in the Dutch Republic. Less messy and malodorous than oils, watercolour paints lent themselves to the work of amateurs without a technical background in the preparation of pigments. In fact, the ambitious Anna Maria van Schurman even dismissed watercolour as a 'simple, easy craft' when compared to the oil painting she preferred.[25]

With the inclusion of her watercolours, the later pages in the *Materi-boeck* represent the first stages of what became a key practice of Gesina's art: the interplay of poetic texts and visual imagery, occupying a single page. An early example of this interplay reveals how Gesina often used figurative imagery to complement, but not directly illustrate, the calligraphic text (fig.33). Here, an amorous couplet, written in four different colours of ink, is juxtaposed with a drawing of a young boy playing a fiddle. The recurrence of the same colours ties figure and text together, while the child's music-making evokes an atmosphere of song and jollity without literally illustrating the text, which reads in translation, 'If someone kisses you without reason, give him back some and be satisfied'.[26] The literal meaning of the text is instead illustrated on the preceding page, where a young couple kiss beside a river or pond (fig.34). The frankness of the couple's embrace reinforces the encouraging eroticism of the couplet, while appearing at odds with the pious statements inscribed elsewhere in the *Materi-boeck*. Rather than attempting to trace a coherent worldview across the album's pages, we can read it as an organic, real-time record of the conflicting messages about love and sexuality that a young Dutch woman absorbed from her culture around the year 1650 and that appealed differently to her at different moments in her life.

Another drawing preserved by Gesina in the Ter Borch family archive sheds further light on the genesis of her young fiddler (fig.35). This lively black chalk sketch shows the same child from Gesina's watercolour, but juxtaposed with another view of the same sitter, seated on a bench. An inscription in Gerard the Elder's hand identifies the drawing as the work of Harmen ter Borch, made 'from the life' on 13 January 1650. This drawing makes clear that as Gesina took her own steps towards becoming a figurative artist as well as a calligrapher, she used her brothers' drawings as prototypes, benefitting from the practice of life study that their father had passed on to them. At the same time, a comparison of the two depictions of the fiddling boy attests to the early emergence of Gesina's own individual style. Her use of coloured washes adds visual interest to the child, even suggesting the delicate flush of his cheeks. Taking advantage of her skill with the pen, she heightened the calligraphic lines of his curls and embellished his cap with two plumes not present in the original drawing. Her fiddler speaks to the lessons she absorbed from other artists in the Ter Borch family but also to her emergence as a mature artist in her own right.

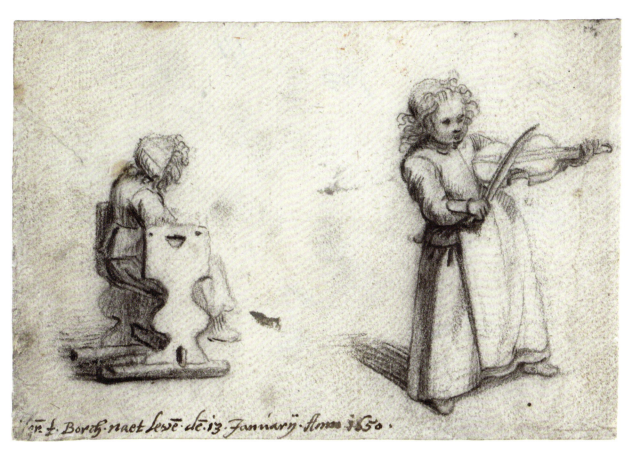

35 Harmen ter Borch, *Two Studies of a Young Boy*, 1650, black chalk, 10.7 × 16 cm (4 ¼ × 6 ¼ in), Rijksmuseum, Amsterdam

36 Gerard ter Borch the Younger, *The Ratification of the Treaty of Münster*, 1648, oil on copper, 45.4 × 58.5 cm (17 ⅞ × 23 in), Rijksmuseum, Amsterdam (on long-term loan from the National Gallery, London)

3
Modern Pictures

The close of the 1640s marked a turning point in the life and art of the Ter Borch family. As we have seen, 1648 is the date of Gesina's earliest surviving drawing, and 1649 marks the shift in her *Materi-boeck* towards secular literary sources and an explicitly female voice. These same years also saw the homecoming of Gerard the Younger after 15 years of itinerancy, and the turn within his art towards elegant scenes of domestic life. All of these changes, artistic and personal, overlapped with a major milestone in the history of the Dutch Republic: the conclusion of 80 years of war against Spain, ratified with the Treaty of Münster in 1648. Gerard the Younger was an eyewitness to the treaty's signing, having spent the previous two and a half years in Münster, painting portraits of both the Dutch and Spanish envoys to the peace negotiations.[1] (During his peripatetic journeyman years, Gerard had travelled to Spain and even painted a now lost portrait of King Philip IV, an unlikely honour for a Dutch Protestant artist in this period.) Gerard's crowning achievement in Münster was an ambitious group portrait depicting the ratification of the treaty itself (fig.36). In a measure of his confidence, Gerard included a self-portrait among the dignitaries, appearing at the far left and looking directly out at the beholder from above a drooping moustache. He returned to Zwolle laden with sketches that clearly fired Gesina's curiosity; she soon copied his depictions of Westphalian and Spanish dress in her own drawings.

The period of peace and prosperity initiated by the Treaty of Münster had major consequences for Dutch painting. With the surplus income generated by a booming economy, wealthy Dutch people invested more in luxury goods, including works of art. At the same time, the defensiveness and siege mentality of the first half of the seventeenth century gave way to a worldliness and cosmopolitanism that reflected the Dutch Republic's emergence on the global stage. In the decades that followed the treaty, the wealthiest Dutch people began to model their clothing, behaviour and homes on those of French aristocrats. A pursuit of refinement and civility, expressed in practices like dance, etiquette and handwriting, spread across the more affluent segments of society.[2]

All these shifts contributed to the rise of so-called high-life genre painting, the type of painting for which Gerard ter Borch the Younger is most famous today. Art historians use 'genre painting', a term that did not exist in the seventeenth century, as a broad catch-all for scenes of everyday life.[3] Unlike history paintings, genre paintings do not usually have specific literary sources, although they may draw on stock characters or situations from popular

theatre. When they emerged as a widespread type of imagery in the mid-sixteenth-century Netherlands, genre paintings generally focused on scenes from the lives of the lower classes. Taverns, brothels or army encampments all provided popular settings for these scenes of drinking and carousing. This subject matter might be explored in relatively affordable prints, but also in exquisitely crafted paintings made for the highest end of the art market. Because the class identity of the consumers of these paintings was so different from that of the people they depicted, art historians have sometimes read low-life genre scenes as dehumanizing images of social others, intended to reinforce the superiority of the viewer over the viewed. (The pejorative nomenclature of 'low-life' itself reinforces this supposition.) Other scholars have seen in such scenes of carnival merrymaking a taste for harmless amusement, or a subversive celebration of the persistence of folk culture and revelry in the face of official morality.

The interpretation of genre paintings, particularly the question of their moralizing nature or use of what a previous generation of scholars termed 'disguised symbolism', represents one of the most intense subjects of debate within the study of Dutch art. Until the second half of the twentieth century, Dutch painting was frequently characterized, particularly by non-Dutch critics, as a 'mere' transcription of reality, without the intellectual and literary content that distinguished the most prestigious Italian and French art. In response to this long history of deprecation, Dutch scholars working in the wake of the Second World War provided ample documentation for the cultural context from which genre painting emerged, and of links between these paintings and contemporary poems, sermons and other literary texts. These interpretations often adduced the combined literary-visual genre known as the emblem print (fig.37).[4] Here, an epigrammatic statement of a general truth is accompanied by a visual allegory, usually with a further verbal elucidation below.

Drawing clues from these prints, art historians of the 'emblematic' school have argued that the seemingly ordinary objects that appear within genre paintings, like birdcages or strings of pearls, in fact encode symbolic meanings that give these paintings a clear moral message.

Against this school of interpretation, other scholars have argued that reducing genre paintings to moralizing texts misses precisely those qualities that distinguish them from affordable prints or didactic poems. Why, such scholars ask, would sophisticated consumers have spent large sums on works of painstaking facture, simply to remind themselves of hackneyed sentiments just as easily conveyed by a penny print? These interpreters tend instead to view genre painting as a realm of optical experience and pleasure, in which artists were primarily focused on displaying their mastery in the description of the visible world.[5] A textbook illustration of these opposing viewpoints would be to ask whether, when looking at a genre painting by Gerard ter Borch of a splendidly dressed young woman, we are meant primarily to admire the rendering of her satin gown, or to identify her as a deplorable victim of seduction (fig.2 above).

At the close of the twentieth century, scholars often carried out this debate in vociferous and divisive terms. By now, however, most would agree that elite genre paintings both engage with contemporary social mores and offer a surplus value that exceeds didactic instruction. Indeed, one of the pleasures provided by the greatest Dutch genre paintings is the burden of interpretation that they place on the beholder. Given a set of more or less enigmatic clues through body language, costume, setting and accessories, we can invent our own stories about what is happening, without recourse to a single literary prototype to limit the free play of our imagination.

The albums of Gesina ter Borch offer us another window into the mindset that period viewers brought to Dutch genre paintings. As an artist who frequently juxtaposed literary texts with scenes of domestic

37 Roemer Visscher, *Penetrat et Solidiora*, in *Sinnepoppen*, 1614, engraving, 13.7 × 18.8 cm (5 ⅜ × 7 ⅜ in), Rijksmuseum, Amsterdam

life, she is one of our best witnesses to how elite seventeenth-century Dutch women thought about genre imagery and its connection to contemporary literature. Gesina also allowed privileged viewers to inscribe their commentary on her art directly into her albums, providing invaluable documentation for her own genre scenes' earliest reception. At the same time, the collaboration between Gesina and her half-brother Gerard, sparked when he returned to Zwolle from Münster and began to take his siblings as models for highly innovative scenes of domestic life, is essential to any understanding of the genesis and meaning of high-life genre painting.

As noted above, seventeenth-century people did not use the term 'genre painting'. Instead, they were likely to refer to this kind of picture as 'modern', meaning that it depicted subject matter that was both contemporary and fashionable. A well-known instance of this usage comes from a letter that Gerard the Elder wrote to Gerard the Younger in 1635, when the latter was serving an apprenticeship in London. Along with instructions to 'serve God above all', and to 'take note of your linen', the father encouraged his son to paint 'modern compositions' (*ordonantsij van modarn*).[6] Although the phrase is ambiguous, it most likely indicated the kind of scene of fashionable life

MODERN PICTURES 61

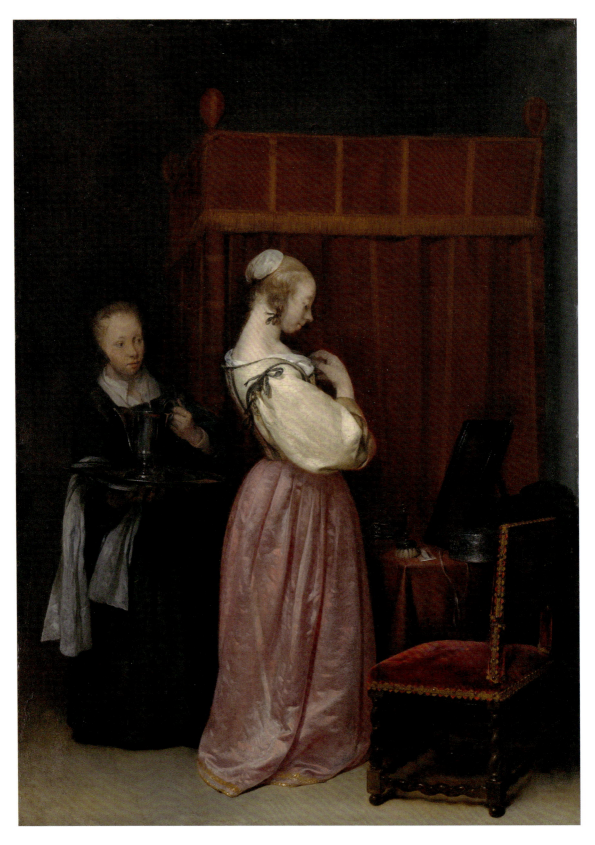

38 Gerard ter Borch the Younger, *A Young Woman at Her Toilette with a Maid*, c.1650, oil on panel, 47.6 × 34.6 cm (18 ¾ × 13 ⅝ in), The Metropolitan Museum of Art, New York

for which Gerard the Younger would soon become famous. The phrase 'modern pictures' (*moderne beelden*) also appears in contemporary Dutch inventories and has been associated with the genre paintings of Judith Leyster.[7] In his own attempt to define the modern manner, the Dutch painter Gérard de Lairesse (1641–1711) associated it with the swiftly changing fashions of the urban bourgeoisie, best captured by painters who themselves belonged to that milieu, since it is easier 'for a citizen to play a citizen's part than any other; and for a painter to keep to the management of what he daily meets with'.[8] Viewed in this light, Gerard the Younger's high-life genre scenes can be read as an advertisement of his family's own refinement. Kettering has further argued that his paintings were viewed as particularly modern, not just for their attention to contemporary fashion, but also for their qualities of 'narrative ambiguity and psychological subtlety'.[9]

All these features are apparent in the first high-life genre painting that Ter Borch made, shortly after he returned to Zwolle from Münster in 1648 (fig.38). The painting depicts two women within an interior. Standing before a bed, the central, brightly illuminated figure has raised a hand to adjust or tighten her bodice. Her gaze is lowered, and she faces a dressing table bearing a mirror, comb, powder puff and other accessories. Waiting in the shadows behind her is another, slightly younger woman. With a linen towel slung over one arm, she carries a pitcher and basin of brightly polished silver. The mere act of describing a genre painting requires the beholder to make determinations about social relationships based on body language, clothing and other clues. In the case of Gerard's painting, we can say with confidence that there is a class difference between the two women depicted, and that the woman with the pitcher and basin is a maidservant in attendance upon her mistress. The brilliant rose-coloured satin of the taller woman's skirt, trimmed with gold thread at its hem, makes her the focal point of the picture, while her action and gaze establish her self-absorption. The maid, by contrast, looks at her mistress, echoing our own act of looking at the picture.

At a remove of nearly 400 years, it can be difficult to recover just how revolutionary this picture of two ordinary and anonymous women would have been. Its innovations become clearer, however, when we contrast Gerard's painting with one made a few decades earlier by the Flemish painter Peter Paul Rubens (1577–1640; fig.39). Like Gerard's, Rubens's painting depicts a central, brightly illuminated woman before a mirror, flanked by a female attendant. In the earlier painting, both women are nude, and a young, winged and equally nude boy holds up the mirror in which the central woman studies herself. The nudity and the winged attendant place this scene in the realm of myth and allow us to identify the blonde woman as Venus, the goddess of love and beauty. Adopting a frequent trope of early modern depictions of beautiful women, Rubens instrumentalizes the blackness of Venus's attendant as a foil to the white skin and fair hair of his central figure.[10] Rubens's painting, with its abundance of bare flesh, may be grounded in the study of live models, but their appearance has been filtered through a process of idealization and art historical citation. The painting's removal from contemporary life gives licence to its eroticism.

By contrast, every detail of Gerard's painting is grounded in the contemporary, with a close attention to fashion and furniture that can allow it to be dated almost to the year. While a much less explicit image than Rubens's, it imparts its own voyeuristic frisson by showing beholders something they were never meant to see: the private morning ritual of a well-to-do young woman. In a culture that placed enormous value on female modesty, the painting intrudes upon a woman's privacy and exposes her to view. The realism of the painting derives not only from its domestic detail but also from the individuality of the figures depicted. Unlike Rubens's Venus, these are recognizably real women.

39 Peter Paul Rubens, *Venus in Front of the Mirror*, c.1614–15, oil on panel, 123 × 98 cm (48 ⅜ × 38 ⅝ in), The Princely Collections, Liechtenstein

Identifying individuals from a pre-photographic era based on resemblances shared between different works of art is a perilous business. Artists often assimilated their models to a signature style, with the result that a family resemblance links most figures within their body of work. Even when models with a distinctive likeness reappear within an artistic corpus like Rubens's, we often lack the ability to identify them by name. In the case of Gerard ter Borch's paintings, however, we can compare the models in his paintings with the portraits (and self-portraits) in Gesina's albums and the drawings by other family members that she preserved. These works illuminate Gerard's recruitment of models from his family circle and, by extension, the inspiration that he drew from his family's way of life as he devised his innovative genre paintings.

In the case of Gesina, scholars have worked backward from the self-portraits she painted to identify her with a series of young women who appear in Gerard's genre paintings beginning with the *Young Woman at her Toilette* of *c*.1650.[11] We have a strong sense of how Gesina looked around the year 1660, thanks to her self-portraits and a contemporary chalk drawing by her brother Moses (fig.40). A woman with nearly identical features appears in many of Gerard's genre scenes from roughly the same date, such as the painting now in Helsinki of the woman with the wineglass (fig.2 above). In the case of Gerard's first genre scenes however, which predate Gesina's secure self-portraits by a good decade, identifications must be more tentative.

The woman standing at her toilette in Gerard's earliest high-life picture has a high brow, receding chin and long slender neck. These features recur in a pair of quick sketches Gerard made around the time of his return to Zwolle, where the sitter has her hair combed back into a tight bun, with cascades of loose strands falling from her temples, a similar hairstyle to that in the genre painting of the young woman adjusting her bodice (fig.41). A significantly earlier drawing by Gerard the Elder may depict this same woman as an adolescent; she appears bent over a book, but has a similar high forehead, tightly combed hair, long nose and narrow, receding chin (fig.42). Kettering has plausibly identified this girl, wearing the costume of the early 1630s, with Anna ter Borch, who was born in 1622, nine years before Gesina.[12] In 1960, the art historian Sturla Gudlaugsson speculated that Anna ter Borch may have served as the model for both fig.41 and for Gerard's celebrated genre scene known by the later title of *The Unwelcome News* (fig.43).[13]

There are striking discrepancies between Gesina's self-portraits and the young woman who appears in Gerard's earliest genre paintings. Even allowing for the physical changes that occur over the course of a decade, it seems unlikely that Gesina, with her round face and slightly upturned nose, was the model for Gerard's first young woman at her toilette, or the quick sketches that he made shortly after his return from Münster. Nevertheless, it is clear that Gesina's likeness predominates in the high-life pictures her half-brother painted in the 1660s, and she most likely began modelling for him well before that date.

Perhaps more interesting than the question of which specific paintings by Gerard took Gesina as their model is the role that she played in sparking her half-brother's shift in subject matter following his return to Overijssel. As we have seen, by 1649, Gesina was immersed in contemporary literature and its investigation of the liminal status of the *vrijster*. In her drawings, she had begun to document contemporary fashions and mores with a gently ironic eye. If her albums are any indication, she filled her life at this period with musical parties and merry outings in the company of other young people. Both in her literary interests and her sociability she embodied a new female archetype (and a vexed new female freedom) that came to define Gerard's art. Rather than deploying the gendered and objectifying language of the 'muse' to describe the creative

40 Moses ter Borch, *Gesina ter Borch*, 1660, black and white chalk on blue paper, 19.4 × 14.5 cm (7 ⅝ × 5 ¾ in), Rijksmuseum, Amsterdam

41 Gerard ter Borch the Younger, *Two Studies of Anna ter Borch (?)*, c.1648, pencil, black chalk and brown ink, 19.8 × 10.7 cm (7 ¾ × 4 ¼ in), Rijksmuseum, Amsterdam

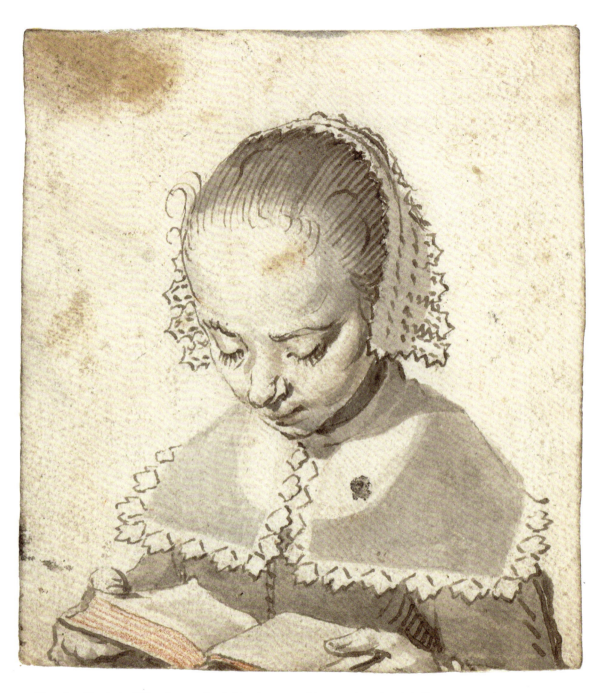

42 Gerard ter Borch the Elder, *Anna ter Borch (?)*, c.1632, pen and brown ink, with red chalk, 9.7 × 8.8 cm (3 ⅞ × 3 ½ in), Rijksmuseum, Amsterdam

43 Gerard ter Borch the Younger, *The Unwelcome News*, 1653, oil on panel, 66.9 × 59.3 cm (26 ⅜ × 23 ⅜ in), Mauritshuis, The Hague

44 Jan Steen, *Wine Is a Mocker*, c.1663–4, oil on canvas, 87.3 × 104.8 cm (34 ⅜ × 41 ¼ in), The Norton Simon Museum, Pasadena, CA

45 Dirck Bleker, *The Penitent Mary Magdalene*, 1651, oil on canvas, 112 × 83 cm (44 ⅛ × 32 ⅝ in), Rijksmuseum, Amsterdam

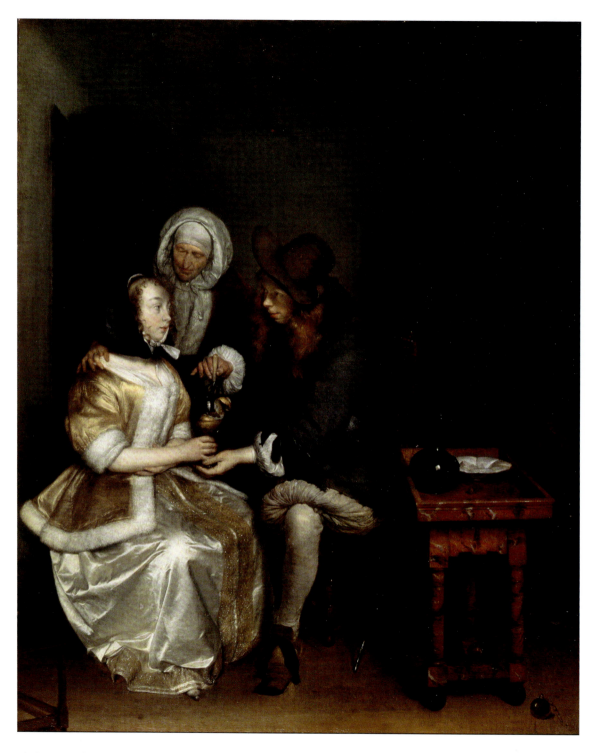

46 Gerard ter Borch the Younger, *The Glass of Lemonade*, c.1664, oil on canvas, transferred from panel, 67.2 × 54 cm (26 ½ × 21 ¼ in), State Hermitage Museum, St Petersburg

47 Gerard ter Borch the Younger, *Horse Stable*, c.1654, oil on panel, 45.4 × 53.5 cm (17 ⅞ × 21 ⅛ in), The J. Paul Getty Museum, Los Angeles, CA

48 Gesina ter Borch, *Studies of Dogs*, in *Poetry Album*, fol.40r, *c.*1665, watercolour, 30.8 × 20.2 cm (12 ⅛ × 8 in), Rijksmuseum, Amsterdam

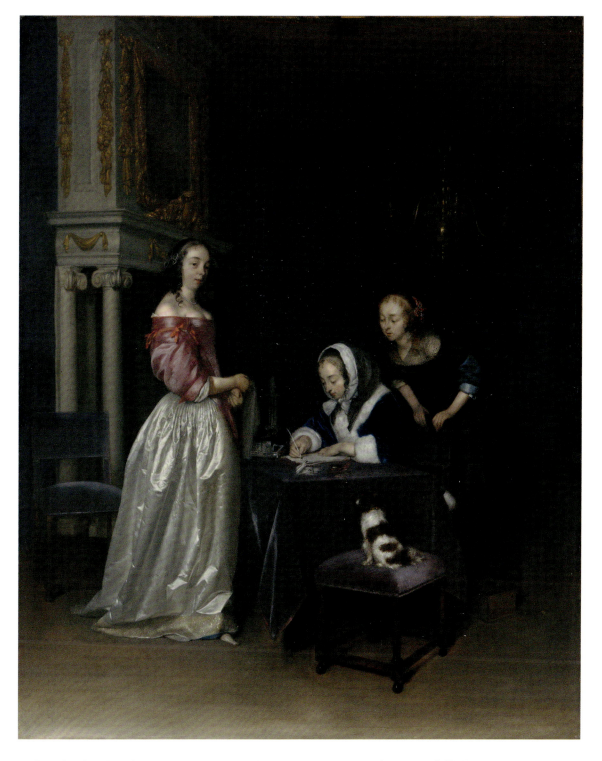

49 Gerard ter Borch the Younger, *Curiosity*, c.1662, oil on canvas, 76.2 × 62.2 cm (30 × 24 ½ in), The Metropolitan Museum of Art, New York

exchange between Gerard and Gesina at this pivotal moment, we can see her as a collaborator and an interlocutor who transformed his subject matter.

Within his paintings, Gerard cast Gesina in roles that aligned with her literary interests and self-presentation as a *vrijster*, but she also appears in more transgressive poses associated with sex work. Artists' use of family members as models was nothing new in the seventeenth century, and connoisseurs were eager to identify the models for figures in celebrated paintings. In 1638, for example, the Governor of the Spanish Netherlands said of one painting by Rubens that 'The Venus in the middle is a very faithful portrait of his own wife'.[14] Gérard de Lairesse, meanwhile, criticized the kind of painter who transgressed class boundaries by taking 'his clownish unmannerly maid-servant for his model' or putting 'a lord's dress on a school-boy, or his own son'.[15] Interesting testimony from one artist's model survives in an early biography of Jan Steen by Jacob Campo Weyerman. The biographer records Steen's wife Marietje lamenting that he 'often portrayed her, but always as something disreputable, be it as a drunken woman, or a procuress, or another time as a merry strumpet'.[16] Weyerman told the story for comedic effect, but Steen's own art can be brutally frank about the derision directed at women who were perceived to have violated boundaries of morality and decorum. In his *Wine Is a Mocker*, for example, people gather to jeer at a 'drunken woman' of the kind for which Marietje had to pose (fig.44).

Another documented artist's model, contemporary with Gesina ter Borch, was the Haarlem hat-maker and sex worker Maria de la Motte, who was identified as 'the regular model' of the painter Dirck Bleker (1621/2–after 1672) in a legal deposition from 1658 (fig.45). Other documents outline the precariousness of de la Motte's existence, with arrests for prostitution and for brandishing a knife outside the house of a man with whom she had committed adultery. De la Motte posed regularly in the nude at the Haarlem painters' guild, and her collaboration with Bleker imparted an eroticism to his paintings that made them much sought after by sophisticated collectors including the stadtholder, Prince William II of Orange.[17]

In this context, Gesina's appearance within her brother's paintings in the guise of a sex worker acquires an added charge of reputational peril. In one of Gerard's most unsettling paintings, Gesina modelled for a richly dressed woman seated in a shadowy interior (fig.46). She crosses her arms over her lap while a young man, modelled on her brother Moses, leans forward to muddle a twist of lemon peel in her drink. An older woman stands over the pair, placing her hand on the young woman's shoulder and pulling back her chemise to display the milky flesh beneath. A four-poster bed in the background makes clear the intended nature of the negotiation underway.

Gerard's paintings took advantage of the increasing architectural division of the home into more or less private spaces, seeming to invite beholders behind closed doors.[18] Other works explored the boundaries between home and world, and the social hierarchies enforced at these border zones. One painting, now in Los Angeles, takes as its primary subject a beautifully dappled horse in a stable (fig.47).[19] A man stands behind the horse, perhaps running a brush over its flank, while on the far right, a woman appears in the doorway, watching the groom. Her jewellery designates her as the likely mistress of the house; Gerard took as his model for this figure his stepmother, Wiesken Matthijs. Where Gesina repeatedly posed as a *vrijster* for Gerard, Wiesken provided him with a paradigmatic mother and matron, assuming that guise in numerous paintings.[20] Her role and her mission here are more ambiguous; has she come to interrupt the groom with a command, or is she lost in thought, perhaps even struck with desire, as she silently observes him engrossed in his work?

There is no evidence, unlike with Rubens or Steen, that contemporary viewers outside the Ter Borch

family circle could identify the models for Gerard's paintings. But their themes of voyeurism, seduction, sex work and self-display indicate his awareness of the transgressive potential of even the most exquisitely crafted scenes. Toggling between Gerard's paintings and Gesina's albums reveals that this awareness was shared between brother and sister, artist and model.

For example, Gesina frequently drew the family dog, a floppy-eared brown and white spaniel who also appears several times in Gerard's paintings (fig.48). In one picture now in New York, known by the later but apt title *Curiosity*, the dog perches on a stool, his hindquarters facing towards the viewer (fig.49). The little dog looks with rapt attention at the private activity of three women. The central figure, her hair demurely covered, sits at a desk writing a letter, presumably in response to the opened letter alongside it. A young girl peers over her shoulder, while a third woman stands a little apart from the group, her shoulders and cleavage bared. The figures represent three stages of a woman's life – an innocent, curious girl, a marriageable beauty or *vrijster*, and a matron – much as they were presented in the contemporary writings of authors like Jacob Cats. In the painting, Gerard explored how women help each other navigate the perils of courtship – the married woman is likely assisting her younger friend to respond to a suitor's letter. The little dog stands in for the beholder (or artist) who gets to see something normally hidden from male eyes. From a copy of another drawing by Gesina, made years later by her student, Anna Cornelia Moda, we learn that the dog was named Acteon, after the figure in Greek mythology who spied on Diana and her maidens – and was torn apart by his own hounds as punishment.[21] Naming her lapdog after this infamous voyeur, Gesina may have had Gerard's art in mind. Perhaps Acteon's inclusion in Gerard's paintings let him serve as a kind of inside joke between the two siblings, an acknowledgement on Gerard's part of his own excessive curiosity.

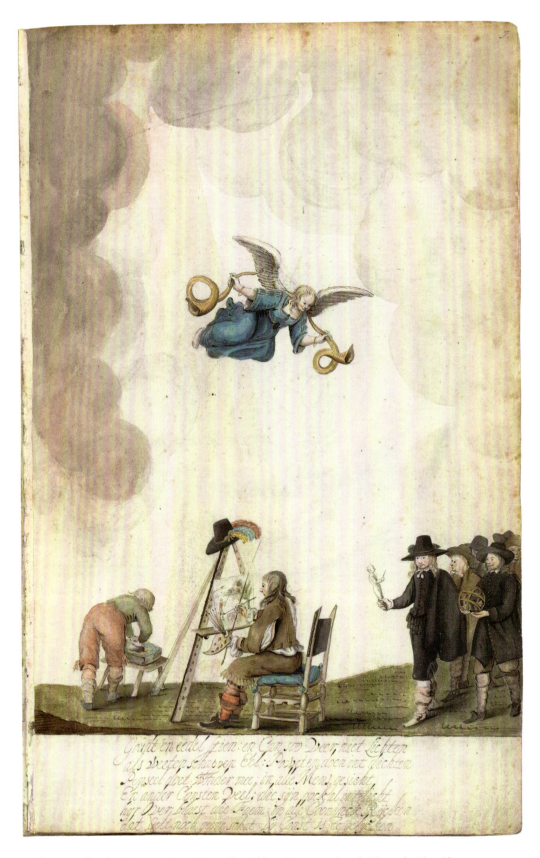

50 Gesina ter Borch, *Homage to Art*, in *Poetry Album*, fol.1r, 1652, watercolour, heightened with gold, 31.3 × 20.4 cm (12 ⅜ × 8 in), Rijksmuseum, Amsterdam

4
Art and Love

What function did Gesina ter Borch intend for her albums and family archive? And what do her own images and writings reveal about her ambitions and desired audience? As we have seen, she found one allegory for art-making in the image of a woman carving a spontaneous self-memorial into a tree trunk, drawn on the artist's thirtieth birthday (fig.1 above). In addition to this self-portrait, her two mature albums, the *Poetry Album* and the *Art Book*, contain an abundance of prefatory material, commentary from admirers and other allegorical drawings. All of these provide extensive insights into both the artist's intentions and her earliest reception.

Gesina's second major artistic project, the *Poetry Album*, is bound in parchment embossed with the artist's initials and was originally tied with green ribbon; it boasts a heft that aligns with her increased confidence following the days of the *Materi-boeck*. Gesina began the album on 18 November 1652, three days after her twenty-first birthday, suggesting that she may have received the blank volume as a birthday gift.[1] The opening drawing depicts a painter seated at his easel, at work on a landscape featuring a shepherd and his flock (fig.50). To the left of the painter, an apprentice grinds pigments, while a group of soberly clad men enters from the right, carrying attributes of art and learning, such as an astrolabe and a small mannequin intended for instruction in posing the human body. In the clouds above, an allegorical embodiment of Fame (notably the only female figure) sounds a fanfare. Below this scene, Gesina has inscribed verses that boast of the superiority of art and learning over wealth, with the confident conclusion that 'in all kingdoms / No money or treasure can compare to art'.[2]

Although their authorship in many cases remains unclear, the poetic texts that appear alongside Gesina's allegorical drawings and self-portraits are a key source of contemporary insight into her art. Indeed, we can view them as authorized commentary, inscribed by Gesina or her friends directly onto the page to clarify the message she intended to impart with a given image. These texts are also typical of the medium in which Gesina chose to present and preserve her art, namely the album. Like the emblem prints discussed above, albums frequently combine the visual with the textual. But unlike prints, which might have an international circulation, albums have an inherent intimacy that shaped Gesina's approach – and that has determined the limited audience and reception for her work.

Aristocratic women in the Netherlands had kept *alba amicorum*, or friendship albums, since the sixteenth century. Like Gesina's albums, these

earlier collections tended to resemble song books, anthologizing popular tunes. Whereas an upper-class man's album might reflect the pan-European travels that completed his education, with each page inscribed or illustrated by a different acquaintance encountered en route, women's albums more frequently record the long-standing intimacy of a local coterie.[3] For example, between the years 1575 and 1609, the Zwolle-born aristocrat Joanna (or Johanna) Bentinck (1564/5–1630) kept three albums in which she and others inscribed songs and love poems. These albums record Bentinck's experiences of courtship and marriage, including poems by her future husband, but they also contain the playful or jealous commentary of other men in her social circle (fig.51).[4]

In her keeping of albums, as in her artistic accomplishments more generally, Gesina reflected the aspirations of the Ter Borch family, adopting cultural practices that in the late sixteenth and early seventeenth centuries were almost exclusively the preserve of aristocratic women. But her albums reveal a notable escalation in ambition over the practices of earlier upper-class album-makers. Albums like Joanna Bentinck's contain only crude visual elaboration, in the form of curlicues, hearts or other symbols. Gesina, by contrast, placed imagery at the heart of her project, combining everyday scenes drawn from genre painting with self-portraits and complex allegories. Raised in a milieu of professionally trained artists, she far surpassed her aristocratic predecessors in her play between the visual and verbal. Furthermore, Gesina's albums emphasize her personal authorship and artistry in a departure from previous women's albums, where the album-maker was more likely to function as the impresario behind an assemblage of many different voices and hands.

The reader or viewer of an album normally moves from front to back, in sequence, as with any book. But the present-day arrangement of pages in an album should not be taken at face value as indicating the chronology of its making. Many albums have been rebound, either by their original makers or at later stages in their history. Gesina, for example, appears to have rebound her *Poetry Album* nearly a decade after she began it, inserting prefatory material that significantly postdates her opening drawing with its homage to the power of art. The first folio of the album as it now exists is a poem dated to Gesina's twenty-ninth birthday on 15 November 1660, written by her admirer Hendrik Jordis. The poem adopts the conceit of providing Gesina with a 'paper laurel wreath' (*papiere laure krans*) that must take the place of true laurel given the frosty time of year when Gesina was born.[5] Jordis praises Gesina's abilities to paint flowers that never fade or wilt and gallantly compares the blush of her cheeks to a summer rose blooming in the midst of autumn's chill. Ultimately, however, it is Gesina's 'intelligence, and more than human mind' that provide the true objects of Jordis's praise. Jordis developed this theme further in a second poem that immediately follows the birthday tribute, a meditation on Gesina's personal motto, *Deugt Maackt Schoonheijt*, or 'Virtue Makes Beauty'. The next pages contain more of Jordis's writing, in the form of spiritual meditations and a 'Christian ABC'.

Jordis, a merchant from Amsterdam, appears to have been Gesina's primary suitor and creative interlocutor around the time she made her most ambitious drawings, including the birthday self-portrait in which she inscribes his initials into a tree. Although few details about his biography or their relationship survive outside of the albums themselves, Jordis clearly had serious literary aspirations. In 1667, by which time he appears to have exited from Gesina's life, he was involved with a troupe of Dutch actors in the founding of Stockholm's first permanent theatre, for which occasion he wrote a play in praise of Sweden's Queen Hedwig Eleonora.[6] Jordis's prefatory matter to the *Poetry Album* recalls the oscillation we have already encountered in the *Materi-boeck* between pious sentiment and amorous lyricism. Gesina's

51 Floris Buchorst, inscription in the album of Joanna Bentinck, fol.82v, 1581, pen and ink, dimensions unknown, Hoge Raad van Adel, The Hague

decision to rebind her album with Jordis's verse at its beginning anointed him as her chosen commentator and interpreter, one who not only praised her art's transcendence over time and death, but also underlined the pious and virtuous components of her artistic practice. The emphasis on Gesina's identity as the album's maker continues in the other pages inserted at the time of the album's rebinding, c.1660. These include Gesina's self-portrait and a rendering of the Ter Borch coat of arms.

The self-portrait has its own accompanying text, inscribed below the painted field and signed by Joost Hermans Roldanus, the local schoolmaster and calligrapher (see fig.3 above). Here again, an inscription serves as original and authorized commentary, offering an interpretation approved by Gesina herself. Roldanus's quatrain continues themes from Jordis's longer poems, in which praise for Gesina's physical beauty is subordinated to a tribute to her intellect and virtue:

> Here is displayed the person of Miss ter Borch,
> By her artful hand depicted from life,
> But there is no one capable of depicting
> Her witty mind and her virtues altogether.[7]

Roldanus's tribute builds upon a centuries-old tradition of poems about portraits of beautiful women, in which the speaker concedes that the (male) painter has captured the physical appearance of the sitter but failed to render some essential component such as her voice or soul. That Roldanus reworked this convention to praise the self-portrait of a female artist gives it an interesting new piquancy. Instead of qualifying his praise for the artist's skill by noting what she has failed to capture, Roldanus

ART AND LOVE 81

attributes an intelligence and virtue to her that no artist could capture. At the same time, his poem's appearance as a kind of preface to the larger album, alongside Jordis's tributes, suggests that the volume as a whole records the workings of Gesina's witty and virtuous mind through the judicious selection and illustration of poetic texts.

Before turning to those texts, and Gesina's accompanying illustrations, it is worth comparing the prefatory pages of the *Poetry Album* with the even more ambitious poems, commentaries and drawings that introduce Gesina's third and final album, which Jordis called the *Konstboek*, or *Art Book*. Chronologically, the beginning of the *Art Book* overlaps with the rebinding of the *Poetry Album* and the insertion of the prefatory material discussed above, all occurring in a flurry of creativity and collaboration around the year 1660. The commentaries and poems in the *Art Book* restate in ever more elaborate terms the tributes from the *Poetry Album*. Texts by Jordis and Roldanus join poems signed by Hendrik Wolfsen, Robertus Altius and H. Fisscher, giving the impression of a literary coterie vying with one another in their tributes to Gesina. As in the *Poetry Album*, the Ter Borch family coat of arms and a pair of self-portraits open the album, purveying different modes of artistic self-representation. But the boldest act of self-portrayal is the allegorical drawing that follows the coat of arms, preceding the poetic tributes and more conventional self-portraits. Indeed, this drawing is in some respects the most ambitious individual work in Gesina's entire oeuvre (fig.52).

Drawn and painted directly onto one page of the oblong album, the allegory revises the *Homage to Art* that Gesina had created some eight years before (fig.50). Both drawings centre on the figure of the artist seated at an easel, with a pigment grinder to the left and celestial beings hovering in the upper register. But whereas both the artist and his companions in the earlier drawing are male, the embodiment of painting in the *Art Book* is a beautifully dressed young woman, who places her bare foot on the chest of a grizzled male figure with mismatched wings and a broken scythe. Pinned under the weight of her easel, this defeated Father Time lies atop a skeleton gesturing futilely with a snapped arrow. Driving home the message of art's triumph over time and death, a shattered hourglass spills its sand onto the studio floor, while a phoenix, symbol of rebirth, perches atop the easel. The interior boasts stretched canvases, palettes and other tools of the painter's trade, with two cherubs busying themselves as assistants, grinding pigments or reading from a book. Female figures representing Poetry (in blue, with a laurel crown) and History (writing with a quill pen) stand by to advise the artist on her work. Directly overhead, four cherubs sound a heavenly serenade. Two more cherubs hover at upper left, bearing aloft a young woman's portrait that they crown with laurels.

Because most abstract nouns – for example, 'Justice' or 'History' – are feminine in Latin, there was a long-standing tradition in European art of depicting female figures as the embodiment of these concepts. This tradition was codified in a hugely influential publication by the Italian iconographer Cesare Ripa, the *Iconologia*, first published in 1593. For example, Ripa recommended that the art of painting ('Pictura') be depicted as a woman wearing a piece of fabric over her mouth (to signify painting's muteness) and a mask hanging from a golden chain around her neck. Gesina incorporated all these attributes in her allegory, and Jordis elucidated them in punctilious detail in the 'Explanation of the Title Drawing or Triumph of Painting' that directly follows the drawing. (Jordis also wrote an elaborate allegorical drama on the theme of painting's triumph over death that fills the final pages of the *Art Book*.[8])

Just as the poetic tributes to Gesina revised a long-standing tradition of writing about female portraiture, her use of Ripa's allegory gains a new edge when considered in the light of her own identity as a woman artist. For a male artist to

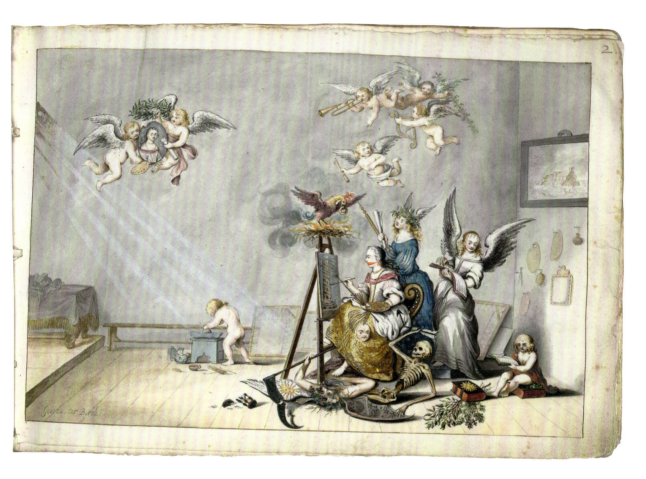

52 Gesina ter Borch, *The Triumph of Painting over Death*, in *Art Book*, fol.2r, 1660, watercolour, heightened with gold, 24.3 × 36 cm (9 ½ × 14 ⅛ in), Rijksmuseum, Amsterdam

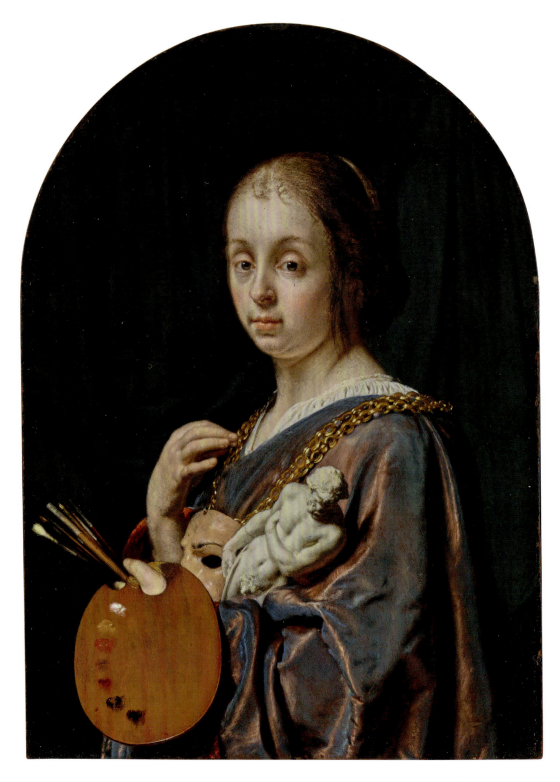

53 Frans van Mieris, *Pictura (An Allegory of Painting)*, 1661, oil on copper, 12.7 × 8.9 cm (5 × 3 ½ in), The J. Paul Getty Museum, Los Angeles, CA

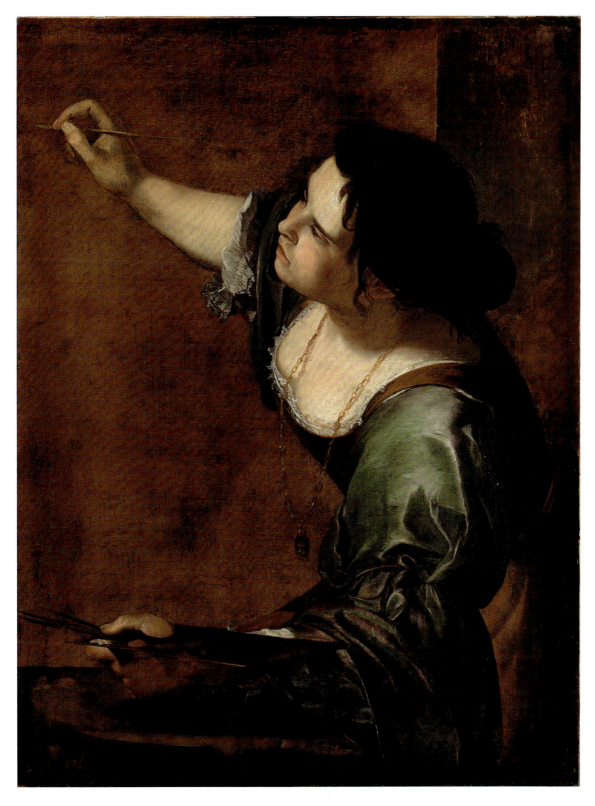

54 Artemisia Gentileschi, *Self-Portrait as the Allegory of Painting (La Pittura)*, c.1638–9, oil on canvas, 98.6 × 75.2 cm (38 ⅞ × 29 ⅝ in), The Royal Collection, United Kingdom

depict a woman as the embodiment of painting, as, for example, Frans van Mieris did in an almost exactly contemporaneous work, was not necessarily an endorsement of the actual artistic practices of real-world women (fig.53).[9] Mieris's Pictura, for which his wife most likely modelled, is static and passive; her palette and brushes are identifying attributes rather than active tools. Gesina's Pictura, by contrast, raises her brush to the canvas, focusing her rapt attention on a depiction of the Tower of Babel, which Jordis explained as a reference to the venerable origins of the visual arts. Gesina's watercolour doubles the image of the woman artist through the inclusion of the portrait that is borne aloft and crowned with laurels. Dressed identically, the two women are clearly meant to be the same figure, depicted as both painter and sitter, subject and object. But can we make a straightforward identification between this double figure of the woman painter and the actual maker of the watercolour, Gesina ter Borch?

Gesina was not the first woman artist to draw upon Ripa's *Iconologia* to create an image that oscillates between allegory and self-portraiture. While serving at the court of Charles I in London in the late 1630s, Artemisia Gentileschi painted what has generally been viewed as a self-portrait, where she appears at work wearing a gold chain and mask pendant (fig.54).[10]

Gesina hewed more closely than either Van Mieris or Gentileschi to Ripa's prescriptions (such as the bound mouth), and this fidelity may explain certain departures from the features recorded in her more straightforward self-portraits. For example, the woman in the drawing is shown with black hair, whereas Gesina generally depicts herself as a strawberry blonde. But in Jordis's key to the picture he explains that the black hair and eyebrows derive from colour symbolism, representing 'the steady and considered deliberation that a good master applies to the work' of composition and representation.[11] While not a literal self-portrait in every physiognomic detail, the double image of the woman artist reinforces the claims made in the prefatory poems of both the *Poetry Album* and the *Art Book*, namely that Gesina's art represents an act of self-assertion, a performance of feminine virtue and, most important of all, a triumph over death.

Having considered the prefatory material to her two mature albums, we are positioned to return to the remainder of Gesina's *Poetry Album* and its complex interplay between text and image. Like the commonplace book she began as a teenager, the *Poetry Album* reflects Gesina's wide-ranging interests, expansive literary culture and eclectic source material. The illustrations range from single figures in the margins to fully enclosed *bas-de-page* scenes, and alternate between pastoral imagery and figures taken from contemporary life, with occasional biblical narratives. A tender Adoration of the Shepherds is immediately followed by a vignette of domestic violence, in which a husband and wife attack one another with a slipper and fire tongs. Much of the imagery of courtship and flirtation could be taken from contemporary genre painting, but Gesina also explores more disturbing scenarios of violence, grief and suicide.

The poems (in many cases, more properly songs) in the *Poetry Album* are primarily amorous in subject matter, but also include comic and religious verse, as well as two bitterly satirical poems by Gerard the Elder castigating the corruption of other civic officials. Alongside verse, the album contains classical aphorisms in mirror writing, sketches of the Ter Borch family dog and a list of colour symbols. Hans Luijten, in his extensive study of Gesina's literary sources, has made a persuasive analogy between the composition of certain pages in Gesina's *Poetry Album* and the tripartite structure of emblem prints, which combine a more or less enigmatic image (the *pictura*), a terse saying or proverb (the *motto*) and a lengthier explication (the *subscriptio*).[12] In the case of Gesina's albums, the meaning of a vignette can be unpacked from the poem it illustrates, often accompanied by a pithy one-line aphorism. For example, in one scene, a

55 Gesina ter Borch, *Poetry Album*, fol.59r, c.1654, watercolour, heightened with gold and silver, 31.3 × 20.4 cm (12 ⅜ × 8 in), Rijksmuseum, Amsterdam

young woman offers a platter of fruit to a cavalier grasping the branch of a pear tree (fig.55). The man's gesture towards the woman is visually ambiguous but becomes clear upon reading the text inscribed above, a poem by Jacob Cats. Here, the male speaker declines the offer of fruit, saying he prefers a pear he has plucked himself. The aphorism below the verse drives the point home: 'Offered service is disregarded.' Read together, image, poem and aphorism argue for a conservative sexual morality, in which men prefer to play the role of aggressors, rejecting women who too readily offer themselves.

The orchard scene described above depicts figures in fashionable contemporary dress. Much of the poetry and imagery in the album, however, is in the pastoral mode, offering an idealized vision of the loves of beautiful young shepherds and shepherdesses. Pastoral poetry, with roots going back to antiquity, enjoyed enormous popularity in the Dutch Republic, where its escapist dreams of rural life were eagerly consumed by the harried urban elite.[13] Pastoral and high-life genre imagery are to a certain extent inverses of one another, with the former resolutely timeless and unreal and the latter insistently contemporary, fashionable and of the moment. Both modes, however, focus on youth and lovemaking, and both clearly appealed to the same young and leisured audience, as indicated by Gesina's albums.

A poet of particular significance for Gesina was Jan Harmensz. Krul (c.1602–46), whose poems were often addressed to well-born young women, offering them guidance and admonitions as they faced the perils of courtship.[14] But Krul's poetry also revelled in the amorous freedom of the pastoral genre. One of the first texts in Gesina's album is a speech taken from Krul's 1623 play *Diana*, in which a young Greek princess, Cecilia, forswears life at court to seek happiness as a shepherdess in the company of her beloved Florentius (fig.56).[15] As is frequently the case in the *Poetry Album*, deviations in spelling indicate that Gesina may have learned the text by ear, rather than copying a printed source. She has furthermore added a heading to the speech, giving a tune to which it might be sung. Standing in the margin on the right is the figure of a barefoot shepherdess, presumably Cecilia herself. With her hat wreathed in flowers and a laurel-garlanded crook in one hand, this figure is a further instance of a poetic persona appropriated by Gesina as she explored different literary treatments of the female voice.

Pastoral imagery represents another area of collaboration and exchange between Gesina and Gerard the Younger. In one painting from the early 1650s, the same period when Gesina began her *Poetry Album*, Gerard depicted his half-sister as a shepherdess, posed before her flock (fig.57). Gesina's crown of leaves and shimmering satin dress make clear that she is no ordinary shepherdess, but rather a poetic figure in line with Krul's Cecilia. In another version of the composition, Gesina appears without the sheep, instead accompanied by a female companion who hands her a flute. These two paintings are so anomalous within Gerard's larger body of work that they likely represent actual portraits of Gesina, informed by her literary interests and painted at her request.[16] In any case, like the *vrijster*, the pastoral shepherdess contributes an important facet to Gesina's self-fashioning drawn from her wide-ranging reading of poetry, plays and songs. These paintings moreover mark the emergence within Gerard's oeuvre of a key archetype: the beautiful woman dressed in light-coloured satin, whose dignity and aloofness associate her with the unobtainable beloveds of poetry in the Petrarchan tradition.[17]

Given the ideals of modesty and restraint that governed elite women's behaviour, it is all the more surprising that Gesina occasionally transgressed the bounds of decorum demarcated within both pastoral poetry and high-life genre painting to depict extremes of violence or despair. One of the most shocking images in the *Poetry Album* represents the aftermath of a double suicide (fig.58). Here, the bottom of the page depicts the interior of a tavern. On the left, leaning against a barrel, a man holding

56 Gesina ter Borch, *Poetry Album*, fol.5r, c.1652, watercolour, 31.3 × 20.4 cm (12 ⅜ × 8 in), Rijksmuseum, Amsterdam

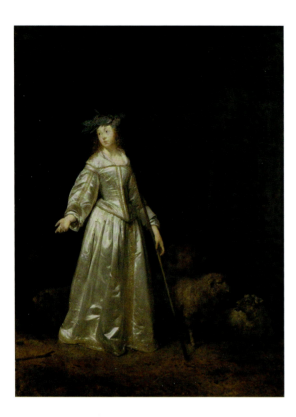

57 Gerard ter Borch the Younger, *A Shepherdess*, c.1652, oil on canvas, 66 × 50 cm (26 × 19 ⅝ in), Museum Wasserburg Anholt, Isselburg

a *roemer* glass gestures towards the tragic scene that has just unfolded beside him. One man lies sprawled on the floor, dead from a self-inflicted stab wound. Another man hangs from the mantel of the fireplace, having kicked a stool out from under his legs. The doorway opens to reveal a seemingly unrelated scene, with a woman leaning over a crib to berate her husband, the words, 'the rascal, etc.' (*den schelm, etc*) written as though emerging from her mouth.

The poem inscribed above the illustration makes clear that both the suicides and the domestic dispute are meant to serve as cautionary tales, warning men of the perils of love. The speaker of the poem, identifiable with the drinker on the left of the scene, banishes Venus, 'the cause of all pain' (*oorsaeck aller smert*) from his heart, devoting himself to wine instead. He then narrates the stories of three men. One, married hastily in his youth, finds himself under the thumb of a 'hellish angry wife' (*helsche boose wijf*). The other, made 'mad and desperate' (*dol en disperaet*) by love, stabs himself, while a third, rejected by the *vrijster* of his choice, hangs himself. The speaker concludes by bidding other men to devote themselves, like him, to Bacchus, beer and wine.[18]

What should we make of Gesina's choice to include this frankly misogynistic drinking song in her *Poetry Album*? One of the key pleasures Gesina seems to have taken in creating the album was in practising a kind of ventriloquism, adopting different voices, male and female, and with them, different perspectives on the topic of love. We have already seen her assume the voice of the self-recriminating Misandre and the would-be shepherdess Cecilia. Here, the male speaker of the drinking song gave her the pretext to envision graphic violence that has no parallel in the genteel genre paintings of her half-brother Gerard. In fact, in its dramatic narrative content, the scene of double suicide more closely resembles an unprecedented form of contemporary history painting.

In the *Poetry Album*, Gesina adopted the same calligraphic hand from the later pages of the *Materiboeck*, with its artful suggestion of spattered ink. For the most part, she worked directly on the bound pages of the album, whose eclectic contents suggest that she did not proceed with a preordained structure in mind. A few unfinished drawings towards the album's end give insight into her working method, as well as suggesting that she set the project aside at some point (fig.59). Based on the evidence of these pages, we can assume that Gesina first wrote out the poetry in ink, and then used the remaining space on the page to sketch an illustration in pencil. The under-drawing was then overlaid with watercolour, occasionally heightened with silver or gold leaf.

In some of the most impressive drawings in the album, Gesina turned the volume 90 degrees to achieve an oblong format suitable for ambitious landscapes. In one example, two cowherds rest with their flock by the side of the road at dawn or dusk (fig.60). Faint blue and red washes suggest the changing colours of the sky, and rapid calligraphic strokes of the pen capture tufts of grass, ruts in the road and curlicues of foliage. Freed from the imperative to illustrate a pre-existing text, Gesina instead evoked an atmosphere of rural repose in line with the pastoral imagery of so many of the poems she collected.

As noted above, much of the verse included in the album has headings that give the tune to which the text can be sung. The absence of any musical notation suggests the extent to which seventeenth-century Dutch people carried a whole repertoire of popular songs in their heads, passed on through oral transmission. At the same time, the *Poetry Album* shares features with the many printed songbooks, often illustrated, that circulated widely in the Dutch Republic, often as lovers' gifts.[19] Gesina may have copied some songs into her album directly from printed anthologies, but her eccentric spelling and other variations indicate that she likely learned many of the songs by ear. Rather than reproducing and illustrating any pre-existing songbook as a kind of luxury manuscript, she made her own anthology of favourite song texts, combined with poems written in her honour and her increasingly ambitious drawings. The *Poetry Album* may have been a functional songbook, brought out for musical gatherings in the Ter Borch household. But its excellent state of preservation suggests that any such use was limited and that it was more likely presented to visitors for careful admiration and perusal, not active use.

In another instance of the overlap between Gesina and Gerard's respective artistic projects, the latter frequently used his half-sister as the model for scenes of music-making in the same years that she was compiling her *Poetry Album*. In one such scene, now in the Louvre, a seated Gesina appears with her lips parted in song, one hand raised as though to keep time (fig.61). She appears to be following a text inscribed on the sheet of paper in her hand, while the lutenist accompanying her plays from a bound songbook. A page boy entering from the right carries a tray with a glass of beer and has a man's black hat tucked under his arm. These items, as well as the page's amused outward glance, seem to imply the presence of a male beholder, for whose benefit the two women perform.[20] It is tempting to imagine Gesina using her songbook in such a context; while Gerard's painting is a fiction, it reinforces the notion that Gesina mobilized her musical accomplishments within her larger enactment of feminine virtue and desirability. Indeed, Jordis praised Gesina's ability to sing and play the harpsichord alongside her gifts as a visual artist.[21]

More evidence for the album's function comes from the poetic tributes to Gesina that cluster in the closing pages. In one particularly interesting juxtaposition, a poem in praise of one of Gesina's drawings, which she added to the album at the time of its rebinding, immediately precedes the drawing itself. The full-page drawing, dated 1659, depicts an elegant social interaction, with a well-dressed couple arriving at a country estate (fig.62). They are greeted at the doorway by their hostess, her hands demurely crossed at her waist. The man in the couple doffs his plumed hat with one hand while guiding his companion with the other. The cultivated body language of all three figures contrasts with the dog who rushes eagerly towards the visitors, while the bowing and pecking fowl in the foreground enact their own humorous emulation of the central trio. In the background, another cavalier, elegantly posed with a walking stick, appears ready to join the party at any moment.

This scene of greeting provides not so much a narrative as an inventory of social graces. Such a reading finds support in the accompanying poem by an author identified only as 'S.d.S.'.[22] Entitled 'On the artful depiction of the modest greeting by the

wijs
Coomt mijn flora

1.
Vreede De wijs versaeck aller smert
'K verjaegh en ban u geheel uijt mijn Hert
Want ghij niet anders baert dan arre de pijn
Wech ie, te min, 'k verdrijf u uijt mijn sin
En hou het met de wijn

2.
Wijlle De wesen d' een in ongemaeckt
Aen 't wijf besteet sijn Drije jeucht
Tot hij door Vreucht in Commer en Verdriet
Door 't naer gekijff vant Heesche roose wijf
Sij grijnsdet, doet te niet

3.
Dees door liefd de Dol en Dispereet
Begeert sijn Dwit en neemt een pook te baet
De aerd om dat sijn Wijster hem slaet af
De neemt een Seel die hij knoopt om sijn kleel
Maeckt selv een bengelt graf

4.
Bedaert wijsers 'k bid u toch bedaert
Com volgt met mij den Vreeder Bachus naer
En mint den wijn die alle droevheijt weet
Het bottelbier maeckt niets dan groot ser
Maer doet geen Over daet

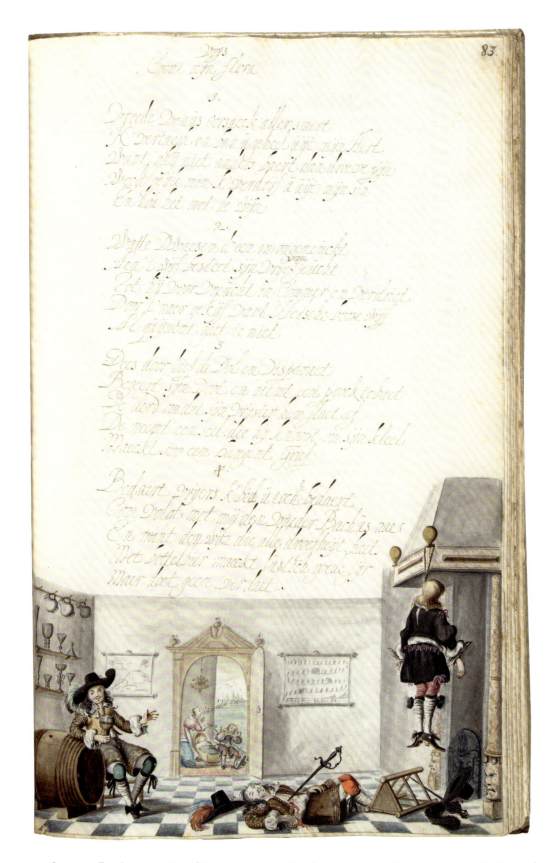

58 Gesina ter Borch, *Poetry Album*, fol.83r, c.1658, watercolour, heightened with silver, 31.3 × 20.4 cm (12 3/8 × 8 in), Rijksmuseum, Amsterdam

85.

La Grideline

1.
Ick die de Dobbel steenen
Bij de Tebuck en Bier
Veel liever als sterenen,
Hoorde, dat Dennis weer
Weer aen mijn vit was Legen
Toen ick bij de Kaefse maecht
Mijn tijt versleet
Veer ick niet en weet
Anders mee kan doen als seggen
Dats mij soo drat behaecht.

2.
Kscheltse Door grote gecken
Kreijt was Een Jaffers hort
Die sich kan Laeten Erecken
Door han seleef de mort
Kheeltse maer Door droge Jaffers
En Door Drilen al te gaer
De wen Dermaech
In Een Roode Laak
Van de Eerelijcke Jaffers
Meten Dinden emmers maer

3.
Wrts ick de Eooxer loncken
Wyt mijn Sewindaes ooch
Zol om mijn Siel het Doncken
Brijden ick hort at hooch
Cannen schijuen Doppel steenen
Smeet ick met gewelt opt Vier
En de Tiebach
Gaf ick de Sack
Doe gingh ick mij selver speenen
Van het Geijle Dennis Dyer

4.
Doen gaf ick mij gants over
Door ingevinsels min
Een minuts hartin Rover
De amstels Innck Heldin
Maer soo zoet ick haer doen nijgen
En haer om haer Liermen Drucck
Sy playts Den min
Die ick nu mijn Sin
Wenschte, Erage ick niet, dan dreijgen
Dwrs heb ick Door nu de Erveck

Vers 5.

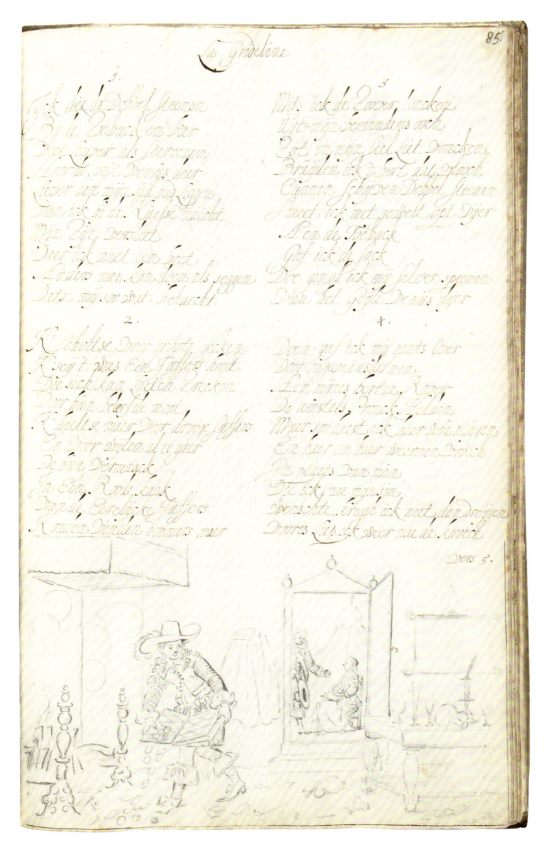

59 Gesina ter Borch, *Poetry Album*, fol.85r, *c*.1658, pen, ink, and pencil, 31.3 × 20.4 cm (12 ⅜ × 8 in), Rijksmuseum, Amsterdam

60 Gesina ter Borch, *Poetry Album*, fol.65r, *c.*1658, watercolour, 31.3 × 20.4 cm (12 ⅜ × 8 in), Rijksmuseum, Amsterdam

wise, clever, and witty Miss Geesien ter Borch', the poem is less an ekphrastic exercise, vividly capturing the details of the scene, than a panegyric to the artist herself. Not only does Gesina possess the mind of an Apelles, the legendary painter of antiquity, but her art also conveys a lesson in refinement: 'it teaches [us] to make polite greetings' (*beleefde groutiens geeven*). In a phrase that inspired Hans Luijten's reading of Gesina's album as a kind of emblem book, the poet describes the artist's 'flourishes full of learning, interpreted in an emblematic fashion' (*swiren vol van leer amblemsche wijs geduijt*). The poem provides support to the scholarly contention that high-life genre painting served a civilizing function by modelling exemplary comportment. In this case, however, it was not a professional artist who supplied paying clients with aspirational imagery. Rather, Gesina, in both her art and in her person, functioned for her self-selected audience as the embodiment of female virtue and accomplishment.

Intriguingly, the final lines of this poem position the author as a lover (*minnaer*) sending his own little greeting (*groutien*) in the form of this poem to Gesina, identified as the hostess who stands in the doorway. Separated from Gesina, the author adopts Petrarchan convention to describe himself as numb except for the pain of unrequited love, hoping only for death. In this reading, which clearly met with Gesina's approval, the drawing is yet another self-portrait, one in which Gesina serves as both the unobtainable beloved of lyric poetry and an exemplar of genteel comportment. But she also places herself in the role of gatekeeper, standing at the threshold of an elegant residence and controlling admission to its pleasures. This representation of Gesina as the artist who restricts access to her work aligns with another poetic tribute a few pages later in the album, dated to 27 February 1659.[23] This poem adopts the conceit of a user's manual for a future reader of the album. Addressed 'to the permitted beholder and reader of this book' (*den toegelatene aanschouwer en leser deses boeks*), the poem frames access to the album as a rare privilege, bestowed by the album-maker herself:

> Should you receive the honour of leafing through these pages,
> Behold how GESINA'S mind, strengthened with art, can sate
> Your eye!
> ...
> Who dares still say from ignorance and wilful delusion
> That wit and artistry are not the province of young women,
> Having perused GESINA'S work?[24]

The poem makes clear the extent to which Gesina saw privileged access as a defining feature of her albums, which aimed not at fame or marketplace success, but rather the delectation of a self-selected coterie. The poem is also striking in its marshalling of Gesina's album as a refutation of misogynist arguments about women's artistic abilities.

The final pages of the *Poetry Album* have a more haphazard feel than the rest of the album, as it appears to take on the function of a scrapbook into which Gesina occasionally pasted or transcribed texts or images that she found important over the course of many years. There is a print envisioning the Temple of Solomon in Jerusalem, as well as another list of colour symbols. But there are also mourning poems for her half-brother Moses, who died in 1667. The final two poems, as mentioned above, are Gesina's transcriptions of acerbic verse by Gerard the Elder, scorning 'the gentlemen of the greedy city' (*De Heeren vander grijp stadt*).[25] As incongruous as they may appear in the wake of the love poetry that predominates in the rest of the album, these poems indicate an important shift in Gesina's art as she entered her thirties, away from a singular focus on courtship and towards a more expansive project of preserving family memory.

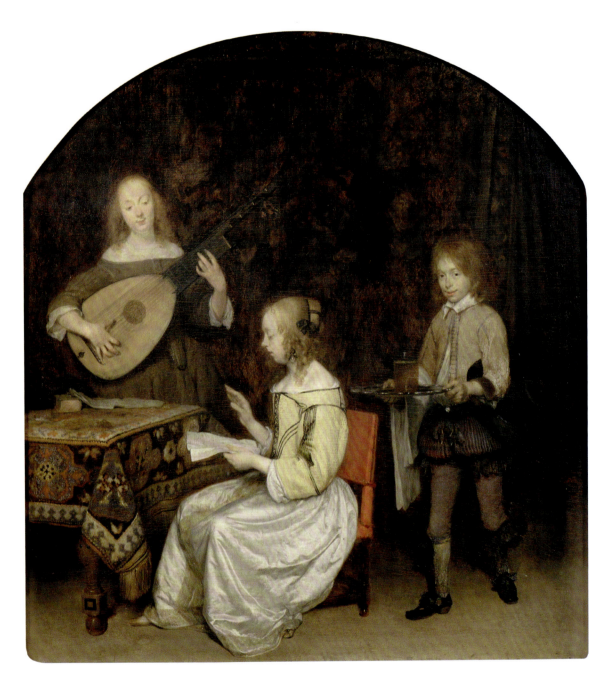

61 Gerard ter Borch the Younger, *The Concert*, c.1657, oil on panel, 47 × 44 cm (18 ½ × 17 ⅜ in), Musée du Louvre, Paris

62 Gesina ter Borch, *Poetry Album*, fol.90r, 1659, watercolour, heightened with silver, 31.3 × 20.4 cm (12 ⅜ × 8 in), Rijksmuseum, Amsterdam

63 Gesina ter Borch, *Art Book*, fol.29r, *c.*1661, watercolour, 24.3 × 36 cm (9 ½ × 14 ⅛ in), Rijksmuseum, Amsterdam

5

The Triumph of Painting

The elaborate allegory of painting's triumph over death, discussed in the previous chapter (fig.52 above), provides a fitting introduction to Gesina's most ambitious, extensive and eclectic album. In his prefatory texts for the album, Gesina's admirer Hendrik Jordis called it her *Art Book*, a terminology I have followed here. Alison McNeil Kettering, however, has proposed an apt alternative title, the *Family Scrapbook*. In fact, the album encompasses at least two major projects: the full-page, highly refined genre scenes and portraits of Gesina's artistic maturity, and the archive she created of important family documents and commemorative images. This chapter will explore the series of major drawings with which the album begins, while the family archive provides the subject of the following chapter.

The birthday self-portrait depicting Gesina carving an inscription into the trunk of a tree (fig.1 above) is one of a number of drawings in the *Art Book* that commemorate outings taken by Gesina and her friends into the countryside around Zwolle. The imagery of rural strolls, horseback rides and open-air banquets that preoccupied her is particularly striking given the ideal of housebound female virtue so prevalent in seventeenth-century Dutch culture, and even in the panegyric texts that Gesina included in her albums. This tension between scenes of outdoor enjoyment and Gesina's (self-)positioning as a paragon of domestic virtue reflects much of the ambivalence animating Dutch genre imagery.

As discussed above, the birthday self-portrait reworks and personalizes a long tradition of depicting pastoral lovers carving their names or other texts into trees. But the reader or viewer of Gesina's album encounters the drawing in a different context, between two poems that describe an outing from Zwolle to the nearby village of Hattem on 17 May 1660.[1] One of the poems can be attributed to Gesina's friend and collaborator Jordis and is signed with an abbreviated form of his motto. The other poem, signed *G I M G*, must be by another member of the party. Both poems describe the same course of events: on a day of beautiful spring weather, a party from Zwolle travelled by ferry over the IJssel river into the neighbouring province of Gelderland and then to the summit of the Trijsberg, a small elevation. In the shade of alder trees, they dined on local cream and ham, only to be caught in a thunderstorm before scurrying back home to Zwolle. Both poets conclude that a little suffering (in the form of a good soaking) is well worth a day of pleasure that can be remembered years hence.

The two poems about the outing to Hattem fall into a category that literary historians describe as occasional verse, meaning poetry written to

commemorate, or on the occasion of, a specific event. Such verse can be solemn, describing a death or royal visit, but is often light-hearted and quotidian in its concerns, as in the example of these two poems. Professional writers commemorated marriages or burials in commissioned poems with small print runs, numerous examples of which survive in the Ter Borch family archive. But much occasional verse was written by amateurs and only circulated in manuscript. The 'occasional' also offers a helpful category for many of Gesina's drawings, which depict meaningful moments in the private life of the Ter Borch family and their circle. These occasions range from the pleasurable outings encountered early in the album to the deaths and losses endured by Gesina and her siblings over the course of the 1660s and 1670s.

As noted before, Gesina's self-portrait carving into a tree bears the date of her thirtieth birthday, on 15 November 1661. But its depiction of leafy green trees and women without cloaks or hoods suggests a spring or summer landscape, a temporality reinforced by the drawing's placement between the two poems describing the outing to Hattem on 17 May 1660. Kettering has made the persuasive suggestion that Gesina 'executed the drawing on her thirtieth birthday ... in order to recall the pleasant excursion a year and a half before'.[2] The self-portrait thus offers a vivid example of drawing as a form of concentrated and creative recollection. Other drawings in close sequence with the self-portrait may also evoke the excursion to Hattem. On the page following the poem by Hendrik Jordis, Gesina drew a man walking with a dog down a country road towards a small hill with a group of elegantly dressed figures at its crest (fig.63). The dog, with blue and red ribbons tied around his neck, is identical to the spaniel in the birthday self-portrait, while the man himself appears among the figures in the background of that drawing. Most likely, this second drawing depicts Jordis approaching the Trijsberg, perhaps already gathering the thoughts he will soon transform into verse. Complicating matters

are the two different dates inscribed on a tree trunk, above Gesina's signature: Thursday, 16 April 1657 and Thursday, 4 April 1661 (both dates use the old Julian calendar). Neither date aligns with the outing to Hattem in May of 1660. Their meaning is elusive, but perhaps they suggest milestones or bookends in Gesina's relationship with the enigmatic Jordis.

Other drawings in close proximity to the Hattem series evoke further outdoor pleasures and freedoms. A party of young people banquets in the open air, a couple alights from their carriage at a country house, and equestrian figures, including a solitary woman, ride through rural landscapes. The banquet scene is of particular interest because it shares the page with a lengthy ekphrastic poem by the schoolmaster Joost Hermans Roldanus (fig.64). Loosely translated, the opening lines of the poem read as follows:

> *Poem in Praise of this Artful Drawing by Miss Gesina ter Borch*
> Here with an artful hand,
> And with witty and clever understanding,
> Is depicted the enjoyment
> Sometimes had by fresh young folk
> When at a banquet together,
> They are pleasantly gathered:
> They eat a feast of food and sweets
> Or whatever else is served.
> They also drain a little glass
> And hear the good sound
> Of instruments and singing,
> Pleasant and sweet to the ear;
> Yes, everything has been procured
> That can aid in merriment,
> So that one is mirthful without cares:
> All this Miss ter Borch
> Has depicted beautifully and artfully from life …

But, having praised Gesina's skilful depiction of these pleasures, Roldanus is quick to assert that such merriment is foreign to the artist herself:

64 Gesina ter Borch, *Art Book*, fol.15r, 1658, watercolour, heightened with silver, 24.3 × 36 cm (9 ½ × 14 ⅛ in), Rijksmuseum, Amsterdam

> ...she does not often consort
> Where young folk gather;
> For she takes more pleasure in art,
> Which also gains her more praise and favour.

Indeed, Roldanus reminds the reader that 'daughters of decorum and rank / are very rarely out in the street'. Such women, with the Ter Borch daughters as the prime example, prefer to practise the visual arts or make music at home, rather than going on outings 'here and there'. In such a manner, they bring joy to their parents and honour and renown to the family name, just as their brothers may do.[3]

What are we to make of the contrast between Gesina's images of merry outings and Roldanus's assertion of her housebound virtue? It is easy to see elements of her drawing that might have discomfited the moralizing schoolmaster. The young men and women in the banquet scene kiss and hold hands; one woman even sips wine from a glass clenched between her male neighbour's teeth. Having been presented with the provocative drawing by Gesina, Roldanus may have used his poem to remind his pupil of her moral obligations, with his assertion that she rarely left the house more a prescription than a statement of fact. Another poem about the same drawing, inscribed by an unknown writer on the previous page, laments that Gesina failed to include a self-portrait among the revellers, with the gallant interpretation that the artist thus refrained from overshadowing the other women.[4] Perhaps the excursion to Hattem took up so much space in Gesina's artistic imagination because it represented a freedom she rarely enjoyed beyond the confines of her home in the Sassenstraat. Certainly, her images of free movement through the countryside should not be taken as documents of her actual mobility, any more than Roldanus's poem records her true seclusion.

In his insistence on establishing a moral quarantine between Gesina and the sometimes hedonistic subjects she depicted, Roldanus resembles later art historical commentators who have projected moralized readings onto genre paintings' imagery of pleasure. It is important to remember, however, that Gesina controlled the texts that entered her albums. Roldanus's prescriptions met to some extent with her approval, and she may even have enlisted him in a shift in her self-fashioning that becomes clear over the course of the 1660s, as she entered her thirties. From a self-presentation as a *vrijster* or shepherdess, actively engaged in rites of courtship, she gradually transitioned to an identity as the voluntarily unmarried savante, wedded to the arts and the preservation of family memory.[5]

In fact, it may be that the two identities coexisted, just as Gesina enjoyed the play between different voices in the songs and poems she collected. In 1661, Gesina not only drew herself inscribing Jordis's initials into a tree, but also made a much more formal self-portrait, again accompanied by a poem by Roldanus (fig.65). The three-quarter-length likeness shows Gesina grandly attired in lace and black silk, with a large pearl earring and holding a painted fan. She stands before a swag of dark drapery, opening onto a wooded landscape. In the posing of the figure and the display of her fashionable accessories, but not the landscape backdrop, the portrait adheres to the conventions of Gerard the Younger's portraits of female sitters from the same period. Sturla Gudlaugsson, who catalogued Gerard's paintings in the mid-twentieth century, assumed that Gesina had used a portrait by her half-brother as her prototype.[6] In certain cases, as in a portrait of the Amsterdam patrician Aletta Pancras, it is clear that Gesina made direct copies of Gerard's portraits (figs 66 and 67), translating his bravura renderings of expensive textiles from oil paint to watercolour and assimilating lessons about the elegant disposition of hands, drapery and accessories. But in the absence of a surviving prototype by Gerard, we should not assume that Gesina relied on his assistance to create her self-portrait.

65 Gesina ter Borch, *Self-Portrait*, in *Art Book*, fol.12r, 1661, watercolour, heightened with gold and silver, 24.3 × 36 cm (9 ½ × 14 ⅛ in), Rijksmuseum, Amsterdam

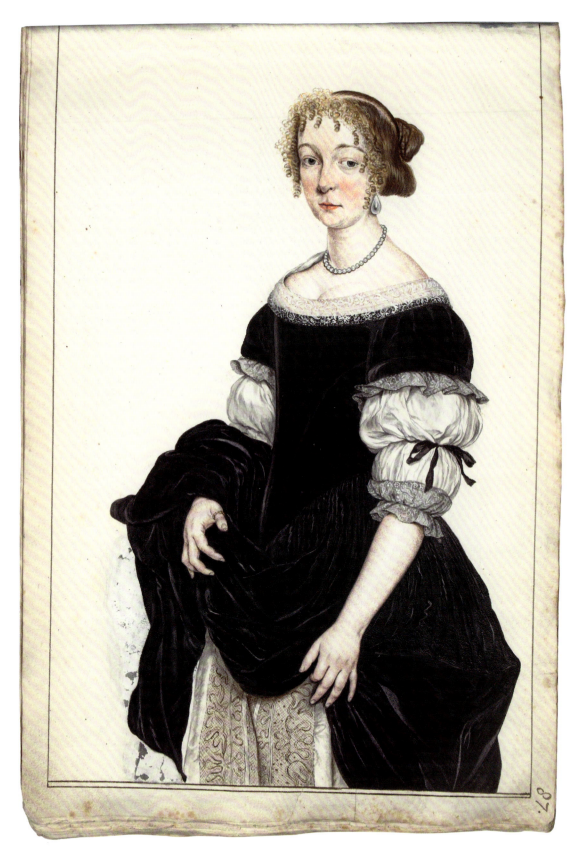

66 Gesina ter Borch, after Gerard ter Borch the Younger, *Portrait of Aletta Pancras*, in *Art Book*, fol.87r, c.1670, watercolour, 24.3 × 36 cm (9 ½ × 14 ⅛ in), Rijksmuseum, Amsterdam

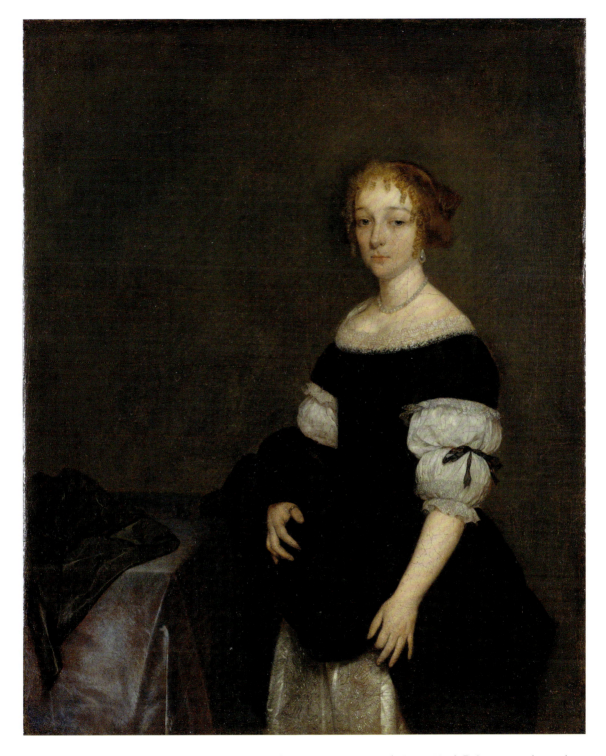

67 Gerard ter Borch the Younger, *Aletta Pancras*, 1670, oil on canvas, 38.5 × 31 cm (15 ⅛ × 12 ¼ in), Rijksmuseum, Amsterdam

The poem by Roldanus inscribed below the portrait lays out the terms of the new identity that Gesina embraced in her maturity:

> Here one sees represented a young lady, beautiful of being,
> Her virtues, honour and art can never be praised enough.
> And when one sees what she does with her brush,
> Who could possibly not be astonished?
> It seems that Pallas has so completely claimed her,
> That neither Venus nor her son may come close to her:
> She chooses to remain free, all her desire is directed to art,
> She lives thus according to her wish, alone in peace and quiet.[7]

If love and romance provided the primary subjects of Gesina's artistic explorations in the *Materi-boeck* and *Poetry Album*, now, according to Roldanus, she has sublimated all erotic desire into her single-minded artistry, in the mould of Pallas Athena, the ancient (and unmarried) goddess of wisdom. On the one hand, Roldanus's reading of Gesina's *vrye staet*, or 'free state', insulates her from the world of sexual freedom depicted in her art, the world of Venus and Cupid. On the other, it offers a striking celebration of a Dutch woman's refusal to occupy the prescribed roles of wife and mother in favour of dedication to her art.

Gesina's portraits and genre scenes of the 1660s and 1670s reveal a turn towards the domestic that reflects the changing circumstances of the Ter Borch siblings' lives. Gerard the Elder, whose caustic verses on local corruption provide the abrupt conclusion of Gesina's *Poetry Album*, transferred the lucrative office of licence master to his son Harmen in 1661 and died on 20 April of the following year. The legal agreement between Gerard the Elder and Harmen, signed by Gesina, her mother and her siblings, guaranteed private incomes for Gerard the Elder's other children, to be paid by Harmen from his earnings as licence master.[8] In making these arrangements, her father established Gesina's financial independence, a crucial factor in her ability to dedicate herself to her art while remaining unmarried.

Harmen and his family acquired their own house in the Sassenstraat, near the family home where Gesina remained with her widowed mother. Other siblings ventured further afield. After many itinerant years, Gerard the Younger had married Geertruyt Matthijs (1612–c.1672), the younger sister of his stepmother (Gesina's mother), in 1654, settling in her native city of Deventer but maintaining close ties with his family in nearby Zwolle. After Gerard's wife's death, his unmarried sister Sara (b.1624) took over the role of housekeeper, remaining with him until her own death in 1680. Anna ter Borch married the merchant Isaac de Hochpied in 1655 and relocated to Haarlem. Moses ter Borch enlisted with the Dutch fleet in the Second Anglo-Dutch War and died in battle in Essex, at the age of 22. Of all the siblings, however, Gesina's younger sister Jenneken (1640–75) travelled the farthest. In 1668 she married the merchant Sijbrant Schellinger and moved with him to his native city of Amsterdam, where they appear to have received several visits from Gesina. In 1674, however, the Schellinger family emigrated to the Dutch colony of Curaçao in the Caribbean, where Jenneken died the following year.

Gesina inscribed many of Sijbrant Schellinger's poems into both the *Poetry Album* and the *Art Book*, and he appears to have taken over Jordis's role as Gesina's poetic collaborator in the later 1660s. One of Gesina's most frequently reproduced drawings depicts Sijbrant and Jenneken at home in Amsterdam (fig.68). Sijbrant appears on the left, seated at a writing table with a sheaf of papers in one hand and a quill pen in the other. Jenneken stands on the opposite side of the table, holding a painted fan and delicately displaying a brightly coloured underskirt. The interior recalls the furnishings in contemporary genre scenes, such as the canopied four-poster

68 Gesina ter Borch, *Jenneken ter Borch and Sijbrant Schellinger*, in *Art Book*, fol.74r, 1669, watercolour, heightened with gold, 24.3 × 36 cm (9 ½ × 14 ⅛ in), Rijksmuseum, Amsterdam

69 Unidentified Isfahan School painter, with additions by Gesina ter Borch, *A Youth Holding a Cup*, in *Art Book*, fol.40r, *c.*1670, watercolour and bodycolour, heightened with gold and silver, 24.3 × 36 cm (9 ½ × 14 ⅛ in), Rijksmuseum, Amsterdam

bed and map hanging on the wall. Alongside the couple, two children occupy the room – one an infant sleeping in a crib woven from cane, the other a toddler in a painted highchair. The presence of the two children has complicated the dating of the drawing. Gesina inscribed it at lower left with the year 1669, at which point Jenneken had only given birth to one, short-lived, child; her two surviving sons, who would play important roles in Gesina's later life, were not born until 1671 and 1672.[9] The drawing may depict Sijbrant's children from his previous marriage, or perhaps Gesina misdated the drawing during a later campaign of annotating her album.

Whatever the precise dating or the identities of the two children, the watercolour accords with the relative informality of later seventeenth-century Dutch family portraiture. Gesina does not depict the children as miniature adults or emblems of dynastic continuance. Although elaborately dressed in lace and ribbons, they are plump and distinctly childlike, one napping and the other reaching for the dog clambering up his highchair. While Jenneken's elegant pose recalls more formal, aristocratic portraiture, Sijbrant leans forward in his seat, as though temporarily interrupted in his correspondence. The intimacy between husband, wife and children resembles similar innovations of Gerard the Younger's family portraits. Because Gesina owned a now untraced double portrait of Sijbrant and Jenneken by Gerard that she bequeathed in her last will to their children, most writers have assumed that her watercolour copies an original composition by her half-brother.[10] But again, in the absence of a surviving prototype, the question of Gesina's dependence on Gerard in devising her portraits must remain open. As Gudlaugsson noted, however, many of the objects in Gesina's drawing recur in other paintings by Gerard, among them the inkwell, candlestick and map. Both siblings' work attests to a scrupulous attention to the material world that surrounded them and bespoke the wealth and social standing of their sitters.

From circumstantial evidence in the albums, Gesina appears to have spent considerable time in Amsterdam in 1669–70 and the years 1672–4, when Zwolle endured occupation by the troops of the Bishop of Münster. Her brother-in-law Sijbrant was well connected in the Amsterdam patriciate, and she copied portraits of his relatives by Gerard the Younger (fig.66). But Gesina's sojourns in the Republic's largest and most cosmopolitan city also widened her horizons in other ways, as attested by one of the most remarkable inclusions in her *Art Book*, a miniature by a contemporary Persian painter depicting an elegant youth (fig.69).

Recent technical study at the Rijksmuseum has demonstrated that Gesina took a damaged miniature by an unknown painter of the Isfahan School, and painted over the background, sash and plume, carefully recreating the style of the original, before adding it to her album.[11] By this time, a number of reciprocal embassies and trade delegations had strengthened ties between the Dutch Republic and the Safavid Empire in Persia. In the 1650s, Rembrandt had made a series of loose copies of miniatures originating from the Mughal courts in India, working on Asian paper.[12] But the drawing in Gesina's album is the earliest surviving Persian miniature in a Dutch collection and a remarkable testament to the range of artistic inspirations available to her.

Another legacy of Gesina's visits to Amsterdam is a poem inscribed in the *Art Book* and dated 1674. Written by the poet Anna Adriana Geerdinx, who signed herself 'your devoted friend', this poem was added to the prefatory material by Gesina's male admirers at the time she rebound the album. Praising an art that 'shall never die', Geerdinx reveals herself to be the grateful recipient of one of Gesina's own drawings, with the poetic tribute intended as recompense.[13] Geerdinx terms the gift drawing a 'sign of friendship' (*vrindtschapsteken*), and her poem vividly captures the economy of mutual admiration in which Gesina had established herself at midlife.

THE TRIUMPH OF PAINTING 109

70 Gesina ter Borch, after Hans Holbein the Younger, *The Dance of Death*, in *Art Book*, fol.23r, c.1670, watercolour, 24.3 × 36 cm (9 ½ × 14 ⅛ in), Rijksmuseum, Amsterdam

6

A Dance with Death

For all its scenes of mirth and merrymaking, Gesina's *Art Book* is haunted by the imagery of death. Sometimes the figure of death, embodied by a skeleton, is vanquished, as in the opening allegory (fig.52 above). But in many other cases, it is death who triumphs. Such is the case in the several copies and variations that Gesina included in her *Art Book* of so-called Dance of Death imagery by the sixteenth-century German artist Hans Holbein the Younger (1497/8–1543; fig.70).

Originally designed as the sheath for a dagger, Holbein's frieze depicts boisterous skeletons who enlist various glamorous or powerful figures in a fatal dance. Gesina copied segments of Holbein's drawing in black and white and then added her own updated versions in colour directly below, replacing, for example, the diadem-wearing woman at the centre with a contemporary cavalier, or the nondescript dog at the feet of the skeletal drummer with the Ter Borch family pet. Both macabre and humorous, Holbein's original *Dance of Death* (published 1538) emphasized the levelling effect of human mortality. Gesina harnessed his venerable imagery for personal ends, repeatedly crafting images in which Death appears as a gleeful interloper in the life of the Ter Borch family. Indeed, much of Gesina's final album appears to have functioned as an extended project of mourning, translating into words and images the many losses that beset her in the second half of her life.

To judge from her albums, no loss was as devastating for Gesina as the death of her younger brother Moses, who was killed during the Second Anglo-Dutch War in 1667. Moses, whose surviving drawings attest to the artistic talent he shared with his siblings (figs 10 and 40 above), joined the Dutch navy as a volunteer in 1664. The Republic's forces, under the celebrated admiral Michiel de Ruyter (1607–76), scored a major victory in June 1667, sailing up the River Medway to wreak havoc on the English fleet and capture its flagship, the HMS *Royal Charles*. But the Dutch subsequently endured a defeat at the Battle of Landguard Fort on 2 July, during which Moses ter Borch was killed. Over the next several years, Gesina devoted much of her artistic practice to drawings that allegorize Moses's heroic death, interleaved with poems on the same subject. In mourning Moses, Gesina found a poetic interlocutor in her brother-in-law Sijbrant Schellinger, much as she once had in Hendrik Jordis. The subject now, however, was not Gesina's own artistic triumph, but rather the entire Ter Borch family's grief for Moses.

The art of mourning in the seventeenth-century Dutch Republic was highly formalized. Drawing on

ancient rhetorical strategies, funerary poems moved through a tripartite progression, from *laus* (praise) to *luctus* (lamentation) and *consolatio* (consolation).[1] Schellinger's poems about Moses emulate this structure, while Gesina's accompanying drawings progress through their own stages of premonition, horror and commemoration. Although the drawings of Moses grouped together with Schellinger's poems appear on stylistic and iconographic grounds to post-date his death in England, Gesina inscribed several of them with dates from his lifetime, a similar practice of retrospective dating that she used in the drawings commemorating her relationship with Jordis.

The first of the Moses drawings in the *Art Book* returns to the countryside outside of Zwolle, scene of the happy outings commemorated earlier in the album (fig.71). Here, Moses has stopped on a country road to have his palm read by a woman seated under a tree. Dressed in rags, this soothsayer resembles the fortune-telling Roma women who are stock figures of much early modern European art. But rather than presenting the fortune-teller as a deceiver, in the way many artists did, Gesina shows her to be genuinely alarmed at the fate she reads in Moses's palm. Does this scene represent an actual encounter, remembered with the bitter hindsight of Moses's death? Instead, perhaps it adopts a conventional motif to evoke Gesina's own foreboding about her brother's military service.

The next drawing in the sequence departs from the relative realism of the first to show Moses standing on the shore, his arm grasped by a grotesque demon with the head of a donkey, the wings of a bat and distended human breasts (fig.72). The demon holds a fishing rod, its hook dangling before the open mouth of a woman whose head bobs above the waves. A storm-tossed ship with a broken mast in the background bears the coat of arms of Zwolle, while in the foreground a mouse approaches a lethal trap. The drawing expresses Gesina's belief that Moses's enlistment in the Dutch fleet was a fatal misadventure, in which the young man was baited by dreams of glory into giving up his life.[2]

By contrast, Schellinger's poems, which are interleaved with Gesina's drawings, glorify Moses's death as an act of patriotic self-sacrifice. A printed broadsheet by a professional eulogist that Gesina also pasted into the album continues this theme. An acrostic poem by Schellinger on Moses's name speaks in his voice for a 'last leave-taking' (*laetste afscheijt*), in which he reassures his family that even if he dies, he will rest 'upon the bed of honour' (*op 't bed van eer*).[3] In another poem, entitled 'Tears for the Death of the Noble Hero Mr. Moses ter Borch', Schellinger compares Moses to the Roman heroes Marcus Curtius, Horatius and Mucius Scaevola, all examples of devotion to the fatherland. A third poem, with indications that it was meant to be sung, concludes with an imaginary epitaph for Moses:

> Here lies Ter Borch, who full of courage
> Willingly gave body and blood
> For the good of the fatherland
> He practised at all times to act
> With honour, as was never seen more
> Than at the last.[4]

A further two drawings by Gesina envision Moses as standing on the English coast, while skeletons wreak havoc and Dutch warships founder (fig.73). Despite these ominous backdrops, filled with the symbolic language of death and defeat, Gesina always depicted Moses as a serene and immaculate young dandy, at a psychological remove from the catastrophes that envelop him. The posthumous images of Moses continue Gesina's exploration of the genre of portraiture, particularly its ability to project onto a subject the qualities of serenity and self-possession. In Gesina's portraits, sitters are 'fashioned' by the clothing they wear, and Moses's attire is notably elaborate. (She may even have updated his clothing to keep him in line with fashions that emerged only after his death.[5])

71 Gesina ter Borch, *Art Book*, fol.70r, 1674, watercolour, heightened with gold, 24.3 × 36 cm (9 ½ × 14 ⅛ in), Rijksmuseum, Amsterdam

Gesina's engagement with the genre of portraiture inevitably entailed dialogue with the work of her half-brother Gerard. In fact, the two siblings collaborated on a portrait of Moses that translates the symbolism of Gesina's watercolours into an independent oil painting (fig.74). Here, Moses appears in front of a rock face, wearing the richly embellished yellow *juste-au-corps* jacket from his other portraits. He leans on a walking stick, placing his feet in a balletic arrangement that speaks to a body schooled in courtly movement and dance. Impinging on this image of youth and grace, however, are ominous symbolic attributes such as a snake that curves towards Moses's head, a fluttering butterfly and a pocket-watch, all of which give intimations of transience and death.

Even viewed with the naked eye, the portrait is clearly the work of two different artists. The face, hands, greyhound and cuirass were most likely painted by Gerard, and the rest of the work completed by Gesina. She was also responsible for devising the dense gathering of allegorical signifiers, which represent a striking departure from Gerard's other portraits.[6] The portrait of Moses raises the intriguing question of Gesina's use of oil paint. She was clearly immersed in the work of her father and half-brother Gerard in this medium, and, when it came time to allegorize her own artistic practice in

A DANCE WITH DEATH 113

72 Gesina ter Borch, *Art Book*, fol.75r, *c.*1674, watercolour, 24.3 × 36 cm (9 ½ × 14 ⅛ in), Rijksmuseum, Amsterdam

73 Gesina ter Borch, *Art Book*, fol.83r, after 1667, watercolour, heightened with silver, 24.3 × 36 cm (9 ½ × 14 ⅛ in), Rijksmuseum, Amsterdam

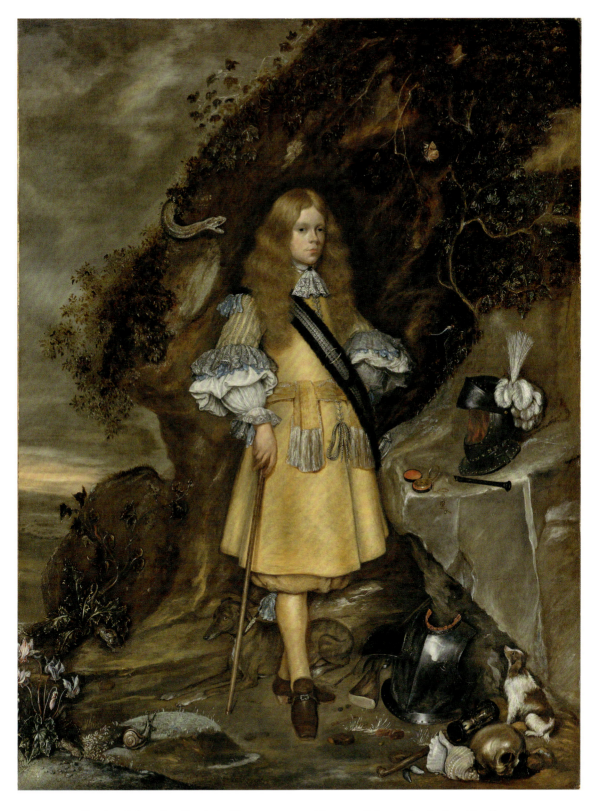

74 Gesina ter Borch and Gerard ter Borch the Younger, *Memorial Portrait of Moses ter Borch*, after 1667, oil on canvas, 76.2 × 56.5 cm (30 × 22 ¼ in), Rijksmuseum, Amsterdam

The Triumph of Painting over Death, she chose to depict herself as an oil painter, not a watercolourist. Yet, until very recently, the posthumous portrait of Moses was the only oil painting that could be conclusively attributed to Gesina, and that only in part. (A depiction of Samson and Delilah in the museum at Zwolle with a traditional attribution to Gesina was convincingly reattributed to Hendrik Bloemaert [*c.*1601–72] several decades ago.[7])

In 2023, however, the National Gallery of Art in Washington acquired a portrait of a boy, dressed in sheepskins and holding a *kolf* stick (*kolf* being a game with a distant resemblance to modern ice hockey; fig.75). Basing their argument on the sitter's physical resemblance to known portraits of Moses, the museum's curators have argued for an attribution to Gesina, with some unspecified participation by Gerard, and a date of *c.*1655.[8] This attribution raises the fascinating possibility that Gesina painted in oils over a period of roughly 15 years – and that other, as yet unidentified, works by her in this medium may exist.

Indeed, a painting at the Fisher Museum in Los Angeles appears to represent a further collaborative portrait by Gesina and Gerard (fig.76).[9] The still life on the left, featuring an elaborate bouquet as well as writing implements, a flute, an hourglass, and a string of pearls, is in the same crisp style as the allegorical elements in the posthumous portrait of Moses. If the attribution is correct, then the painting represents an important expansion of Gesina's oeuvre to include the genre of floral still life, which attracted many celebrated female practitioners in the seventeenth century.

Just as this book was going to press, the scholars Carla van de Puttelaar and Fred Meijer made the announcement of the spectacular discovery of a signed portrait by Gesina that they identify as a posthumous portrait of Moses ter Borch as a young child (fig.77).[10] The rapid pace of these resurfacings reflects both the renewed scholarly attention to early modern women artists as well as the high prices they have begun to command on the art market. (The posthumous portrait of Moses as a young child was immediately acquired by the Rijksmuseum.) But a full understanding of the contours and extent of Gesina's practice of oil painting must await a comparative technical analysis of all the works in question.

If the year 1648, which saw the ratification of the Treaty of Münster, marked one turning point in the history of the Dutch Republic, then 1672 was another. Known in Dutch as the *Rampjaar*, or 'year of catastrophe', 1672 witnessed the near annihilation of the Republic in the face of attacks from the combined armies of France, England and the bishops of Cologne and Münster. While the so-called Water Line, created by artificial flooding, protected the cities of Holland from occupation, Zwolle, in the east of the Republic, was more vulnerable. In alliance with Louis XIV of France, Christoph Bernhard von Galen (1606–78), the Prince-Bishop of Münster, led a two-year occupation of Overijssel marked by plundering and brutality. In June of 1672, Zwolle capitulated to the Bishop's forces, and many residents fled westward. The city was only liberated with the conclusion of the war in 1674, by which time its population had decreased by half. Judging by the inscriptions in her album, Gesina spent at least part of the occupation in Amsterdam, perhaps with the family of her brother-in-law Sijbrant Schellinger. The Ter Borch family archive contains a satirical poem, most likely in Gesina's own hand, that accuses the Bishop of Münster of fighting 'with the staff that the devil gave him', and calls on the Dutch lion to 'strike the pope dead'.[11] While her earlier drawings expressed a curiosity about Catholic ritual and architecture, the catastrophes of the early 1670s entailed a hardening of sectarian lines. Gesina's health also appears to have suffered during this period, as her doctor drew up a list of harmful foods for her to avoid.[12]

The Dutch economy suffered grievously from the events of the *Rampjaar*, with major consequences for

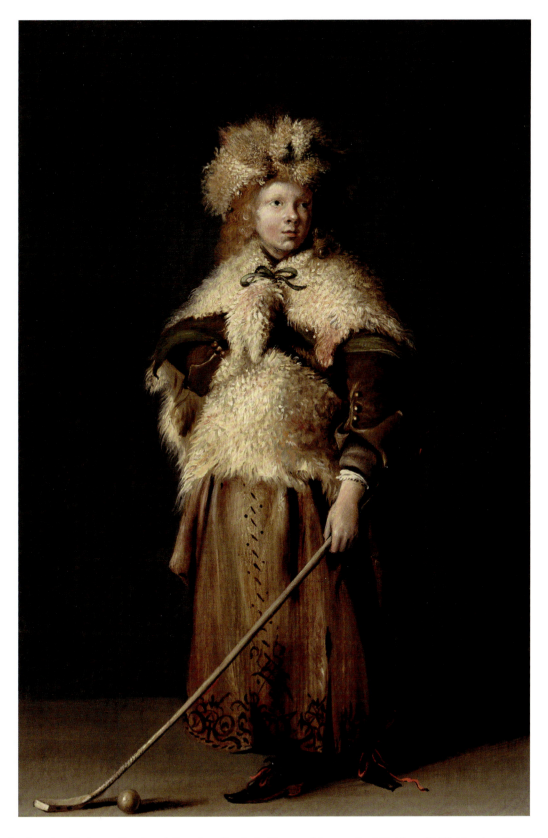

75 Attributed to Gesina ter Borch and Gerard ter Borch the Younger, *Moses ter Borch Holding a Kolf Stick*, c.1655, oil on panel, 39.4 × 26.7 cm (15 ½ × 10 ½ in), National Gallery of Art, Washington, DC

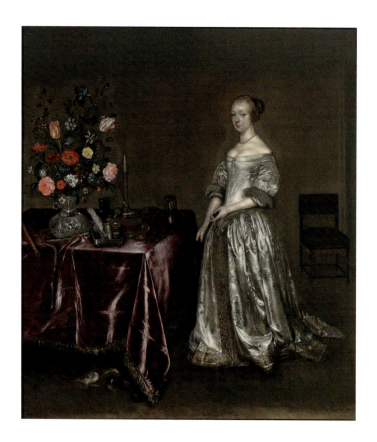

76 Attributed to Gesina ter Borch and Gerard ter Borch the Younger, *Portrait of a Young Woman*, c.1670, oil on canvas, 76.2 × 66 cm (30 × 26 in), USC Fisher Museum of Art, Gift of the Armand Hammer Foundation, Los Angeles

77 Attributed to Gesina ter Borch, *Posthumous Portrait of Moses ter Borch as a Child*, c.1667, oil on canvas, 56 × 45 cm (22 × 17 ¾ in), Rijksmuseum, Amsterdam

the art market. After Johannes Vermeer's death in December 1675, his widow, Catherina Bolnes, sought protection from her creditors at the High Court of Holland and Zealand, lamenting that her 'husband during the recent war with the King of France . . . had been able to earn very little or hardly anything at all'.[13] Gerard ter Borch the Younger fared somewhat better, apparently spending most of the war in Amsterdam, where he was likely joined by Gesina. A portrait he had painted of William III, Prince of Orange, shortly before the surrender of Deventer, was damaged during the occupation, prompting Gerard to make a replacement.[14]

The economic crisis may also have motivated the emigration of Gesina's sister Jenneken, with her husband and children, to the Caribbean island of Curaçao, which had been a Dutch colony since 1634. Very little information survives about the Schellinger family's time on the island. One primary source is Gesina's own annotation on a poem by Joost Hermans Roldanus that was printed in honour of her sister's marriage to Sijbrant Schellinger:

> Anno 1675 the 13th/23rd [sic] of August my sister Janneken [sic] ter Borch died at Curaçao in the West Indies after having been ill for ten to eleven weeks and was buried honourably there, as befits a person of quality, as her husband writes, and left behind three children . . . The little daughter was born at Curaçao the 13th of December 1674 and was called Hillegonda after Schellinger's mother . . .[15]

Gesina also inserted into her album a loose newssheet from 25 February 1679, reporting on Sijbrant Schellinger's role in the capture of a French fleet that had threatened the island.[16]

By the early 1680s, Jenneken's children, Cornelis, Gerrit and Hillegonda, were back in Zwolle. Gesina responded to her family's Caribbean sojourn with a portrait of her niece Hillegonda against an imaginary Curaçaoan backdrop, constructed from fragments of textual accounts, printed depictions and objects from a *Kunstkammer* or cabinet of curiosities (fig.78). The young girl appears standing on the seashore, in the shade of a tree with two parrots perched in its branches. (The birds, like the palm trees and some of the background architecture, were direct borrowings from a 1581 print, an allegory of America by Johannes Sadeler after Dirck Barendsz.) In the foreground are a turtle and a parasol or shield made of featherwork. The waters behind Hillegonda feature both a sea monster and a squadron of ships flying the Dutch flag. Farther down the shoreline, a group of Black figures draw in their fishing nets, while elephants graze beneath palm trees at the edge of a settlement with fanciful buildings.

Previous commentators have assumed that Gesina depicted her niece from life, sometime after the Schellinger children left Curaçao. But the exact date of their return remains unclear, and the likeness is fairly generic, with little resemblance to an actual five-year-old girl. The portrait may in fact be the artist's attempt to envision a niece she had not yet met, in a place to which she would never travel, based on the news reports she read and the printed depictions of faraway places she might come across in Zwolle. As Kettering noted, the rendering of the South African star-pattern turtle's shell in the foreground is accurate, but its limbs have been imagined, suggesting that Gesina worked from a preserved specimen that had no actual link to Curaçao.[17] In depicting this creature at her niece's feet, Gesina attempted the reanimation of a *Kunstkammer* curiosity, just as the flotilla in the background responds to newspaper accounts of triumphant Dutch fleets.

Perhaps most striking to a modern eye is the way that Gesina's portrait makes use of toiling Black bodies as a foil to her niece. The background to Hillegonda's portrait both insists on her Curaçaoan birth, and on her fundamental difference from the island's other inhabitants. Here, as in so many

78 Gesina ter Borch, *Hillegonda Schellinger*, in *Art Book*, fol.92r, 1680, watercolour, heightened with gold and silver, 24.3 × 36 cm (9 ½ × 14 ⅛ in), Rijksmuseum, Amsterdam

79 Gesina ter Borch, *Two Young Men*, in *Art Book*, fol.35r, 1654, watercolour, heightened with silver, 24.3 × 36 cm (9 ½ × 14 ⅛ in), Rijksmuseum, Amsterdam

portraits from the early modern transatlantic world, peripheral Black figures labour at the margins.

Although much of the imagery in the drawing is fanciful or imaginary, there is evidence that Gesina met Black residents of the Dutch Republic, either in Zwolle or Amsterdam.[18] Sixteen years before she drew her niece Hillegonda's image, Gesina ter Borch made another portrait, this time depicting two young Black men (fig.79). Gesina inscribed the drawing with the exact date on which it was made, 11 September 1654, and with the phrase *nae t' leven*, indicating that it was drawn from life. Gesina's inscription, which appears in her own hand only on this drawing in her entire body of work, emphasizes that, unlike her much later portrait of Hillegonda in Curaçao, this image relies neither on her imagination nor on borrowings from printed images. Yet the inscription provides no further information about the sitters of her portrait, not even their names. Around the same time that Gesina made this drawing, her brother Gerard depicted a woman of colour in the genre scene now known as *The Rural Postman*.[19] But, unlike so many other models for Gerard's paintings, this woman has no additional representation within the Ter Borch family albums that might allow us to name her or to sketch her life story.

The portrait of Hillegonda from 1680 is Gesina's last dated drawing, although she lived for another ten years. This is not to imply that her artistic activity ceased entirely in the last decade of her life, but her focus appears to have shifted to teaching younger family members and compiling the artwork produced by her siblings. Gesina's identified students, whose work she preserved in the later pages of the *Art Book*, included her nephews Gerrit and Cornelis Schellinger, as well as a female relative, Anna Cornelia Moda. Contemporaries may have understood an unmarried and childless woman's practice of teaching as an alternative form of maternity. In 1677, Constantijn Huygens wrote a poem celebrating the still-life painter Maria van Oosterwijck (1630–93) who had taken on her maidservant Geertje Pieters (also known as Geertje Wyntges; 1636–1712) as a pupil (fig.80).[20] In the poem, Hugyens praised the 'wonders daily performed' by Van Oosterwijck, among them 'that the maid [that is, virgin] has borne a maid, a maidservant' (*dat de Maeghd een' Maegd, een Dienstmaeght heeft gebaert*). Proposing to rename Geertje Pieters 'Geertruijd van Oosterwijck', Huygens recast one woman's artistic instruction of another as both a social elevation and a striking act of parthenogenesis.

Gesina instructed her young charges not only in drawing and calligraphy but also in the making of delicate paper cut-outs depicting animals or scenes from classical myth (fig.81). Called *knipkunst*, paper cut-outs enjoyed an enormous vogue in the seventeenth century. Like calligraphy, these works offered displays of manual dexterity and were associated with virtuoso female practitioners such as the artist Joanna Koerten (1650–1715).[21]

One might speculate that the shift in Gesina's work from the active production of ambitious drawings to teaching and organizing her family archive reflected a further loss that she suffered in the last decade of her life: the death of Gerard the Younger in late 1681. Although he had spent most of his adult life in Deventer, Gerard's body was brought home to Zwolle for burial. Gesina composed a poetic epitaph for her half-brother, echoing the formulations she had already inscribed into her albums with Jacob Cats's epitaph for Misandre or Sijbrant Schellinger's for Moses ter Borch. 'Here lies a wonder of the world', Gesina's text begins, 'famous in every land'. She records the 'great praise' that Gerard received for his painting of the Treaty of Münster, and predicts that his name will last beyond death, 'as was the case with Apelles', the famed painter of classical antiquity.[22] The poem shows Gesina operating in the mode of an artistic biographer, but her account of Gerard's achievements has one striking omission. Celebrating Gerard as a portraitist, Gesina made no mention of the 'modern pictures' for which she had so often

80 Wallerant Vaillant, *Maria van Oosterwijck*, 1671, oil on canvas, 96 × 78 cm (37 ¾ × 30 ¾ in), Rijksmuseum, Amsterdam

81 Cornelis and Gerrit Schellinger, *Paper Cut-Outs*, in *Art Book*, fol.100r, 1687, white paper over black prepared paper, 15.8 × 20.4 cm (6 ¼ × 8 in), Rijksmuseum, Amsterdam

82 Unknown silversmith, *Memorial Medallion for Gesina ter Borch*, 1690, silver, 3.2 cm (1 ¼ in) diameter, Amsterdam Museum, Amsterdam

modelled, and which have continued to secure Gerard's reputation in the nearly 350 years since his death.

Dying childless, Gerard named his sisters Gesina and Catharina as his 'universal heirs'. Left alone among all the Ter Borch siblings, the two sisters invested part of their inheritance in the purchase of a country house, called the Ramhorst, whose gable they embellished with the Ter Borch family coat of arms.[23] This purchase made into reality the image of Gesina as a landed hostess, standing at the threshold of her country home, that she had already crafted in a drawing (fig.62 above). The embellishment of the gable echoed the ornamentation of her albums, all marked with the Ter Borch arms.

As she approached the end of her own life, Gesina made careful arrangements for the patrimony that she had done so much to preserve and collect. On 16 April 1690, she dictated her last will.[24] This document gives many insights into Gesina's wealth and personal possessions, as well as the steps she took to ensure her artistic legacy. The primary beneficiary of the will was her Curaçao-born niece Hillegonda Schellinger, who received the sum of 1000 guilders, at a time when the annual salary of a schoolmaster was 200 guilders.[25] Hillegonda also received 'my clothes in linen and wool, and all the silver, gold, ornaments and jewels belonging to my person', Gesina's 'best bed' and all the linens housed 'in the *sakkerdanen* chest in the hall' (*sakkerdaan* referred to Brazilian rosewood or jacaranda).[26] Gesina specified that she wanted Hillegonda to wear 'my black crepe gown, and my black woollen skirt, and white serge skirt, and two crepe caps' in mourning for her aunt. Gesina also left mourning clothes to her nephews Gerrit and Cornelis Schellinger, and to her maid Anna Frerix, who furthermore received a bequest of 50 guilders, 'an iron pot, six chairs, and a spinning wheel'. Beyond prescribing specific mourning clothes, she also expressed a wish to be buried in the family grave in Zwolle's Grote Kerk.

Multiple clauses in the will reveal the care Gesina took in disposing of family portraits and her own artwork. She left to Gerrit, Cornelis and Hillegonda Schellinger their parents' portrait by Gerard the Younger, which had perhaps served as the basis for her own drawing (fig.68 above). Another clause stipulated that 'all my portraits, and that of brother Moses and of Father and Mother and Grandfather and Grandmother, along with all my silverware and the household linen that I inherited from Mother' were not to be sold 'but kept for the children'. Finally, she asserted that: 'My sister Catherina ter Borch shall keep my drawing book and all my paper art (*mijn teekenboek en al mijn papierkunst*) for whichever of the children shall be the best or the worthiest, or for all of them together, according to sister's judgement.' With this clause, Gesina initiated a chain of custody that ultimately went from her niece Hillegonda down to Hillegonda's nineteenth-century descendant Lambertus Theodorus Zebinden, and from him to the Rijksmuseum.

Like his ancestor Gesina ter Borch, Zebinden seems to have had a particular investment in family history. In 1882, he loaned his family collection to an antiquarian exhibition held at Zwolle. The Dutch art historian Abraham Bredius examined the *Art Book* at this time and published an article about it in the German periodical *Zeitschrift für bildende Kunst* that provided the first modern art historical account of Gesina's work.[27] Mingling praise with condescension, Bredius established the gendered terms by which Gesina's art would be viewed for a century to come. For example, while noting the quality of Gesina's allegory *The Triumph of Painting over Death* (fig.52 above), Bredius remarked, 'one is keenly aware that this is the work of a woman, and an amateur at that'.[28]

Zebinden's death in 1886 broke the chain of family custody that had kept Gesina's archive together for nearly two centuries. At an auction in Amsterdam, the majority of the drawings, and Gesina's albums, were acquired for the Rijksmuseum. Other family

papers were purchased by Zebinden's nephew and subsequently bequeathed by his widow to an Overijssel antiquarian society in 1913; they can be found today in the province's archives in Zwolle.[29] The incorporation of Gesina's work into the national collection of the Netherlands made it accessible for art historical scholarship, but it was only with the publication, in 1988, of Kettering's meticulous catalogue of the entire Ter Borch studio estate, that a full picture of Gesina's achievement emerged. Subsequent articles by Kettering, Ger and Hans Luijten, Elizabeth Honig and, more recently, Nicole Elizabeth Cook, have further elucidated Gesina's significance, her interactions with contemporary visual and literary culture, and her place within the broader panorama of women artists in the seventeenth-century Dutch Republic. A major exhibition devoted to Gesina brought a large selection of her work back to Zwolle in 2010.[30] In 2021, the installation of Gesina and Gerard's posthumous portrait of Moses (fig.74 above) in the Rijksmuseum's 'Gallery of Honour', alongside Rembrandt's *Night Watch* and Vermeer's *Milkmaid*, represented a milestone in her establishment within the artistic canon of the Netherlands.

Informed by feminist scholarship, novelists have attempted to imagine the lives of women who posed for or otherwise inspired the beloved Dutch genre paintings of the seventeenth century.[31] The most famous example, Tracy Chevalier's *Girl with a Pearl Earring*, published in 1999, offers the first-person account of Griet, a fictional maidservant in the household of Vermeer.[32] Both the novel and the film it inspired vividly evoke the domestic labour of early modern Dutch women, as well as the sexual exploitation that so many of them faced. But, while it offers a psychologically compelling fiction behind the making of Vermeer's most famous painting, this story of a visually acute maidservant never gestures towards the amply documented artistic practices of real Dutch women. As the many examples in this book demonstrate, Dutch women were poets, painters and calligraphers as well as artist's models. Indeed, the case of Geertje Pieters, pupil of Maria van Oosterwijck, shows that at least one seventeenth-century Dutch maidservant became an artist in her own right.

* * *

Gesina ter Borch died the same day that her will was witnessed, 16 April 1690, at the age of 58. In accordance with contemporary custom, her survivors commissioned a silver medallion to be distributed to mourners (fig.82). One side gives Gesina's name and the date of her death, encircling the Ter Borch arms with branches of laurel, just as she had depicted in her albums. The other side resembles an emblem print in its combination of word and image: a hand reaches out from the heavens to snuff out a candle, encircled by the legend: 'So quickly extinguished / So swiftly at rest.'

Over and over in her albums, Gesina ter Borch grappled with the fact of death. At times, she exulted in art's ability to triumph over mortality, at others she seemed to yield to an almost obsessive grief. She always had a clear understanding, however, of her own role as a keeper of family memory and of the power of art to withstand the depredations of time. The fact that, more than three centuries after her death, her albums survive to delight and fascinate us today is a victory over death indeed.

Epilogue

Today, visitors to Zwolle are likely to arrive by train, alighting in a modern part of the city a little to the south of the medieval core that Gesina ter Borch once knew. Walking towards the canal that still encircles the city centre, they might take Terborchstraat, a street of nineteenth-century villas whose name commemorates the town's most famous family. From there, a bridge leads over the canal in the direction of the Sassenpoort, a fifteenth-century survivor of the otherwise long-demolished fortifications that once protected Zwolle from invaders. Passing under the gate, one enters the Sassenstraat, a long, crooked street leading to the Grote Kerk, the large fifteenth-century church where the Ter Borchs worshipped and where many of them were buried. At number 21, a nineteenth-century storefront houses a clothing shop, but the facade still bears the Ter Borch coat of arms. A sign in the doorway informs the curious sightseer:

HOME OF GERARD TER BORCH (1618–1681)
The Ter Borch family of burghers lived near the town hall. Alongside Gerard ter Borch, his brothers Moses and Harmen ter Borch were also worthy painters. His sister Gesina ter Borch was also a very gifted painter.[1]

Although she appears on the sign almost as an afterthought, Gesina ter Borch lived at 21 Sassenstraat far longer than any of her brothers. In line with the renewed attention paid to her in recent years, an updated display at the city museum makes Gesina a protagonist of local history. Here, a digital screen presents the visitor with a first-person narrative in the form of a fictional diary entry, where Gesina recounts making her drawing of two young Black men (fig.79 above). Elsewhere in town, a mural by contemporary artist Donovan Spaanstra riffs on Gerard's depiction of Gesina as a letter writer (fig.13 above; fig.83). Instead of wielding a quill pen, Gesina bends over an iPhone. The adjacent phone screen reveals the English-language message: 'I travelled through time to be with you my dear.' Updating Gesina's image to make her into a text-messaging time traveller, Spaanstra's mural neatly captures the unsettling modernity that makes Dutch genre painting so compelling all these centuries later.

Another echo of early modern Zwolle can be found at the city's Vrouwenhuis, formerly an almshouse for elderly women that now serves as a residence for female students.[2] Founded by the wealthy heiress Aleida Greve (1670–1742) in 1742, the Vrouwenhuis preserves a remarkable group of artworks made by Greve and her friends as young women. Before it was acquired by Greve, the building that is now the Vrouwenhuis had been home to

83 Donovan Spaanstra, *The Letter Writer*, 2021, Zwolle, mural, dimensions unknown

The paintings preserved at the Vrouwenhuis range from portraits to still lifes and genre scenes. Perhaps the most celebrated is a group portrait by Greve's half-sister Cornelia van Marle (1661–98) showing Greve with one of her sisters and a maidservant serving tea (fig.84). Placed in a sumptuous interior with leather wallpaper, a gilded mirror frame and heavy green drapery, the painting is among the first in Dutch art to depict the newly fashionable taste for Asian tea. The refined gestures speak to ideals of feminine comportment, while the outward glances of the figures on either side confront the viewer. Working one year before Gesina ter Borch's death, the young artist almost certainly drew inspiration from her example.

Traditional art history has rarely given space to artists like Gesina ter Borch or Cornelia van Marle, who made their work outside of established institutions of the academy and marketplace, and whose creations have seldom been displayed in museums. Typical metrics of artistic success, such as high prices or prestigious commissions, do not apply here. But, as this book has attempted to show, art that existed outside the framework of the marketplace or academy could still be supremely ambitious. Gesina ter Borch was explicit in framing her albums as works of artistic genius that tackled no less an adversary than death itself. She took careful legal steps to ensure that her art escaped the fate of dispersal and oblivion. Her earliest viewers, handpicked by the artist herself, responded to her work with effusive words of acclaim. Catalogued, exhibited and digitized, these images now reach an audience far greater than their maker could ever have imagined.

another woman painter, Aleida Wolfsen (1648–92), who had studied under Caspar Netscher (*c*.1636–84), himself a student of Gerard ter Borch the Younger. (Aleida Wolfsen's father Hendrik penned one of the poetic tributes to Gesina in her *Art Book*.) Perhaps inspired by the examples of both Gesina and Aleida Wolfsen, Greve and her friends sought out professional instruction in painting as young women, training with the painter Wilhelmus Beurs (1656–1700), who dedicated an artistic treatise to them in 1692. All these links speak to a rich tradition of women artists working in Zwolle in the late seventeenth century.[3]

84 Cornelia van Marle, *A Tea Party*, 1689, oil on canvas, 63 × 51 cm (24 ¾ × 20 ⅛ in), Vrouwenhuis, Stichting het Vrouwenhuis, Zwolle

Notes

I THE FAMILY TER BORCH

1 J.I. van Doorninck, 'Ter Borchiana. I. Verbeterde geslachtslijst', *Verzameling van stukken die betrekking hebben tot Overijsselsch regt en geschiedenis* 16 (1887): 128–39; for other important early publications of Ter Borch family history and documents, see E.W. Moes, 'Gerard ter Borch en zijne familie', *Oud Holland* 4 (1886): 145–65; and M.E. Houck, *Mededeelingen betreffende Gerhard ter Borch, Robert van Voerst, Pieter van Anraedt, Aleijda Wolfsen, Derck Hardensteijn en Hendrik ter Bruggen . . .* (Zwolle: De Erven J.J. Tijl, 1899).

2 For examples, see Alison McNeil Kettering, *Drawings from the Ter Borch Studio Estate*, 2 vols, Catalogus van de Nederlandse Tekeningen in het Rijksprentenkabinet, Rijksmuseum (Catalogue of the Dutch and Flemish Drawings in the Rijksprentenkabinet, Rijksmuseum) 5 (The Hague: Staatsuitgeverij, 1989), vol.2, pp 370–72, cat. nos Gs 11, Gs 12, Gs 13 and Gs 14.

3 For a possible identification of these portraits, see A. Welcker, 'De Stamouders van een schildersgeslacht: Harmen ter Borch en Catharina van Colen', *Oud Holland* 63, no.3/4 (1948): 112–20. Gesina's last will is discussed in greater detail in the final chapter of this book.

4 Kettering, *Drawings from the Ter Borch Studio Estate*, vol.2, p.635.

5 For Gerard the Elder's Italian sojourn, see ibid., vol.1, p.4.

6 'eele schoone bloem van goeden huijs gebooren'; transcribed in Kettering, *Drawings from the Ter Borch Studio Estate*, vol.2, p.866, cat. no.A5.

7 Cited in Simon Schama, *The Embarrassment of Riches: An Interpretation of Dutch Culture in the Golden Age* (New York: Knopf, 1988), p.403.

8 Nicole Elizabeth Cook, 'By Candlelight: Uncovering Early Modern Women's Creative Uses of Night', in *Women Artists and Patrons in the Netherlands, 1500–1700*, ed. Elizabeth A. Sutton, Visual and Material Culture, 1300–1700 14 (Amsterdam: Amsterdam University Press, 2019), pp 55–84.

9 Wayne E. Franits, *Paragons of Virtue: Women and Domesticity in Seventeenth-Century Dutch Art* (Cambridge: Cambridge University Press, 1993).

10 For Hendrickje Stoffels's confession, see Walter L. Strauss and Marjon van der Meulen, *The Rembrandt Documents* (New York: Abaris Books, 1979), p.320.

11 Martha Moffitt Peacock, 'Geertruydt Roghman and the Female Perspective in 17th-Century Dutch Genre Imagery', *Woman's Art Journal* 14, no.2 (1993): 3–10.

12 J. C. Streng and Lydie van Dijk, *Zwolle in de Gouden Eeuw: Cultuur en schilderkunst* (Zwolle: Stedelijk Museum Zwolle / Waanders, 1997).

13 C. H. Wilkinson, ed., *The Poems of Richard Lovelace*, 2nd edn (Oxford: Clarendon Press, 1953), pp 27–9.

14 Johan van Gool, *De nieuwe schouburg der Nederlantsche kunstschilders en schilderessen . . .*, 2 vols (The Hague: printed for the author, 1750), vol.1, pp 32–3.

15 For more on Haverman's surviving work, see Gerrit Albertson, Silvia Centeno and Adam Eaker, 'Margareta Haverman, *A Vase of Flowers*: An Innovative Artist Reexamined', *Metropolitan Museum Journal* 54 (2019): 143–59.

16 For helpful overviews, see the essays collected in Els

Kloek, Catherine Peters Sengers and Esther Tobé, eds, *Vrouwen en kunst in de Republiek: Een overzicht*, Utrechtse historische cahiers 19, nos 1–2 (Hilversum: Verloren, 1998); Sutton, ed., *Women Artists and Patrons in the Netherlands*; and Elizabeth Alice Honig, 'The Art of Being "Artistic": Dutch Women's Creative Practices in the 17th Century', *Woman's Art Journal* 22, no.2 (2001): 31–9.

17 For Leyster, see James A. Welu and Pieter Biesboer, eds, *Judith Leyster: A Dutch Master and Her World* (Zwolle and Worcester, MA: Waanders, 1993).

2 LEARNING TO WRITE

1 Dirck Volckertszoon Coornhert, *Eenen nieuwen ABC of materi-boeck* (Antwerp, 1564). Coornhert's *materi-boeck* is discussed in Ruben Buys, *Sparks of Reason: Vernacular Rationalism in the Low Countries, 1550–1670* (Hilversum: Uitgeverij Verloren, 2015), pp 100–101.

2 For seventeenth-century Dutch calligraphy, see A. R. A. Croiset van Uchelen, *Nederlandse schrijfmeesters uit de zeventiende eeuw* (The Hague: Rijksmuseum Meermanno-Westreenianum, 1978).

3 Jeroen Blaak, *Literacy in Everyday Life: Reading and Writing in Early Modern Dutch Diaries*, trans. Beverley Jackson (Leiden and Boston, MA: Brill, 2009), pp 62–3.

4 See Hendrik Jordis's poem 'Op konterfijtzel vande E. Juffrouw Gesina ter Borch', in *Art Book*, fol.7r–v.

5 Maria Strick, *Toneel der loflijckte schrijfpen. Ten dienste van de const-beminnende jeucht, int licht gebracht door Maria Strick. Fransoysche School-houdende binnen de wydt vermaerde stadt Delff. Ghesneden door Hans Strick* (Delft, 1607), n.p.

6 Columbia University, Butler Library, PLIMPTON 093.93 1605 B63.

7 Anne R. Larsen, *Anna Maria van Schurman, 'The Star of Utrecht': The Educational Vision and Reception of a Savante* (Oxford: Routledge, 2016), pp 79–81.

8 On this topic, see Martine van Elk, 'Female Glass Engravers in the Early Modern Dutch Republic', *Renaissance Quarterly* 73, no.1 (2020): 165–211; for Roemers Visscher specifically, see Nicole Brüderle-Krug, *An Engraved Römer for Huygens: Anna Roemers Visscher* (Amsterdam: Rijksmuseum, 2018).

9 Ann Jensen Adams, 'Disciplining the Hand, Disciplining the Heart: Letter-Writing Paintings and Practices in Seventeenth-Century Holland', in *Love Letters: Dutch Genre Paintings in the Age of Vermeer* (Greenwich, CT and Dublin: Bruce Museum of Arts and Sciences / National Gallery of Ireland, 2003), pp 63–76.

10 'De edle penneconst doet veel, / gelijck oock doet een goet penceel'; 'in u jeught, / Benevens Godes vrees' en deught'; transcribed in Alison McNeil Kettering, *Drawings from the Ter Borch Studio Estate*, 2 vols, Catalogus van de Nederlandse Tekeningen in het Rijksprentenkabinet, Rijksmuseum (Catalogue of the Dutch and Flemish Drawings in the Rijksprentenkabinet, Rijksmuseum) 5 (The Hague: Staatsuitgeverij, 1989), vol.2, p.873, cat. no.E 1.

11 'Const ende Wetenschappen worden van alle verstandige menschen, meerder geestimeert als verganckelijcke goederen ende aerdsche rijckdommen. Daeromme soo behooren alle jonghe luiden, in haere jeught, neerstigh te wesen, om graeye consten ende wetenschappen te leeren'; *Materi-boeck*, fol.3r; transcribed in Kettering, *Drawings from the Ter Borch Studio Estate*, vol.2, p.401.

12 *Materi-boeck*, fol.4r; for a transcription and alternative translation of Gesina's text, whose spelling and syntax depart significantly from Cats's original, as well as an identification of the source, see ibid., vol.2, p.402.

13 For a survey of representations of the *vrijster*, see Wayne E. Franits, *Paragons of Virtue: Women and Domesticity in Seventeenth-Century Dutch Art* (Cambridge: Cambridge University Press, 1993), pp 18–61.

14 Jacob Cats, *Houwelick: Dat is het gansche gelegenheyt des echten-staets...* (Middelburg: Jan Pieterss van de Venne, 1625). Digital text available at https://www.dbnl.org/tekst/cats001houw01_01/.

15 ibid., p.55; for a discussion of this passage, see Domien ten Berge, *De hooggeleerde en zoetvloeiende dichter Jacob Cats* (The Hague: Nijhoff, 1979), p.80.

16 Jacob Cats, *Trou-ringh* (Dordrecht: Hendrick van Esch, 1637). Digital text available at https://www.dbnl.org/tekst/cats001trou01_01/.

17 Jacob Cats, *Verhalen uit de Trou-Ringh*, ed. Johan Koppenol (Amsterdam: Amsterdam University Press, 2003), p.10.

18 'die tot heden toe in net geschreven boecken, / Haer lust en tijt-verdrijf maer is gewoon te soecken'; 'Een schrift dat wilder gaet'. Cats, *Trou-ringh*, p.405.

19 ibid., pp 634–61.

20 Blaak, *Literacy in Everyday Life*, p.30.

21 Rensselaer W. Lee, *Names on Trees: Ariosto into Art*, Princeton Essays on the Arts 3 (Princeton, NJ: Princeton University Press, 1977).

22 R.E.O. Ekkart, 'Epitafen in Hollandse kerken', *De Stichting Oude Hollandse Kerken* 10 (Spring 1980): 3–12.

23 'Wat is die liefde een seltsaem dingen / Vol sotternij'; transcribed in Kettering, *Drawings from the Ter Borch Studio Estate*, vol.2, p.402.

24 ibid., vol.2, p.398.

25 Alison McNeil Kettering, 'Watercolor and Women in the Early Modern Netherlands: Between Mirror and Comb', *Woman's Art Journal* 42, no.1 (Spring/Summer 2021): 27–35, quotation p.29.

26 Translation from Kettering, *Drawings from the Ter Borch Studio Estate*, vol.2, p.408, fol.17r.

3 MODERN PICTURES

1 See Alison McNeil Kettering, *Gerard ter Borch and the Treaty of Münster* (The Hague and Zwolle: Mauritshuis and Waanders Publishers, 1998); and Jonathan I. Israel, 'Art and Diplomacy: Gerard ter Borch and the Münster Peace Negotiations, 1646–48', in *Conflicts of Empires: Spain, the Low Countries and the Struggle for World Supremacy, 1585–1713* (London: Hambledon Press, 1997).

2 Wayne E. Franits, '"For People of Fashion": Domestic Imagery and the Art Market in the Dutch Republic', *Nederlands Kunsthistorisch Jaarboek (NKJ) / Netherlands Yearbook for History of Art* 51 (2000): 294–316.

3 For one wide-ranging recent survey, with references to the earlier literature, see Wayne E. Franits, *Dutch Seventeenth-Century Genre Painting: Its Stylistic and Thematic Evolution* (New Haven, CT: Yale University Press, 2004).

4 For a classic example of this approach, see E. de Jongh, 'Pearls of Virtue and Pearls of Vice', *Simiolus: Netherlands Quarterly for the History of Art* 8, no.2 (January 1975): 69–97.

5 This argument was most influentially stated in Svetlana Alpers, *The Art of Describing: Dutch Art in the Seventeenth Century* (Chicago, IL: University of Chicago Press, 1983).

6 For the text of the letter and an English translation, see Arthur K. Wheelock, ed., *Gerard ter Borch* (Washington, DC: National Gallery of Art, 2004), p.189.

7 Pieter Biesboer, 'Judith Leyster: Painter of "Modern Figures"', in *Judith Leyster: A Dutch Master and Her World*, eds James Welu and Pieter Biesboer (Zwolle and Worcester, MA: Waanders, 1993), pp 75–92.

8 Gérard de Lairesse, *A Treatise on the Art of Painting, in All Its Branches: Accompanied by Seventy Engraved Plates, and Exemplified by Remarks on the Paintings of the Best Masters*, ed. William Marshall Craig (London: Edward Orme, 1817), p.121.

9 Alison McNeil Kettering, 'Gerard ter Borch and the Modern Manner', in *Gerard ter Borch*, ed. Wheelock, pp 19–30, quotation from p.26.

10 For this topic, see Kim F. Hall, *Things of Darkness: Economies of Race and Gender in Early Modern England* (Ithaca, NY: Cornell University Press, 1995), esp. pp 211–12.

11 This identification goes back at least to S.J. Gudlaugsson, *Gerard ter Borch: Katalog der Gemälde Gerard ter Borchs, sowie biographisches Material*, 2 vols (The Hague: M. Nijhoff, 1959–60), vol.1, cat. no.77, p.96.

12 Alison McNeil Kettering, *Drawings from the Ter Borch Studio Estate*, 2 vols, Catalogus van de Nederlandse Tekeningen in het Rijksprentenkabinet, Rijksmuseum (Catalogue of the Dutch and Flemish Drawings in the Rijksprentenkabinet, Rijksmuseum) 5 (The Hague: Staatsuitgeverij, 1989), vol.1, p.78, cat. no.GSr 107.

13 Gudlaugsson, *Gerard ter Borch*, vol.1, pp 90–91, and vol.2, p.37.

14 Letter of 27 February 1639, from Cardinal Infante Ferdinand to Philip IV of Spain; published in Max Rooses and Charles Ruelens, *Correspondance de Rubens et documents épistolaires concernant sa vie et ses oeuvres*, 6 vols (Antwerp: Veuve de Backer, 1887), vol.6, p.228.

15 De Lairesse, *A Treatise*, p.112.

16 'Dat Jan Steen haar dikmaals konterfyte, doch altoos als een onzeedig voorwerp, dan voor een dronke Wyf, nu als een Koppelaares, en op een ander tyd voor een geyle Snol'; Jacob Campo Weyerman, *De levens-beschryvingen der Nederlandsche konst-schilders en konst-schilderessen . . .*, 4 vols (The Hague: E. Boucquet, 1729), vol.2, p.362.

17 S.A.C. Dudok van Heel, 'Het "gewoonlijck model" van de schilder Dirck Bleker', *Bulletin van Het Rijksmuseum* 29, no.4 (January 1981): 214–20.

18 For links between domestic architecture and Dutch genre painting, see Martha Hollander, *An Entrance for the Eyes: Space and Meaning in Seventeenth-Century Dutch Art* (Berkeley and Los Angeles, CA: University of California Press, 2002), esp. pp 120–24.

19 For this painting, see Peter Sutton, 'The Noblest of

Livestock', *The J. Paul Getty Museum Journal* 15 (1987): 97–110.
20. For the identification of Wiesken Matthijs as Gerard's model in other paintings, see Marjorie E. Wieseman's catalogue entries in *Gerard ter Borch*, ed. Wheelock, cat. nos 18–20, pp 87–96.
21. The drawing is preserved in Gesina's *Art Book*, fol.69r.

4 ART AND LOVE

1. Alison McNeil Kettering, *Drawings from the Ter Borch Studio Estate*, 2 vols, Catalogus van de Nederlandse Tekeningen in het Rijksprentenkabinet, Rijksmuseum (Catalogue of the Dutch and Flemish Drawings in the Rijksprentenkabinet, Rijksmuseum) 5 (The Hague: Staatsuitgeverij, 1989), vol.2, p.416.
2. Translation taken from ibid., vol.2, p.423.
3. Clara Strijbosch, 'The Many Shades of Love: Possessors and Inscribers of Sixteenth-Century Women's Alba', in *Identity, Intertextuality, and Performance in Early Modern Song Culture*, eds D.E. van der Poel, Louis Peter Grijp and W. van Anrooij, Intersections 43 (Leiden and Boston, MA: Brill, 2016), pp 178–208. For Dutch *alba amicorum* more generally, see K. Thomassen, C. Bosters and Rijksmuseum Meermanno-Westreenianum, eds, *Alba Amicorum: Vijf eeuwen vriendschap op papier gezet: Het album amicorum en het poëziealbum in de Nederlanden* (Maarssen and The Hague: G. Schwartz / SDU, in collaboration with the Rijksmuseum Meermanno-Westreenianum, Museum van het Boek, 1990).
4. Johan Oosterman, 'Die ik mijn hart wil geven: Het album van Joanna Bentinck en de zestiende-eeuwse vrouwenalba', *Literatuur* 19 (2002): 194–202.
5. For the full text of the poem, see Kettering, *Drawings from the Ter Borch Studio Estate*, vol.2, p.420.
6. Gunilla Dahlberg, 'Die holländischen Komödianten im Schweden des 17. Jahrhunderts', *De zeventiende eeuw* 10 (1994): 310–27.
7. 'Hier is het lichaem van Juffrou ter Borch verheven, / Door haer konstrijcke hant, wel afgebeelt naer 't leven: / Maer haer geestrijck verstant en al haer deuchden t' saem, / Recht af te beelden, daer is niemant toe bequaem'; text transcribed in Kettering, *Drawings from the Ter Borch Studio Estate*, vol.2, p.423.
8. Hendrik Jordis's *Verklaaringe* or Explanation appears on fols 3r–5r, and his allegorical drama on fols 158r–174r. For an extended interpretation of the drawing and Jordis's texts, see G. Luijten, '"De Triomf van de schilderkunst": Een titeltekening van Gesina ter Borch en een toneelstuk', *Bulletin van het Rijksmuseum* 36, no.4 (1988): 283–314.
9. For an overview of Dutch representations of Pictura, see Sophie Schnackenburg, *'Pictura' in den Niederlanden: Ihre Genese und Entwicklung vom 16. bis zur Mitte des 17. Jahrhunderts*, Studien zur Kunstgeschichte, Band 221 (Hildesheim: Georg Olms Verlag, 2022); Van Mieris's painting is discussed pp 345–62.
10. Mary D. Garrard, 'Artemisia Gentileschi's Self-Portrait as the Allegory of Painting', *The Art Bulletin* 62, no.1 (March 1980): 97–112; Sheila Barker, *Artemisia Gentileschi* (London: Lund Humphries, 2022), pp 101–103.
11. 'De swarte haeren en winchbrauwen beteekenen de stadige en wel overdagte beradinge die een goet meester te werk legt'; transcribed in Kettering, *Drawings from the Ter Borch Studio Estate*, vol.2, p.619.
12. H. Luijten, '"Swiren vol van leer, amblemsche wijs geduijt." Een opmerkelijk zeventiende-eeuws poëzie-album van Gesina ter Borch', *Bulletin van het Rijksmuseum* 36, no.4 (1988): 315–42.
13. Alison McNeil Kettering, *The Dutch Arcadia: Pastoral Art and Its Audience in the Golden Age* (Montclair, NJ and Woodbridge, Suffolk: Allanheld and Schram / Boydell Press, 1983).
14. Karel Porteman and Mieke B. Smits-Veldt, *Een nieuw vaderland voor de muzen: geschiedenis van de Nederlandse literatuur, 1560–1700* (Amsterdam: Bert Bakker, 2008), pp 392–6.
15. The play was published in Jan Harmensz. Krul, *Eerlycke tytkorting* (Haarlem: Hendrick van Marcke and Theunis Jansen, 1634), pp 58–9. Digital text available at https://www.dbnl.org/tekst/krul001eerl01_01/index.php.
16. Kettering, *The Dutch Arcadia*, pp 78–80.
17. Alison McNeil Kettering, 'Ter Borch's Ladies in Satin', *Art History* 16, no.1 (1993): 95–124.
18. For the full text, see Kettering, *Drawings from the Ter Borch Studio Estate*, vol.2, p.461.
19. Luijten, '"Swiren vol van leer"', p.319.
20. Kettering, 'Ter Borch's Ladies in Satin', p.108.
21. Hendrik Jordis's 'Op konterfijtzel vande E. Juffrouw Gesina ter Borch', in *Art Book*, fol.7r-v; transcribed in Kettering, *Drawings from the Ter Borch Studio Estate*, vol.2, pp 621–2.
22. 'Op de Constrijke afbeltenisse van de zeedige saluatie,

23 'Aan den toegelatene aanschouwer en leser deses boeks', *Poetry Album*, fol.99r; transcribed in ibid., vol.2, p.470.
24 'Bekomt ghij d'eere van dees bladen door te bladen, / Ziet, hoe GESIJNAAS geest door kunst gesterkt verzaden / Uw ooglust kan!... Wie dorf verstandeloos uijt eijgen waan noch spreken, / Dat geest en kunst-zucht niet in 't jufferlijk zou steken, / Als hij GESIJNAAS werk doorziet?'; Kettering has persuasively attributed the poem to the 'H. Fisscher' who signed another tribute in Gesina's *Art Book*; see ibid., vol.2, p.470.
25 Transcribed in ibid., vol.2, p.474.

Opening note (column 1 start): door de weijse ende schrandere geestige Juffr. Geesien ter Borch', *Poetry Album*, fol.89v; transcribed in ibid., vol.2, p.465.

5 THE TRIUMPH OF PAINTING

1 The poems, both untitled, appear on fols 26r and 28r of the *Art Book*; for transcriptions, see Alison McNeil Kettering, *Drawings from the Ter Borch Studio Estate*, 2 vols, Catalogus van de Nederlandse Tekeningen in het Rijksprentenkabinet, Rijksmuseum (Catalogue of the Dutch and Flemish Drawings in the Rijksprentenkabinet, Rijksmuseum) 5 (The Hague: Staatsuitgeverij, 1989), vol.2, pp 628–9.
2 ibid., vol.2, p.629.
3 For the full text of the poem, see ibid., vol.2, pp 625–6.
4 The untitled poem appears on fol.14r of the *Art Book*.
5 For a discussion of how Gesina might have self-consciously fashioned her image in emulation of the famous savante Anna Maria van Schurman, see Martha Moffitt Peacock, *Heroines, Harpies, and Housewives: Imaging Women of Consequence in the Dutch Golden Age*, Brill's Studies in Intellectual History, 312 (Leiden and Boston, MA: Brill, 2020), pp 164–9.
6 S.J. Gudlaugsson, *Gerard ter Borch: Katalog der Gemälde Gerard ter Borchs, sowie biographisches Material*, 2 vols (The Hague: M. Nijhoff, 1959–60), vol.2, p.176, cat. no.171.
7 English translation from Kettering, *Drawings from the Ter Borch Studio Estate*, vol.2, p.624.
8 The document is transcribed in Gudlaugsson, *Gerard ter Borch*, vol.2, pp 25–6. It was not signed by Gerard the Younger, who was apparently absent from Zwolle at the time.
9 On the drawing's dating, see Kettering, *Drawings from the Ter Borch Studio Estate*, vol.2, p.639.
10 Gudlaugsson, *Gerard ter Borch*, vol.2, pp 207–208, cat. no.225; Kettering, *Drawings from the Ter Borch Studio Estate*, vol.2, p.639.
11 Jan de Hond, Amélie Couvrat-Desvergnes, Leila Sauvage, Forough Sajadi and Paolo D'Imporzano, 'An Iranian Youth in an Album from Zwolle', *The Rijksmuseum Bulletin* 68, no.3 (2020): 204–31.
12 For Rembrandt's drawings, see Stephanie Schrader, ed., *Rembrandt and the Inspiration of India* (Los Angeles, CA: The J. Paul Getty Museum, 2018).
13 *Art Book*, fol.13r. For the full text of the poem, see Kettering, *Drawings from the Ter Borch Studio Estate*, vol.2, pp 624–5.

6 A DANCE WITH DEATH

1 S.F. Witstein, *Funeraire poëzie in de Nederlandse Renaissance. Enkele funeraire gedichten van Heinsius, Hooft, Huygens en Vondel bezien tegen de achtergrond van de theorie betreffende het genre* (Assen: Van Gorcum, 1969).
2 For this interpretation, see Alison McNeil Kettering, *Drawings from the Ter Borch Studio Estate*, 2 vols, Catalogus van de Nederlandse Tekeningen in het Rijksprentenkabinet, Rijksmuseum (Catalogue of the Dutch and Flemish Drawings in the Rijksprentenkabinet, Rijksmuseum) 5 (The Hague: Staatsuitgeverij, 1989), vol.2, p.640.
3 For a full transcription, see ibid., vol.2, p.641.
4 For these poems, see ibid., vol.2, p.643 (translation modified).
5 ibid., vol.2, p.644.
6 Alison McNeil Kettering, 'Het "Portret van Moses ter Borch" door Gerard en Gesina ter Borch', *Bulletin van het Rijksmuseum* 43, no.4 (1995): 317–35.
7 Christina J.A. Wansink, 'Simson en Delila; niet Gesina ter Borch, maar Hendrik Bloemaert', *Oud Holland* 102, no.3 (1988): 236–42.
8 I am grateful to Alexandra Libby and Betsy Wieseman of the National Gallery of Art, Washington, DC, for discussing this work with me.
9 I am grateful to Betsy Wieseman for bringing this work to my attention. A similar portrait combining female figure and floral still life is in the collection of Greg Fisher at Bolwick Hall, Norfolk, but I have not yet been able to examine it in person.
10 Carla van de Puttelaar, with Fred G. Meijer, *Gesina ter*

11 *Borch (1631–1690): A Testimony of Love* (Amsterdam: Zebregs & Röell, 2024).
11 Kettering, *Drawings from the Ter Borch Studio Estate*, vol.2, p.874.
12 'Medische voorschriften van Cornelius Hooghlant, medicinae doctor, voor Gesina ter Borch betreffende het gebruik van spijzen en drank, 1672'; Collectie Overijssel, Vereeniging tot beoefening van Overijsselsch Regt en Geschiedenis (VORG), collectie archivalia, toegang 0285.1.1.1.1.1.6.17.
13 Cited in John Michael Montias, *Vermeer and His Milieu: A Web of Social History* (Princeton, NJ: Princeton University Press, 1989), pp 344–5, no.367.
14 S.J. Gudlaugsson, *Gerard ter Borch: Katalog der Gemälde Gerard ter Borchs, sowie biographisches Material*, 2 vols (The Hague: M. Nijhoff, 1959–60), vol.1, pp 28–9.
15 Gesina ter Borch's notes about her sister's death were published in an anonymous query published in *De Navorscher*, vol.20 (1870), p.316. I have been unable to trace their current whereabouts. The uncertainty about the date of Jenneken's death may reflect the illegibility of the original notes.
16 *Oprechte Haerlemse Saturdaegse Courant*, no.83 (25 February 1679), inserted into fol.92 of Gesina's *Art Book*.
17 Kettering, *Drawings from the Ter Borch Studio Estate*, vol.2, p.646.
18 On the Black presence in the seventeenth-century Dutch Republic, see Elmer Kolfin and Epco Runia, eds, *Black in Rembrandt's Time* (Zwolle: WBOOKS, 2020); for Overijssel in particular, see Marco Krijnsen, Martin van der Linde and Esther van Velden, eds, *Overijssel en slavernij* (Zwolle: WBOOKS, 2023).
19 For this painting, see Gudlaugsson, *Gerard ter Borch*, vol.2, p.120, cat. no.111.
20 J.A. Worp, ed., *De gedichten van Constantijn Huygens: Naar zijn handschrift uitgegeven*, 9 vols (Groningen: J.B. Wolters, 1892), vol.8, p.163.
21 Jos Hiddes, 'Kunstenaressen in de marge? Over knipkunst, calligrafie en roem', in *Vrouwen en kunst in de Republiek: Een overzicht*, eds Els Kloek, Catherine Peters Sengers and Esther Tobé, Utrechtse historische cahiers 19, nos 1–2 (Hilversum: Verloren, 1998), pp 107–18.
22 For the full text of Gesina's poem, see Gudlaugsson, *Gerard ter Borch*, vol.2, p.9, cat. no.11.
23 For Gesina's inheritance and the purchase of the Ramhorst, see ibid., vol.2, pp 31–3.
24 For a transcription of the will, see 'Testament van Gesina ter Borch', in J.I. van Doorninck and J. Naninga Uitterdijk, eds, *Bijdragen tot de geschiedenis van Overijssel*, vol.8 (Zwolle: De Erven J.J. Tijl, 1886), pp 147–53.
25 For this statistic, see Simon Schama, *The Embarrassment of Riches: An Interpretation of Dutch Culture in the Golden Age* (New York: Knopf, 1988), p.617.
26 For the identification of *sakkerdaan*, see Iep Wiselius, 'De jacht op Sakkerdaan: Hoe de zoektocht van naam naar houtsoort na 50 jaar tot een goed einde kwam', in *Houttechnologie voor meubelrestauratoren: Handelingen zevende Nederlandse symposium hout- en meubelrestauratie*, eds Hans Piena and Angie Barth (Amsterdam: Stichting Ebenist, 2005), pp 57–63.
27 Abraham Bredius, 'Eine Ter Borch-Sammlung', *Zeitschrift für bildende Kunst* 18 (1883): 370–73.
28 '... man merkt doch sehr, daß eine Frau, und dabei Dilettantin, dies gemacht hat'; ibid., p.370.
29 For the dispersal of the Ter Borch collection, see Kettering, *Drawings from the Ter Borch Studio Estate*, vol.1, pp vii–ix, as well as the finding aid from the Collectie Overijssel, see https://proxy.archieven.nl/20/89D7114C72114647BE4BA972F896E6AC (consulted 3 November 2023).
30 Marjan Brouwer, *De Gouden Eeuw van Gesina ter Borch* (Zwolle: Waanders Uitgeverij / Stedelijk Museum Zwolle, 2010).
31 On this topic, see H. Perry Chapman, 'Reading Dutch Art: Science and Fiction in Vermeer', in *The Art Historian: National Traditions and Institutional Practices*, ed. Michael F. Zimmermann, Clark Studies in the Visual Arts (New Haven, CT: Yale University Press, 2003), pp 110–27.
32 Tracy Chevalier, *Girl with a Pearl Earring* (New York: Dutton, 1999).

EPILOGUE

1 My translation.
2 For the Vrouwenhuis and its collection, see Jan ten Hove, *Het Vrouwenhuis te Zwolle*, 2nd edn (Zwolle: Waanders, 2009).
3 Elizabeth Alice Honig, 'The Art of Being "Artistic": Dutch Women's Creative Practices in the 17th Century', *Woman's Art Journal* 22, no.2 (2001): 31–9, on p.36.

Selected Bibliography

Adams, Ann Jensen. 'Disciplining the Hand, Disciplining the Heart: Letter-Writing Paintings and Practices in Seventeenth-Century Holland.' In *Love Letters: Dutch Genre Paintings in the Age of Vermeer*, pp 63–76. Greenwich, CT and Dublin: Bruce Museum of Arts and Sciences / National Gallery of Ireland, 2003.

Albertson, Gerrit, Silvia Centeno and Adam Eaker. 'Margareta Haverman, *A Vase of Flowers*: An Innovative Artist Reexamined.' *Metropolitan Museum Journal* 54 (2019): 143–59.

Alpers, Svetlana. *The Art of Describing: Dutch Art in the Seventeenth Century*. Chicago, IL: University of Chicago Press, 1983.

Barker, Sheila. *Artemisia Gentileschi*. London: Lund Humphries, 2022.

Berge, Domien ten. *De hooggeleerde en zoetvloeiende dichter Jacob Cats*. The Hague: Nijhoff, 1979.

Biesboer, Pieter. 'Judith Leyster: Painter of "Modern Figures".' In *Judith Leyster: A Dutch Master and Her World*, eds James Welu and Pieter Biesboer, pp 75–92. Zwolle and Worcester, MA: Waanders, 1993.

Blaak, Jeroen. *Literacy in Everyday Life: Reading and Writing in Early Modern Dutch Diaries*. Trans. Beverley Jackson. Leiden and Boston, MA: Brill, 2009.

Bredius, Abraham. 'Eine Ter Borch-Sammlung.' *Zeitschrift für bildende Kunst* 18 (1883): 370–73.

Brouwer, Marjan. *De Gouden Eeuw van Gesina ter Borch*. Zwolle: Waanders Uitgeverij / Stedelijk Museum Zwolle, 2010.

Brüderle-Krug, Nicole. *An Engraved Römer for Huygens: Anna Roemers Visscher*. Amsterdam: Rijksmuseum, 2018.

Buys, Ruben. *Sparks of Reason: Vernacular Rationalism in the Low Countries, 1550–1670*. Hilversum: Uitgeverij Verloren, 2015.

Cats, Jacob. *Houwelick: Dat is het gansche gelegenheyt des echten-staets . . .* Middelburg: Jan Pieterss van de Venne, 1625.

—. *Trou-ringh*. Dordrecht: Hendrick van Esch, 1637.

—. *Verhalen uit de Trou-Ringh*. Ed. Johan Koppenol. Amsterdam: Amsterdam University Press, 2003.

Chapman, H. Perry. 'Reading Dutch Art: Science and Fiction in Vermeer.' In *The Art Historian: National Traditions and Institutional Practices*, ed. Michael F. Zimmermann, pp 110–27. Clark Studies in the Visual Arts. New Haven, CT: Yale University Press, 2003.

Chevalier, Tracy. *Girl with a Pearl Earring*. New York: Dutton, 1999.

Cook, Nicole Elizabeth. 'By Candlelight: Uncovering Early Modern Women's Creative Uses of Night.' In *Women Artists and Patrons in the Netherlands, 1500–1700*, ed. Elizabeth A. Sutton, pp 55–84. Visual and Material Culture, 1300–1700 14. Amsterdam: Amsterdam University Press, 2019.

Croiset van Uchelen, A.R.A. *Nederlandse schrijfmeesters uit de zeventiende eeuw*. The Hague: Rijksmuseum Meermanno-Westreenianum, 1978.

Dahlberg, Gunilla. 'Die holländischen Komödianten im Schweden des 17. Jahrhunderts.' *De zeventiende eeuw* 10 (1994): 310–27.

Doorninck, J.I. van. 'Ter Borchiana. I. Verbeterde geslachtslijst.' *Verzameling van stukken die betrekking hebben tot Overijsselsch regt en geschiedenis* 16 (1887): 128–39.

Doorninck, J.I. van, and J. Naninga Uitterdijk, eds. *Bijdragen tot de geschiedenis van Overijssel*, vol.8. Zwolle: De Erven J.J. Tijl, 1886.

Ekkart, R.E.O. 'Epitafen in Hollandse kerken.' *De Stichting Oude Hollandse Kerken* 10 (Spring 1980): 3–12.

Elk, Martine van. 'Female Glass Engravers in the Early Modern Dutch Republic.' *Renaissance Quarterly* 73, no.1 (2020): 165–211.

Franits, Wayne E. *Paragons of Virtue: Women and Domesticity in Seventeenth-Century Dutch Art*. Cambridge: Cambridge University Press, 1993.

—. '"For People of Fashion": Domestic Imagery and the Art Market in the Dutch Republic.' *Nederlands Kunsthistorisch Jaarboek (NKJ) / Netherlands Yearbook for History of Art* 51 (2000): 294–316.

—. *Dutch Seventeenth-Century Genre Painting: Its Stylistic and Thematic Evolution*. New Haven, CT: Yale University Press, 2004.

Garrard, Mary D. 'Artemisia Gentileschi's Self-Portrait as the Allegory of Painting.' *The Art Bulletin* 62, no.1 (March 1980): 97–112.

Gool, Johan van. *De nieuwe schouburg der Nederlantsche kunstschilders en schilderessen . . .*, 2 vols. The Hague: Printed for the author, 1750.

Gudlaugsson, S.J. *Gerard ter Borch: Katalog der Gemälde Gerard ter Borchs, sowie biographisches Material*, 2 vols. The Hague: M. Nijhoff, 1959–60.

Hall, Kim F. *Things of Darkness: Economies of Race and Gender in Early Modern England*. Ithaca, NY: Cornell University Press, 1995.

Heel, S.A.C. Dudok van. 'Het "gewoonlijck model" van de schilder Dirck Bleker.' *Bulletin van Het Rijksmuseum* 29, no.4 (January 1981): 214–20.

Hiddes, Jos. 'Kunstenaressen in de marge? Over knipkunst, calligrafie en roem.' In *Vrouwen en kunst in de Republiek: Een overzicht*, eds Els Kloek, Catherine Peters Sengers and Esther Tobé, pp 107–18. Utrechtse historische cahiers 19, nos 1–2. Hilversum: Verloren, 1998.

Hollander, Martha. *An Entrance for the Eyes: Space and Meaning in Seventeenth-Century Dutch Art*. Berkeley and Los Angeles, CA: University of California Press, 2002.

Hond, Jan de, Amélie Couvrat-Desvergnes, Leila Sauvage, Forough Sajadi and Paolo D'Imporzano. 'An Iranian Youth in an Album from Zwolle.' *The Rijksmuseum Bulletin* 68, no.3 (2020): 204–31.

Honig, Elizabeth Alice. 'The Art of Being "Artistic": Dutch Women's Creative Practices in the 17th Century.' *Woman's Art Journal* 22, no.2 (2001): 31–9.

Houck, M.E. *Mededeelingen betreffende Gerhard ter Borch, Robert van Voerst, Pieter van Anraedt, Aleijda Wolfsen, Derck Hardensteijn en Hendrik ter Bruggen . . .* Zwolle: De Erven J.J. Tijl, 1899.

Hove, Jan ten. *Het Vrouwenhuis te Zwolle*, 2nd edn. Zwolle: Waanders, 2009.

Israel, Jonathan I. 'Art and Diplomacy: Gerard Ter Borch and the Münster Peace Negotiations, 1646–48.' In *Conflicts of Empires: Spain, the Low Countries and the Struggle for World Supremacy, 1585–1713*. London: Hambledon Press, 1997.

Jongh, E. de. 'Pearls of Virtue and Pearls of Vice.' *Simiolus: Netherlands Quarterly for the History of Art* 8, no.2 (January 1975): 69–97.

Kettering, Alison McNeil. *The Dutch Arcadia: Pastoral Art and Its Audience in the Golden Age*. Montclair, NJ and Woodbridge, Suffolk: Allanheld and Schram / Boydell Press, 1983.

—. *Drawings from the Ter Borch Studio Estate*, 2 vols. Catalogus van de Nederlandse Tekeningen in het Rijksprentenkabinet, Rijksmuseum (Catalogue of the Dutch and Flemish Drawings in the Rijksprentenkabinet, Rijksmuseum) 5. The Hague: Staatsuitgeverij, 1989.

—. 'Ter Borch's Ladies in Satin.' *Art History* 16, no.1 (1993): 95–124.

—. 'Het "Portret van Moses ter Borch" door Gerard en Gesina ter Borch.' *Bulletin van het Rijksmuseum* 43, no.4 (1995): 317–35.

—. *Gerard ter Borch and the Treaty of Münster* (The Hague and Zwolle: Mauritshuis and Waanders Publishers, 1998).

—. 'Gerard ter Borch and the Modern Manner.' In *Gerard ter Borch*, ed. Arthur K. Wheelock, pp 19–30. Washington, DC: National Gallery of Art, 2004.

—. 'Watercolor and Women in the Early Modern Netherlands: Between Mirror and Comb.' *Woman's Art Journal* 42, no.1 (Spring/Summer 2021): 27–35.

Kloek, Els, Catherine Peters Sengers and Esther Tobé,

eds. *Vrouwen en kunst in de Republiek: Een overzicht.* Utrechtse historische cahiers 19, nos 1–2. Hilversum: Verloren, 1998.

Krijnsen, Marco, Martin van der Linde and Esther van Velden, eds. *Overijssel en slavernij.* Zwolle: WBOOKS, 2023.

Krul, Jan Harmensz. *Eerlycke tytkorting.* Haarlem: Hendrick van Marcke and Theunis Jansen, 1634.

Lairesse, Gérard de. *A Treatise on the Art of Painting, in All Its Branches: Accompanied by Seventy Engraved Plates, and Exemplified by Remarks on the Paintings of the Best Masters.* Ed. William Marshall Craig. London: Edward Orme, 1817.

Larsen, Anne R. *Anna Maria van Schurman, 'The Star of Utrecht': The Educational Vision and Reception of a Savante.* Oxford: Routledge, 2016.

Lee, Rensselaer W. *Names on Trees: Ariosto into Art,* Princeton Essays on the Arts 3. Princeton, NJ: Princeton University Press, 1977.

Luijten, G. "De Triomf van de schilderkunst": Een titeltekening van Gesina ter Borch en een toneelstuk.' *Bulletin van het Rijksmuseum* 36, no.4 (1988): 283–314.

Luijten, H. '"Swiren vol van leer, amblemsche wijs geduijt." Een opmerkelijk zeventiende-eeuws poëzie-album van Gesina ter Borch.' *Bulletin van het Rijksmuseum* 36, no.4 (1988): 315–42.

Moes, E.W. 'Gerard ter Borch en zijne familie.' *Oud Holland* 4 (1886): 145–65.

Nevitt, Jr, H. Rodney. *Art and the Culture of Love in Seventeenth-Century Holland.* Cambridge: Cambridge University Press, 2003.

Oosterman, Johan. 'Die ik mijn hart wil geven: Het album van Joanna Bentinck en de zestiende-eeuwse vrouwenalba.' *Literatuur* 19 (2002): 194–202.

Peacock, Martha Moffitt. 'Geertruydt Roghman and the Female Perspective in 17th-Century Dutch Genre Imagery.' *Woman's Art Journal* 14, no.2 (1993): 3–10.

—. *Heroines, Harpies, and Housewives: Imaging Women of Consequence in the Dutch Golden Age.* Brill's Studies in Intellectual History, 312. Leiden and Boston, MA: Brill, 2020.

Porteman, Karel, and Mieke B. Smits-Veldt. *Een nieuw vaderland voor de muzen: Geschiedenis van de Nederlandse literatuur, 1560–1700.* Amsterdam: Bert Bakker, 2008.

Puttelaar, Carla van de, with Fred G. Meijer. *Gesina ter Borch (1631–1690): A Testimony of Love.* Amsterdam: Zebregs & Röell, 2024.

Schama, Simon. *The Embarrassment of Riches: An Interpretation of Dutch Culture in the Golden Age.* New York: Knopf, 1988.

Schnackenburg, Sophie. *'Pictura' in den Niederlanden: Ihre Genese und Entwicklung vom 16. bis zur Mitte des 17. Jahrhunderts.* Studien zur Kunstgeschichte, Band 221. Hildesheim: Georg Olms Verlag, 2022.

Schrader, Stephanie, ed. *Rembrandt and the Inspiration of India.* Los Angeles, CA: The J. Paul Getty Museum, 2018.

Strauss, Walter L., and Marjon van der Meulen. *The Rembrandt Documents.* New York: Abaris Books, 1979.

Streng, J. C., and Lydie van Dijk. *Zwolle in de Gouden Eeuw: Cultuur en schilderkunst.* Zwolle: Stedelijk Museum Zwolle / Waanders, 1997.

Strick, Maria. *Toneel der loflijcke schrijfpen. Ten dienste van de const-beminnende jeucht, int licht gebracht door Maria Strick. Fransoysche School-houdende binnen de wydt vermaerde stadt Delff. Ghesneden door Hans Strick.* Delft, 1607.

Strijbosch, Clara. 'The Many Shades of Love: Possessors and Inscribers of Sixteenth-Century Women's Alba.' In *Identity, Intertextuality, and Performance in Early Modern Song Culture,* ed. D.E. van der Poel, Louis Peter Grijp and W. van Anrooij, pp 178–208. Intersections 43. Leiden and Boston, MA: Brill, 2016.

Sutton, Elizabeth A., ed. *Women Artists and Patrons in the Netherlands, 1500–1700.* Visual and Material Culture, 1300–1700 14. Amsterdam: Amsterdam University Press, 2019.

Sutton, Peter. 'The Noblest of Livestock.' *The J. Paul Getty Museum Journal* 15 (1987): 97–110.

Thomassen, K., C. Bosters and Rijksmuseum Meermanno-Westreenianum, eds. *Alba Amicorum: Vijf eeuwen vriendschap op papier gezet: Het album amicorum en het poëzialbum in de Nederlanden.* Maarssen and The Hague: G. Schwartz / SDU, in collaboration with the Rijksmuseum Meermanno-Westreenianum, Museum van het Boek, 1990.

Wansink, Christina J.A. 'Simson en Delila; niet Gesina ter Borch, maar Hendrik Bloemaert.' *Oud Holland* 102, no.3 (1988): 236–42.

Welcker, A. 'De Stamouders van een schildersgeslacht: Harmen ter Borch en Catharina van Colen.' *Oud Holland* 63, no.3/4 (1948): 112–20.

Welu, James A., and Pieter Biesboer, eds. *Judith Leyster: A*

Dutch Master and Her World. Zwolle and Worcester, MA: Waanders, 1993.

Weyerman, Jacob Campo. *De levens-beschryvingen der Nederlandsche konst-schilders en konst-schilderessen . . .*, 4 vols. The Hague: E. Boucquet, 1729.

Wheelock, Arthur K., ed. *Gerard ter Borch*. Washington, DC: National Gallery of Art, 2004.

Wiselius, Iep. 'De jacht op Sakkerdaan: Hoe de zoektocht van naam naar houtsoort na 50 jaar tot een goed einde kwam.' In *Houttechnologie voor meubelrestauratoren: Handelingenen zevende Nederlandse symposium hout- en meubelrestauratie*, eds Hans Piena and Angie Barth, pp 57–63. Amsterdam: Stichting Ebenist, 2005.

Witstein, S.F. *Funeraire poëzie in de Nederlandse Renaissance. Enkele funeraire gedichten van Heinsius, Hooft, Huygens en Vondel bezien tegen de achtergrond van de theorie betreffende het genre*. Assen: Van Gorcum, 1969.

Worp, J.A., ed. *De gedichten van Constantijn Huygens: Naar zijn handschrift uitgegeven*, 9 vols. Groningen: J.B. Wolters, 1892.

Image Credits

The publisher would like to thank the copyright holders for granting permission to reproduce the images illustrated. Every attempt has been made to trace accurate ownership of copyrighted images in this book. Any errors or omissions will be corrected in subsequent editions provided notification is sent to the publisher.

Amsterdam Museum, Amsterdam: fig. 82
Collectie Overijssel / Collectie Vereeniging tot beoefening van Overijsselsch Regt en Geschiedenis (VORG) te Zwolle: fig. 8
Finnish National Gallery/Sinebrychoff Art Museum, Hjalmar Linder Donation. Photography by Hannu Pakarinen: fig. 2
Courtesy the J. Paul Getty Museum, Los Angeles: figs 20, 47, 53
HIP / Art Resource, NY: fig. 46
Hoge Raad van Adel: fig. 51
KB, National Library of the Netherlands: fig. 25
© Liechtenstein, The Princely Collections, Vaduz-Vienna/Scala, Florence/Art Resource, NY 2023: fig. 39
Louvre, Paris, France/Bridgeman Images: fig. 61
Mauritshuis, The Hague: figs 13, 43
Courtesy the Metropolitan Museum of Art, New York: figs 18, 31, 38, 49
Courtesy the National Gallery of Art, Washington: figs 19, 75
Norton Simon Art Foundation: fig. 44
Photo © Christie's Images/Bridgeman Images: fig. 17
Rijksmuseum, Amsterdam: figs 1, 3, 4, 5, 6, 7, 9, 10, 11, 12, 14, 15, 16, 21, 22, 23, 24, 26, 27, 28, 29, 30, 32, 33, 34, 35, 36, 37, 40, 41, 42, 45, 48, 50, 52, 55, 56, 58, 59, 60, 62, 63, 64, 65, 66, 67, 68, 69, 70, 71, 72, 73, 74, 77, 78, 79, 80, 81
Royal Collection Trust/© His Majesty King Charles III: fig. 54
Photography by author, reproduced by permission of Donovan Spaanstra; fig. 83
USC Fisher Museum of Art, Gift of the Armand Hammer Foundation: fig. 76
Vrouwenhuis, Stichting het Vrouwenhuis, Zwolle: fig. 84
© Wasserbug Anholt. Photography by A. Lechtape: fig. 57

Index

Note: italic page numbers indicate figures. Gesina ter Borch is abbreviated to GtB in headings and subheadings.

albums of GtB 11, 13, 14–17, 77, 79–80, 125–6, 128
 and formats/genres 17
 and genre painting 60–61
 literary sources in 47, 52, 59, 86
 see also Art Book; Materi-boeck; Poetry Album
Aletta Pancras (1670) 102, *105*
Allegorical Portrait of Three Ladies and a Child as The Finding of Erichthonius (Princess Louise Hollandine) *34*
allegories 13, 17, 27, 38, 52, 60, 79, 80, 82–6, 113–16
Amsterdam (Netherlands) 14, 27, 38, 43, 80, 125–6
 GtB in 106, 109, 116, 119, 122
 Rijksmuseum 11, 109, 116, 125, 126
Anna ter Borch (Gerard ter Borch the Elder, c.1632) *68*
Antwerp (Flanders) 20, 42
aphorisms 86, 88
Art Book 99–110, 125, 128
 Black men in *121*, 122, *127*
 Catharina ter Borch in Her Coffin 13, *16*
 Church Interior with Confessional 20–23, *21*
 cut-outs (*knipkunst*) in 122, *124*
 and GtB's identity 102, *103*, 106
 Hillegonda Schellinger 119–22, *120*
 Isfahan School painting in *108*, 109
 memorial to Moses ter Borch in *110*, 111–16, *113*, *114*, *115*, *117*, *118*
 Misandre and the Hermit 49, *50*
 occasional verse in 99–100
 and outdoor excursions/banquets *98*, 99–102, *101*, *102*
 Portrait of Aletta Pancras 102, *104*
 prefatory material in 79, 86
 self-portraits in 102, *103*
 and Sijbrant Schellinger 106–9, *107*
 Ter Borch coat of arms in *18*, 19, 82
 and *Triumph of Painting over Death* 82–6, *83*
 Zwolle street scene in 30–33, *32*
 see also Self-Portrait Inscribing the Trunk of a Tree
art market 14, 27, 38, 59, 60, 116
artist's models 11, 61, 63, 122, 126
 GtB as 13, 14, 17, 27, 65–77, 91, 125

Bentinck, Joanna/Johanna 80, *81*
Bleker, Dirck *71*, 76
Bloemaert, Hendrik 116
ter Borch, Anna (GtB's sister) 41, *42*, 67, *68*, 106
Ter Borch Arms (1660) *18*, 19, 20
ter Borch, Catharina (GtB's sister) 13, *16*, 125
Ter Borch family 19–38, 59
 coat of arms *18*, 19, 20, 23, 52, 81, 82, 125, 127
 dog owned by 11, 77, 86
 GtB's paintings of 13
 as licence masters 19, 23, 106
 and religion 20
Ter Borch family archive 11, 19–20, 79, 99, 100, 116, 122, 125
ter Borch, Gerard, the Elder (GtB's father) 13, 14, 19, 22, 23–6, 43, 61, 86, 95, 106
 Anna ter Borch (c.1632) *68*
 Sacrifice of Isaac, The (c.1609) 23, *23*
 View along the Via Panisperna towards S. Maria Maggiore, Rome (1609) *22*
ter Borch, Gerard, the Younger (GtB's half-brother) 11–13, 17, 23, 26, 27, 38, 106, 119, 127
 artworks copied by GtB 102, 109
 and collaboration with GtB 59, 61, 88, 113, *115*, 116, *117*, *118*
 Concert, The (c.1657) 91, *96*
 Curiosity (c.1662) *75*, 77
 death of 122–5
 family portraits by 109
 and genre painting 11–13, 17, 59, 61–3
 Glass of Lemonade, The (c.1664) *72*, 76
 and GtB as model 13, 14, 17, 27, 65–77, 91, 125
 Horse Stable (c.1654) *73*, 76
 Kamperpoort, Zwolle (c.1631–3) 30, 31, *31*
 Memorial Portrait of Moses ter Borch (with GtB, after 1667) 113–16, *115*, 126
 Moses ter Borch Holding a Kolf Stick (with GtB, c.1655) 116, *117*
 Portrait of a Young Woman (with GtB, c.1670) 116, *118*
 Ratification of the Treaty of Münster (1648) *58*, 59
 Shepherdess, A (c.1652) 88, *90*
 Two Studies of Anna ter Borch (c.1648) *67*

Unwelcome News, The (1653) 69
Woman Seated Holding a Wine Glass (c.1665) *12*, 13, 14, 60, 65
Woman Writing a Letter (1655) 27, *29*
Young Woman at Her Toilette with a Maid (c.1650) *62*, 63
ter Borch, Gesina 66
 albums of *see* albums of GtB
 as amateur painter 14, 31, 33, 34, 38, 125
 artistic style of 14, 31, 38
 artistic themes of 13–14, 27, 47, 86
 as artist's model 13, 14, 17, 27, 65–77, 91, 125
 as calligrapher 11, 13, 17, 41, 42, 44–7, *45*, *46*, 56, 90
 and costume/pose 47, 52, 59, 60, 65, 112
 death of 126
 education of 38, 42
 financial independence of 106
 importance of 13, 17, 126
 intellect of 80, 81
 and love/courtship 14, 47, 56, 65, 80–81, 86, 88, 90, 95, 106
 Memorial Medallion for (1690) *124*, 126
 memorials in modern Zwolle to 127–8, *128*
 and music 42, 65, 91, 96
 and oil painting 116–19
 and poetry *see* poetry
 and religion 20–23, 26
 self-portraits of 11, 13, 14, 79, 80, 81, 82–6, 102, *103*
 signature of 19, 23
 as teacher 122
 as unmarried woman 27, 102, 106
 and *vrijster* 47–9, 65, 76
 will of 125
 working method of 90
ter Borch, Harmen (GtB's brother) 19, 33, 56, *57*, 106, 127
ter Borch, Jenneken (later Schellinger, GtB's sister) 106, 109, 119
ter Borch, Moses (GtB's brother) 19, 33, 65, 76, 95, 106, 127
 Gesina ter Borch (1660) 66
 GtB's memorial to 100, *110*, 111–16, *113*, *114*, *115*, *117*, *118*
 Wiesken Matthijs (1660) *25*
Bredius, Abraham 125
Bufkens, Anna 20, 23

calligraphy 11, 13, 17, 41–3, 44–7, *44*, *45*, *46*, 90, 122
 and epitaph plaques 52
 as moral/virtuous 44, 47
 and poetry 42, 43, 44, 47
Calligraphy Sample with the Letter Q (Strick, 1618) 42, *43*
Calvinism 26, 41, 52
Caravaggio 23
Catharina ter Borch in Her Coffin (1633) 13, *16*
Catholicism 20–23, 116
Cats, Jacob 47–9, 52, 77, 88, 122

Church Interior with Confessional (165) 20–23, *21*
Cockfight in the Sassenstraat, Zwolle (1655) 30–31, *32*
colour symbolism 86, 95
commonplace books 17, 52
Concert, The (Gerard ter Borch the Younger, c.1657) 91, 96
Coornhert, Dirck Volckertszoon 41
Couple Strolling by Moonlight (c.1654) 26
courtship *see vrijster*
Curaçao 14, 106, 119–22
Curiosity (Gerard ter Borch the Younger, c.1662) *75*, 77

Dance of Death (c.1670) *110*, 111
Dance of Death (Holbein, 1538) 111
Deventer (Netherlands) 23, 106, 116, 122
Drawing lesson, The (Steen, c.1665) *37*, 38
drinking song (*Poetry Album*) 88–90
Dutch art 13, 17, 20, 27
 and amateur artists 33
 family portraiture 109
 and genre painting *see* genre painting
 and women artists *see* women artists
Dutch Republic
 aristocrats in 33, 79–80
 bourgeoisie in 59, 63
 calligraphy in 41, 43
 as colonial power 14
 economic crisis in 116–19
 genealogy/coats of arms in 19
 mourning in 111–12
 pastoral poetry in 88
 and Persia 109
 and Second Anglo-Dutch War 106, 111, 112
 and Treaty of Münster (1648) 59, 116, 122
 and warfare/violence 14, 20, 116
 women in 13, 17, 26–7, 49, 52, 99
Dutch Revolt (c.1566–1648) 20

emblem books/prints 17, 60, *61*, 79, 86–8, 95, 126
epitaph plaques 52
Exercise Book (Anna ter Borch, c.1638–41) 41, *42*

Figure Studies (1648) 38, *39*
France/French army 116, 119
Frerix, Anna 125
friendship albums 17, 79–80

Geerdinx, Anna Adriana 109
genre painting 27, 59–63, 80, 99, 102, 106–9, 128
 high-life 11–13, 17, 59, 63
 interpretations of 60

as 'modern pictures' 61–3
and realism 63
Gentileschi, Artemisia 85, 86
Gesina ter Borch (Moses ter Borch, 1660) 66
Glass of Lemonade, The (Gerard ter Borch the Younger, c.1664) 72, 76
Glass with a Poem to Constantijn Huygens (Roemers Visscher, 1619) 43, *44*
Greve, Aleida 127, 128
Grote Kerk, Zwolle 125, 127
Gudlaugsson, Sturla 102, 109

Haarlem (Netherlands) 27, 34, 38, 76, 106
Hattem (Netherlands) 99, 100, 102
Haverman, Margareta 33, *35*
Holbein, Hans the Younger 110, 111
Holland 27, 116, 119
Homage to Art (1652) 78, 79
Horse Stable (Gerard ter Borch the Younger, c.1654) 73, 76
Houwelick (Cats) 47–9, 52
 frontispiece (van de Venne) 47, *48*
Huygens, Constantijn 122
van Huysum, Jan 33
Iconologia (Ripa) 82, 86
Interior of the Oude Kerk, Delft (de Witte, c.1650) *51*, 52
Isfahan School *108*, 109

Jenneken ter Borch and Sijbrant Schellinger (1669) 106–9, *107*
Jordis, Hendrik 19, 80–81, 82, 86, 91, 99, 100, 102, 111

Kamperpoort, Zwolle (Gerard ter Borch the Younger, c.1631–3) 30, 31, *31*
Kettering, Alison McNeil 47, 63, 99, 100, 119, 126
knipkunst 122, *124*
Koerten, Joanna 122
Krul, Jan Harmensz. 88

de Lairesse, Gérard 63, 76
Landscape Sketchbook 31
Leyster, Judith 34–8, *36*, 63
Louise Hollandine, Princess 33, *34*
Luijten, Hans 86, 95, 126
Luijten, Ger 126

Madonna and Child with Saint Anne (c.1653) 23, *24*
Maria van Oosterwijck (Vaillant, 1671) *123*
van Marle, Cornelia 128, *129*
Materi-boeck 39, 43–7, 56, 79, 80, 90, 106
 calligraphy in 44–7, *45*, *46*
 literary sources in 47, 59
 Misandre/Abdon tale in 49, 52

Title Page (1646) *40*, 41
 watercolours in 52–6, *53*, *54*, *55*
Matthijs, Wiesken (GtB's mother) 16, 23, 76
Memorial Portrait of Moses ter Borch (GtB/Gerard ter Borch the Younger, after 1667) 113–16, *115*, 126
van Mieris, Frans *84*, 86
Misandre and the Hermit (c.1649) 49, *50*
Moda, Anna Cornelia 77, 122
Moses ter Borch Holding a Kolf Stick (GtB/Gerard ter Borch the Younger, c.1655) 116, *117*
de la Motte, Maria 76
Münster, Bishop of 109, 116
Münster, Treaty of (1648) 58, 59, 116, 122
music 42, 65, 91, 96

Netherlands *see* Dutch Republic

occasional verse 99–100
oil painting 113–16
van Oosterwijck, Maria 122, *123*, 126
Overijssel province (Dutch Republic) 19, 20, 65, 116

Pancras, Aletta 102, *104*, *105*
pastoral theme 88, *89*, 91, *94*
Penetrat et Solidiora (Visscher, 1614) 61
Penitent Mary Magdelene, The (Bleker, 1651) 71, 76
Persia 109
Pictura (An Allegory of Painting) (Van Mieris, 1661) *84*, 86
Pieters, Geertje 122, 126
poetry 11, 13, 14, 26, 42, 43, 44, 47, 79
 and images, interplay of 86–8
 occasional verse 99–100
 as tributes to GtB 33, 80–82, 91, 95, 109, 128
Poetry Album 15, 17, 74, 78, 86–95
 calligraphy in 90
 colour symbols in 86, 95
 and emblem prints 86–8, *87*, 95
 Gerard the Elder's verses in 86, 95, 106
 greeting scene in 91–5, *97*
 Jordis's tributes in 80–81, 82
 pastoral theme in 88, *89*, 91, *94*
 poems as songs in 86, 88–90, 91
 prefatory material in 79, 80, 82, 86
 rebound/re-ordered 80, 81
 Roldanus's tribute in 81–2
 as scrapbook 95
 spelling deviations in 88
 text–image interplay in 86–8
 unfinished drawings in 90, *93*
 violent imagery in 88–90, *92*

Portrait of Aletta Pancras (c.1670) 102, *104*
Portrait of a Young Woman (GtB/Gerard ter Borch he Younger, c.1670) 116, *118*
portraiture 112–13, 119–22, 128
Posthumous Portrait of Moses ter Borch as a Child (c.1667) 116, *118*
Protestantism 20, 23, 27

Ramhorst (country house) 125
Ratification of the Treaty of Münster (Gerard ter Borch the Younger, 1648) *58*, 59
Rembrandt 27, 126
Rijksmuseum (Amsterdam) 11, 109, 116, 125, 126
Ripa, Cesare 82, 86
Roghman, Geertruydt 27, *28*
Roldanus, Joost Hermans 42, 44, 47, 81–2, 100–102, 106, 119
Rome (Italy) 23
Rubens, Peter Paul 63, *64*, 65, 76

Sacrifice of Isaac, The (Gerard ter Borch the Elder, c.1609) 23, *23*
Samples of Hebrew, Greek and Arabic Calligraphy (Van Schurman) 43, *44*
Sassenstraat, Zwolle 30–31, *32*, 102, 106, 127
Schellinger, Cornelius/Schellinger, Gerrit (GtB's nephews) 119, 122, *124*, 125
Schellinger, Hillegonda (GtB's niece) 119–22, *120*, 125
Schellinger, Sijbrant (GtB's brother-in-law) 106–9, 111, 112, 116, 119, 122
van Schurman, Anna Maria 43, *44*, 56
Self-Portrait (1659) *15*
Self-Portrait (1661) 102, *103*
Self-Portrait as the Allegory of Painting (La Pittura) (Gentileschi, c.1638–9) *85*, 86
Self-Portrait Inscribing the Trunk of a Tree (1661) *10*, 11, 14, 30, 52, 79, 99, 100
Self-Portrait (Leyster, c.1630) *38*
sex workers 11, 13, 27, 76
Shepherdess, A (Gerard ter Borch the Younger, c.1652) 88, *90*
songbooks 17, 91
Spaanstra, Donovan 127, *128*
Spain 20, 59
Steen, Jan *37*, 38, 70, 76
Steen, Marietje 76
still life painting 116, 128
Stoffels, Hendrickje 27
Strick, Maria 42, 43
Studies of Dogs (c.1665) 74, *77*

Tea Party, A (Van Marle, 1689) 128, *129*
topographical drawing 23, 30, 31
Triumph of Painting over Death, The (1660) 82, *83*, 99, 113–16, 125

Two Studies of Anna ter Borch (Gerard ter Borch the Younger, c.1648) *67*
Two Studies of a Young Boy (Harmen ter Borch, 1650) 56, *57*
Two Young Men (1654) *121*, 122

Unwelcome News, The (Gerard ter Borch the Younger, 1653) *69*

Vaillant, Wallerant 123
Vase of Flowers, A (Haverman, 1716) *35*
van de Venne, Adriaen 47, 49
Venus in Front of the Mirror (Rubens, c.1614–15) 63, *64*
Vermeer, Johannes 13, 17, 20, 119, 126
Visscher, Roemer *61*
Visscher, Anna Roemers 43, *44*
View along the Via Panisperna towards S. Maria Maggiore, Rome (Gerard ter Borch the Elder, 1609) *22*
violence, theme of 13–14, 86, 88, *92*
vrijster 47–9, 65, 76, 77, 88, 102
Vrouwenhuis, Zwolle 127–8

watercolours 17, 19, 52–6
Wiesken Matthijs (Moses ter Borch, 1660) *25*
Wine is a Mocker (Steen, c.1663–4) *70*, 76
de Witte, Emanuel *51*, 52
Wolfsen, Aleida 128
Wolfsen, Hendrik 82, 128
Woman Scouring Metalware (Roghman, c.1648–52) 27, *28*
Woman Seated Holding a Wine Glass (Gerard ter Borch the Younger, c.1665) *12*, 13, 14, 60, 65
Woman Writing a Letter (Gerard ter Borch the Younger, 1655) 27, *29*
women 13, 26–7, 33, 99, 106
 assertiveness of 27, 86
 and calligraphy 42, 43
 and courtship *see vrijster*
 and domestic labour 27, 126
 literacy of 27
 virtuous, modesty/restraint of 27, 88, 99, 102
women artists 14, 17, 33–8, 116, 122, 125, 126, 128

Young Woman at Her Toilette with a Maid (Gerard ter Borch the Younger, c.1650) *62*, 63, 65
Youth Holding a Cup, A (Isfahan School painter/GtB, c.1670) *108*

Zebinden, Lambertus Theodorus 125
Zwolle (Netherlands) 8, 19, 20, 23, 27–31, *30*, 42, 52, 63, 65, 99, 122, 125, 126
 memorials to GtB in 127–8, *128*
 occupation of (1672–4) 14, 109, 116, 119